Understand the craft of the lan... ...int a personal response

Underpinning all good landscape painting is obs... ...dpoint, this book introduces the artist to painting the natural and man-made landscape. Initially equipped with just a handful of pencils and paper to explore the world outside, it allows confidence to grow alongside an understanding of the art and craft of painting landscape.

Written by artist Richard Pikesley, it demonstrates his approach and that of other contributors, who illustrate the diversity of paths that can be taken to achieve a passionate and personal response to the landscape. Richly illustrated with over 300 images, this book is an essential companion and inspiration for all aspiring and experienced landscape artists.

- Emphasizes the importance of observation, and advises on how to 'learn' the landscape
- Teaches the rudiments of drawing, and develops confidence and technical understanding of the subject
- Explains colour mixing on the palette, and how colour works in nature and is affected by sunlight
- Includes a guide to the materials, equipment and techniques of the landscape painter
- Completes the process with advice on presenting, framing and displaying your work, and how to find exhibition opportunities

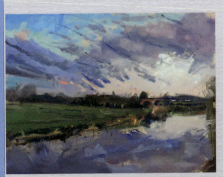
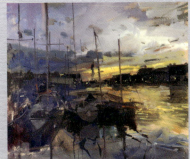
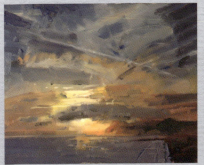

Landscape Painting

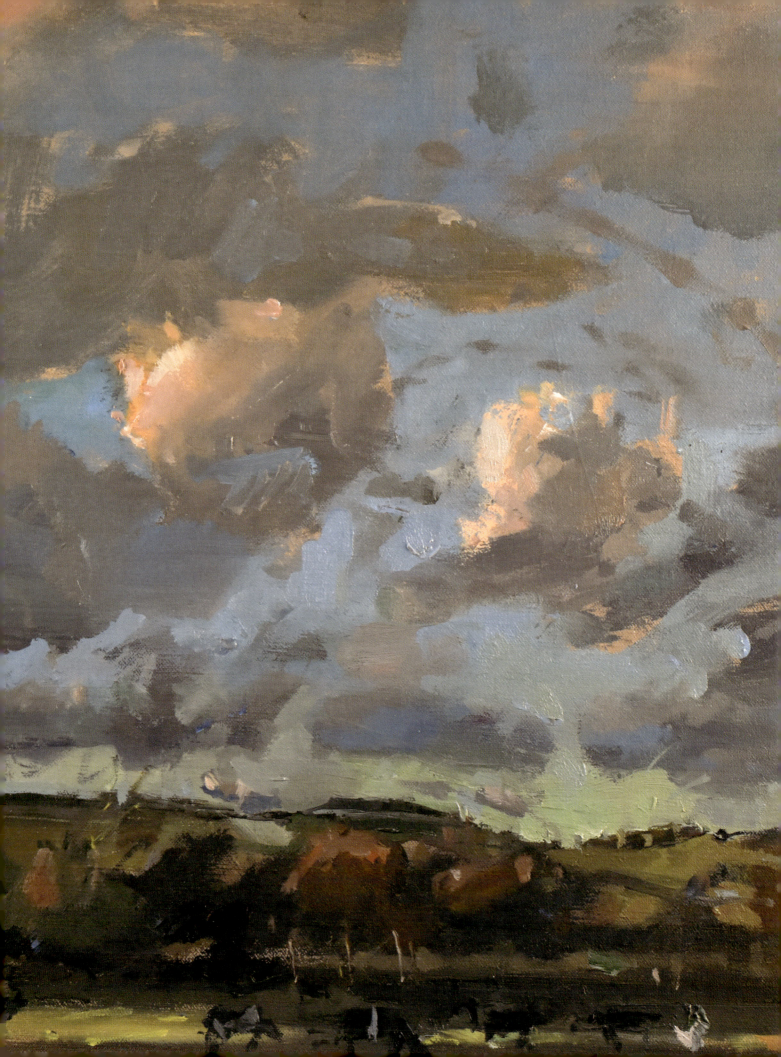

Landscape Painting

RICHARD PIKESLEY

CROWOOD

First published in 2019 by
The Crowood Press Ltd
Ramsbury, Marlborough
Wiltshire SN8 2HR

enquiries@crowood.com
www.crowood.com

This impression 2021

British Library Cataloguing-in-Publication Data
A catalogue record for this book is available from the British Library.

ISBN 978 1 78500 671 5

DEDICATION

To Debs, of course. But as painting can be a mysterious and intangible business, and never knowing what I know until it's said out loud, this book also owes much to all those students, teachers, friends and fellow artists, conversations with whom have shaped and given voice to how I feel about painting.

Graphic design and typesetting by Peggy & Co. Design
Printed and bound in India by Parksons Graphics Pvt. Ltd., Mumbai.

CONTENTS

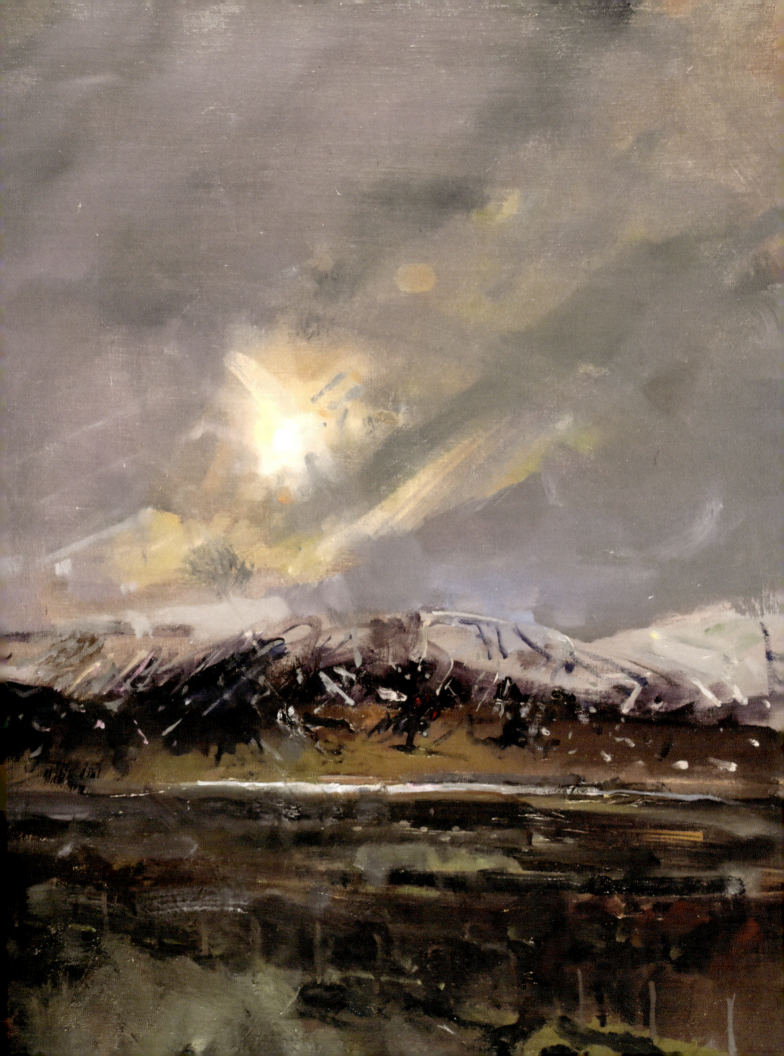

Introduction

For most of my working life I have been a landscape painter. As a child I drew and painted, and made a mess, all the time. Later, after I'd finished my years at art college and was teaching full-time, I would always have my paints and brushes with me so that I could squeeze in a brief spell of working on the spot on my journey to and from work. I'd organized my life so that I had a twenty-mile drive to and from work each day, initially over the Chiltern Hills and then along Dorset's extraordinary Jurassic coast. That daily thread of work kept me sane and kept me going as a painter. Alongside having to order my thoughts to teach others it was the most formative part of my development.

I mention this now as I know that, for many readers, painting landscape has to be fitted around busy lives, perhaps at weekends or an annual holiday. What I hope you will take from this book is that painting, and more particularly working from landscape, is an ongoing and immersive process, something to do every day, even if just for five minutes in a sketchbook or perhaps in your head on a train journey. It's as much about habits of seeing as about doing, and even a modest amount of time set aside each week will be enough to get you started.

For the past thirty years I have been lucky enough to paint full-time and am able to organize my life around a cycle of painting and exhibiting. The paintings I am doing now have roots that go a long way down, back into my past and an accumulation of earlier experiences and encounters. But alongside painting I've always kept a thread of teaching going and find it hugely enjoyable working alongside individuals and small groups. It is from this experience, and many conversations and encounters, that this book has grown. Painting is a long way from the sequential inevitability that is described in many books on the subject. For me it is increasingly something that I do all the time, but which involves many false starts and changes of direction along with some surprises. Although to be a good practitioner it is necessary to have a good grounding in the painter's craft, painting itself is not simply a craft activity where if you do the right things in the right order, success will follow; much of this book is therefore about ways of looking as it

■ *Iceland – the Journey North.* Oil on board, 20 × 16 in (51 × 41 cm), Richard Pikesley.

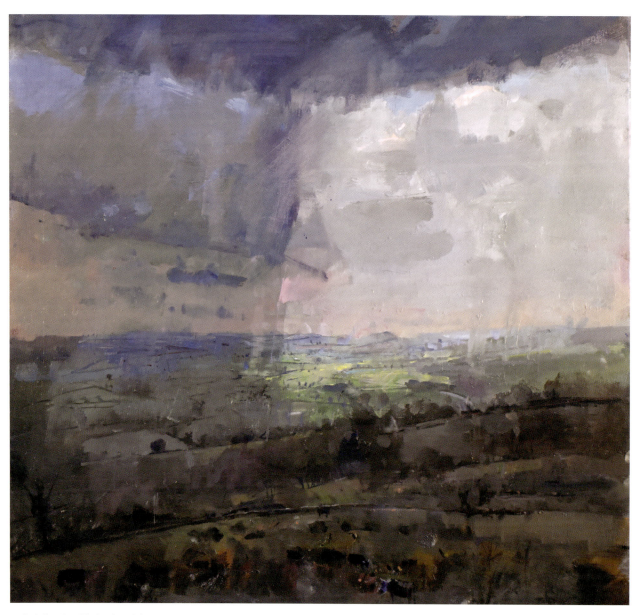

■ *Rain Passing, Pilsdon Pen.* Oil on canvas, 34 x 36 in (86 x 91 cm), Richard Pikesley.

is about making paintings. Like the threads of a tapestry, today's painting might pull on threads that stretch back many years and stitch them in with something brand new and that I've just seen.

For those who have already gained some experience painting in other genres, much that you have already learned will be helpful. Landscape painting does however present the painter with new challenges, both in terms of how the visual world is seen and understood and how that vision might be translated into paint. Working outside often involves dealing with much bigger spaces

than those encountered in a studio and much of the landscape painter's thoughts will be directed towards dealing with this. Consider too that there are no hard and fast boundaries around any of the categories of painting, and landscape painting isn't always about fields and cows. Subjects might, for example, be urban or marine and the approach may vary from the highly realistic to painterly abstraction or narrative fantasy. This book aims to give the reader a grounding in technique and ways of seeing, but without in any way hampering individuality or the development of a personal voice.

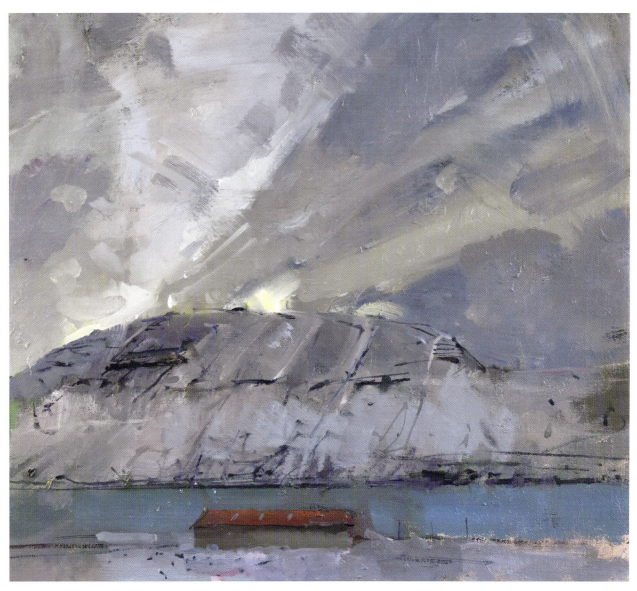

■ *Red Roof, Iceland Sunrise.* Oil on canvas, 18 x 20 in (46 x 51 cm), Richard Pikesley.

Teaching also involves lots of learning, and I know that having to find ways to verbalize all of the rather intangible processes that are involved in the business of painting has helped me understand more. There have been some memorable moments, often one-to-one conversations with students that have helped us both. Sitting at a painter's shoulder I can say 'look at that' or 'have you thought of this?' Having the landscape and the painted response in front of us speeds up the learning process. Painting often feels like a three-way conversation between the artist, the subject and a developing image, and a good teacher simply adds a fourth voice. I've written this book imagining that I am by your side as you work.

I have tried to get you drawing and painting straight away in Chapter 1, and the topics covered do develop in complexity as the book progresses; however, I could have put the chapters together in various different sequences. Above all, I hope the book gets you thinking about painting and how we explore and make sense of the visual landscape.

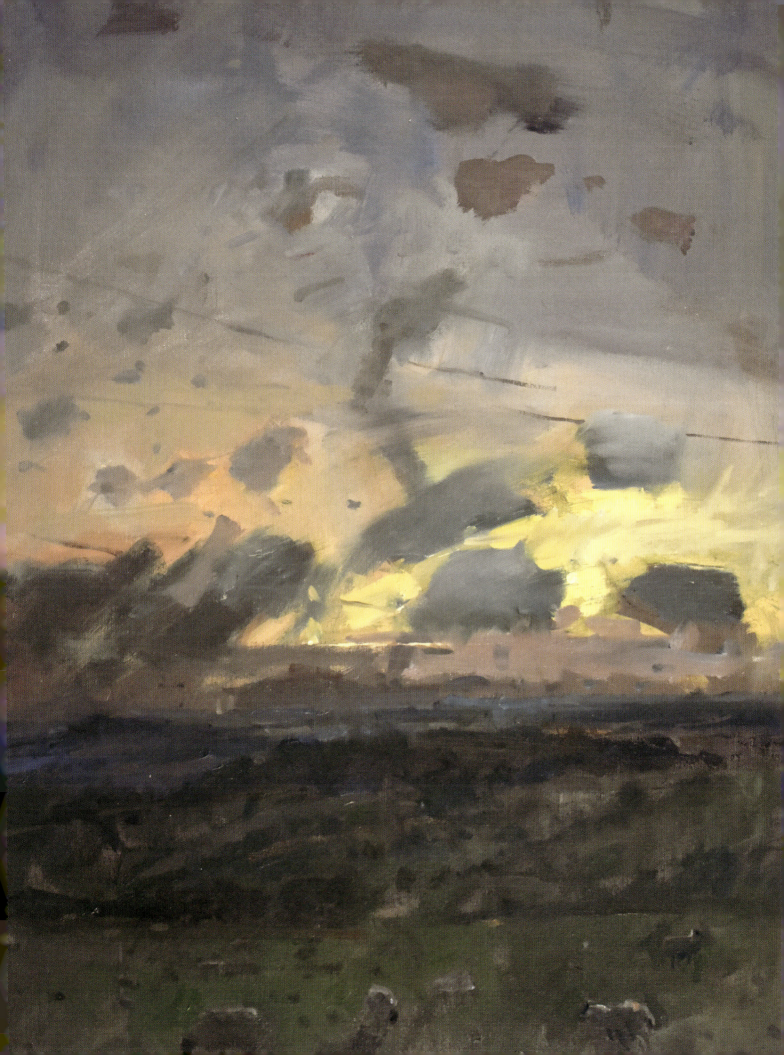

Seeing and Painting

My own experience is that it's much easier to be aware of what I see when I've got a pencil or a brush in my hand. The act of making a mark closes the circuit between the world out there, my thinking eye and a developing image of what I see. It enables the question, 'Is that what I see?', from which the rest simply follows.

Making a drawing slows me down, makes me stand and look and, in addition to the drawing itself, gives me time to process a visual memory and experience of a place. It allows me to make the first step towards the translation from the messy and complicated three-dimensional world towards a response to the encounter on canvas or paper.

Each medium we might use makes us look at the world in a different way. Drawn lines make us aware of the structural bones of a composition whereas loose blocks of oil paint in which edges blur and dissolve reinforces

a sense of the visual world into flowing and continuous space. So, right from the beginning it's good to work across several media, getting into the habit of using each method as a way into a different view of the landscape. Like a child growing up learning two languages, each medium is nuanced to access the visual world from a different direction.

So as we begin, let's equip ourselves with a minimal kit with which to make these initial explorations. We'll need something to make a drawn mark, a surface on which to work, and a source of tone to make things light or dark or somewhere in between. A few colours will complete our basic kit and leave us free to walk around in the landscape without the encumbrance of too much 'stuff'.

What follows is probably already too long a list, so choose from it things you already have or that you can easily find. Buying a lot of equipment or materials is not necessary yet. I'm tempted to put 'a decent pair of boots' at the top of any list of equipment. Remember, landscape painting is essentially an outdoor pursuit, so your personal comfort and safety are essential. You won't work effectively if you're cold or wet through.

■ *Western Sky, Knowle Hill and Beyond*. Oil on canvas, 36 × 24 in (91 × 61 cm), Richard Pikesley.

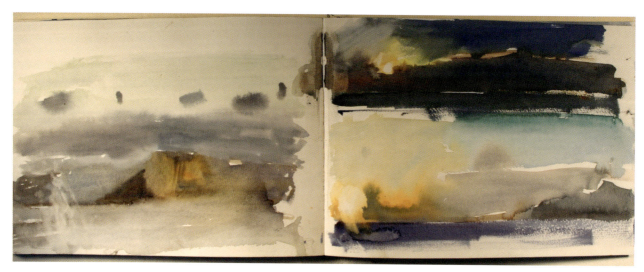

■ Sketchbook studies – where it all starts.

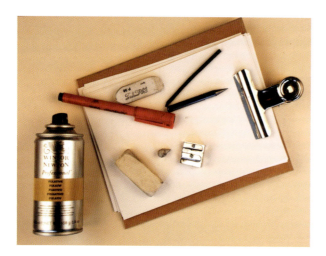

■ The bare necessities: a basic drawing kit.

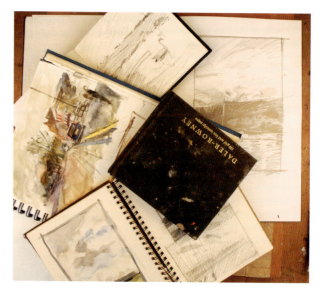

■ Sketchbooks come in all shapes and sizes. Those with spiral bindings will lie flat but tend to self-destruct with heavy use. Buy the best paper you can find.

A BASIC KIT

+ 'B' pencil and sharpener
+ Pens of various sorts: dip pens, cartridge-type drawing pens, ball point, etc.
+ Paper
+ Paints and brushes

PAPER

Use either heavy cartridge, thick enough not to buckle when wet, or hot pressed (HP) watercolour paper with its smooth surface receptive to drawn marks. Cut the paper into working sized sheets depending on personal preference. A 30 × 22 in sheet of paper will yield four sheets of 15 × 11 in, eight sheets of 7.5 × 11 in or sixteen

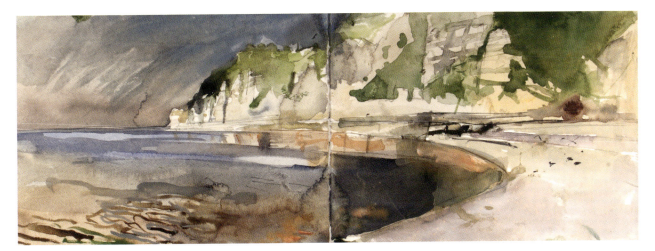

■ Pencil and watercolour, drawn right across a double page spread. Sketchbooks are a valuable resource.

sheets of 7.5 × 5.5 in. I find that cut down into this smallest size, little sheets of heavy watercolour paper are a handy size for my little pocket watercolour kit and a good alternative to a small sketchbook. A lightweight drawing board just a little larger than your preferred size of paper will allow you to use bulldog clips to hold the paper firmly in place. As an alternative to individual sheets of paper by all means use a sketchbook, but choose with care. The quality of paper varies enormously, so try to find something that allows you to make drawn marks with pencil or pen and is robust enough to accept wet washes without buckling. Sketchbooks have one further disadvantage for the travelling landscape artist: as you have to turn the page to reveal a new sheet, the one you've been working on previously will run and blot unless left to dry fully. If I'm using a sketchbook for making watercolour notes I'll use two, and alternate them to allow a bit of drying time.

PAINTS AND BRUSHES

Watercolour, acrylics and gouache will all work well on individual sheets of paper or in sketchbooks. Each has a different quality but all have their place in gathering information. Being water-based, these media need a minimum of other materials and equipment; they dry quickly and help keep things relatively simple through the early stages of learning to paint.

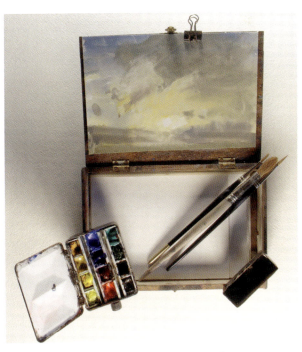

■ My cigar box watercolour kit. Small enough to slip into a pocket, this little box contains everything I need to paint a small watercolour with a few sheets of heavy watercolour paper, brushes and paints. The box of paints even has a water container and water pot built into it.

Watercolour

Watercolour comes in tubes to squirt out onto a palette or in pans made workable by brushing with water. Watercolours are transparent, can be built up in layers, and combine well with pencil or pen lines, which can be seen through the washes. They can also be used as a

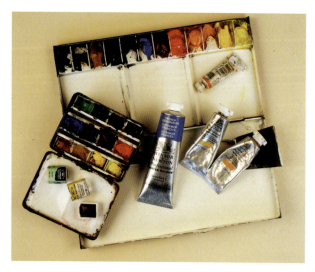

■ Watercolours come in two types, either solid pans or liquid colour in tubes. Both are sold in various sizes.

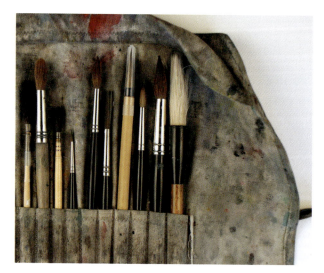

■ Good brushes can be expensive, so look after them with a canvas roll.

tonal wash with just one colour over line drawing. Colour combinations in washes can be tricky initially and we'll deal with this more fully later on.

Gouache

Gouache is sold in tubes; mix with water as with watercolour. These colours are opaque, and are a useful medium on their own and in a mixed-media approach. Originally made for designers, who needed flat colour for preparing artwork for printing, these paints also fabulous for the landscape painter as they allow you to work quickly without having to wait for overlaid washes to dry. When using these colours, try to make colour judgements wet against wet, as these paints change tone just a little as they dry, which makes 'patching' an area of dried colour or calibrating close tonal steps a little tricky.

Acrylics

On the face of it, acrylics have all the advantages of watercolour and gouache (and oil paint for that matter) and few disadvantages. Although I don't often use them, as I'm a bit put off by their somewhat plastic quality, they are transparent enough in thin washes, cover well in thicker layers when mixed with a little white, and dry quickly.

Brushes for watercolour, gouache and acrylics

For now, just a few inexpensive synthetic brushes will do: a couple of pointed ones, one small and one larger, and a wash brush. In general, use the softer type for watercolour and gouache, but hog hair brushes and their synthetic equivalents may be used with acrylics. Take care to wash them after use, especially after using acrylics, which will otherwise quickly dry and destroy the brushes.

STEP OUTSIDE

No grand expedition yet. Bring your minimal kit and step outside. Unless you are completely surrounded by walls you will probably have a view with a mix of distances – some near, others further away. So how do we understand the space around us? Perspective is a system of ordering the space within a drawing or painting and we'll come on to this later, but for now there are plenty of other visual clues which are a little easier to understand. Reading a painting and having a natural sense of space unfolding beyond the picture frame is largely a process of recognizing clues which the artist has left for us. The following section is all about learning how to lay this trail of visual breadcrumbs.

OVERLAPPING

So firstly, let's consider the simple observation that if one thing sits in front of another it blocks part of our view. The world may be seen as a whole series of overlaps, each of which implies distance and space behind it. As a simple demonstration, look at these two hands. Held slightly apart it is hard to know which is closest but as soon as they overlap the spatial relationship is clear. As an exercise, find a simple view in which objects overlap, perhaps a dustbin in front of a tree trunk, which in turn interrupts our view of a building beyond, and so on. Make a drawing that contains nothing other than the way these shapes overlap and create their own illusion of depth.

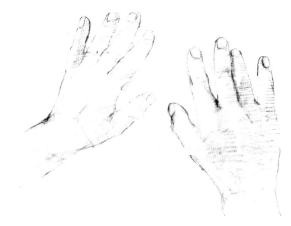

■ It's hard to see which of these two hands held up side by side is nearer.

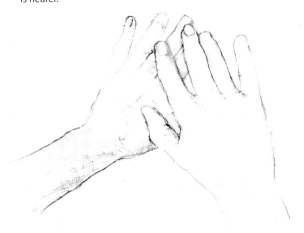

■ As soon as there's an overlap, their spatial relationship is clear.

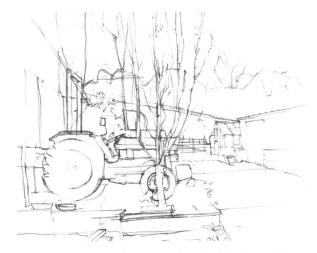

■ Drawn by simply starting at one point and letting the pencil run until it hits the edge of the paper, this drawing is full of overlaps, such as the tree in front of the tractor, and with few other visual cues these are enough for us to understand the space being described.

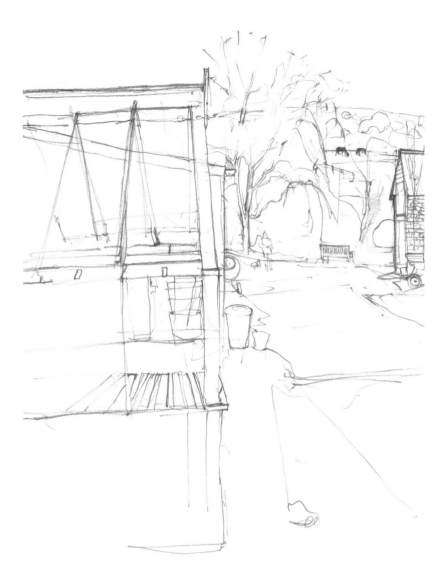

■ With big shapes filling the foreground giving way to smaller enclosures, our expectations help us to interpret the space within this drawing.

EXPECTED DIVISIONS OF SPACE AND SCALE

Standing in an open space we experience the horizon as an approximately straight 'horizontal' running from side to side across our field of view. This conditioning makes us all expect that a rectangle divided horizontally is representing an outside space or landscape.

Enclosed 'lozenges' of shapes reduce in size with distance. The surface of a drawing tends to fall into a pattern of big 'open' spaces in the lower foreground area, and smaller enclosures as you go back towards the horizon. Above the horizon, space reverses and cloud shapes generally open out, increasing in scale as your eye travels upwards.

You don't have to understand all the intricacies of perspective to appreciate that things appear smaller when they are further away from our eye. By carefully recording the relative size of things, a sense of space begins to open up.

MAKING A START

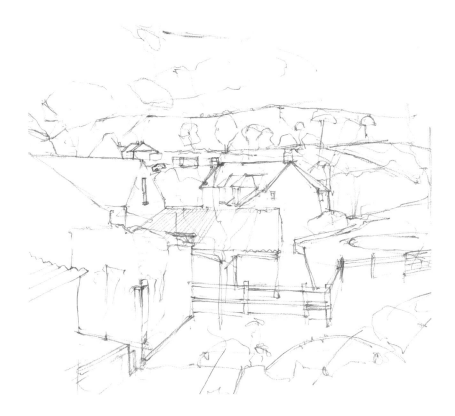

Line alone can say quite a lot. In this drawing I've once again just let the pencil run around the edges of things, recording overlapping and changes of scale. Try not to think about enclosing one thing at a time; instead just simply look for the edges as they crop up.

You're now in the business of noticing things. You are in the centre of a world which falls away from you in all directions, so position yourself where you can stand safely in one spot but turn to get different views. Along with the visual, is the wind on your face or your back? Did it rain in the night?

Initially using just line, drawing with pencil or pen, record what is in front of you until you fill the sheet. Work right up to the edges of the paper, drawing everything you can see without any thought for design or composition. Try to arrange your sheet of paper or sketchbook so that it and the subject are in your eye together, rather than working on your lap, for example, so that your head has to turn as you move your gaze from subject to drawing and back. Consider the spaces between all the edges and fill up the page remembering that part of filling the page may be big open spaces without much incident. When you find yourself just decorating, turn a little to get another vista and repeat the exercise.

If there are moving things within your view – people, clouds, dogs, sheep, etc. – don't leave them out. Record what you can even if it's just the back of a van or someone's legs. Don't worry about any form of completeness other than filling the page.

It's very likely that there will be long edges in the foreground which cut right across a lot of more intricate stuff further back. If this is the case those foreground edges make a great 'ruler' for measuring changes of scale. In the drawings I've made as examples, you will see that I've used a very soft pencil and let it run, leaving the point in contact with the paper as I move around the sheet. I haven't, in these drawings, done any measuring, relying instead on eye alone.

At the end of the exercise you may have five or six drawings. Arrange them so that you can see them all and pick out which one works best. Remember you only have to please yourself.

Now for a good exercise with a big surprise element. You'll need a sheet of transparent acetate film of the sort sold by art shops for wrapping prints and mounted drawings.

Tracing the landscape

Step 1. Select a view through a window which gives you a mix of open space and more intricate detail, ideally with a view through the foreground scene to distance beyond.

Step 2. Tape your acetate film onto the glass with little pieces of masking (drafting) tape so that you can see a view through it. Organize its position to give a view with a good mix of distant and close incidents.

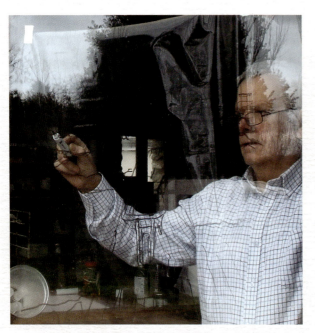

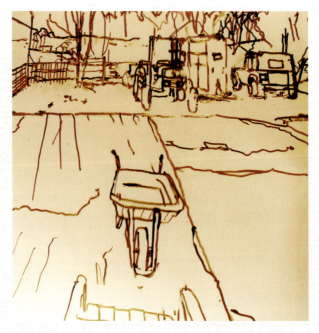

Step 3. Keeping your eye in one position, use the marker pen to trace the major lines of the view onto the surface of the acetate sheet.

Step 4. When you've drawn every edge you can see, remove the acetate sheet from the window and lay it on a sheet of white paper so that you can see the drawing. Photograph the drawing to keep a record, as the pen lines will probably rub off the acetate sheet.

■ Drawn from my seat on a train, my eye was caught by the distinctive tower. Because the apparent scale of the elements within a landscape fall away quickly with perspective, the foreground elements within a composition take up a lot of space and small movements of your eye make a big difference to how the foreground relates to what's beyond.

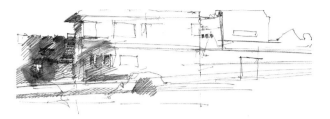

■ The tower disappears behind another building …

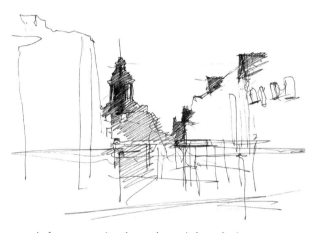

■ … before reappearing. A great lesson in how altering your viewpoint a little opens a wealth of possibilities.

Our brains have a tendency to flatten out space, making near objects seem to shrink a bit while things at extreme distance are 'telescoped' somewhat larger than they're actually seen. The surprise element in this exercise is in understanding the extremities of scale that exist in any view. Elements in the foreground will appear very big and the furthest details will be tiny.

PARALLAX

Another phenomenon which tells us about space is called 'parallax'. Standing with something very close and partially blocking your view, notice exactly what you see. Move your head just a little to one side and notice how the background doesn't change much but the bits close to you are transformed. As I write this I'm looking out of a train window and seeing the distant urban sprawl of south London hovering behind a blur of trackside structures. As the train slows I can make a drawing which soon becomes a little series as the train stops and starts. As it does so, the foreground and middle distance appear to move in relation to what's further behind. The view of a distinctive tower is eclipsed for a moment by trackside buildings, only to reappear in a different context. Even standing at an easel, small movements of my head result in a difference in how the landscape is seen. And our binocular vision creates the appearance

of a three-dimensional world by combining two slightly different views of the world. Parallax is an important part of how we interpret our three-dimensional view and make spatial judgements. We'll return to this later when discussing how we go about choosing viewpoints, but for now, it is enough to know that it's worth trying out different places to stand.

AERIAL PERSPECTIVE – TONE

Nothing to do with straight lines, aerial perspective concerns the way that colour and tone are altered by atmosphere and distance. Painters and other observant people have noticed for centuries that distance plays a big role in how we perceive colour and tone. As with so much in these early chapters, what follows is about allowing your painter's eye to see objectively without preconceptions getting in the way. 'Tone', also known as 'value', simply refers to degrees of lightness or darkness, without any concern for colour.

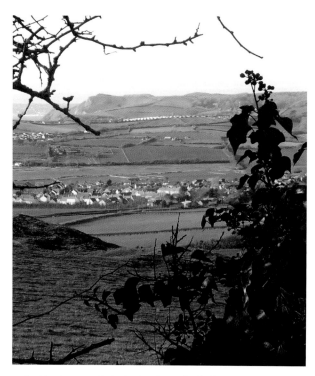

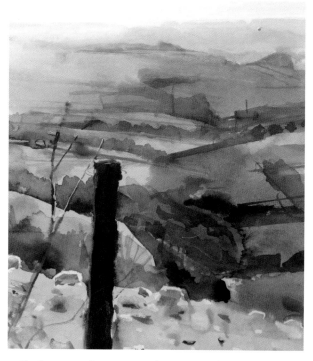

■ In this photograph the hedge through which we are looking is seen very dark and with strong contrast, reducing to tiny steps at the horizon.

■ The fence post close to my eye is seen as much darker than anything further away. The range of perceived tonal steps from light to dark reduces quickly with distance.

I'm standing out in the open fields above my house. There are some long views up here and I've got choices of whether I look out to sea, along the receding coastline, or turn my head and look inland. Choosing this option first, the landscape is mapped out by hedgerows, the first of which is so close I've got my drawing board resting on it as I work. The furthest is about five miles away. Thinking initially just in terms of light and dark, I am immediately aware of a difference between the range of tones in the foreground and what's going on further back.

Now, I've stood next to many inexperienced landscape painters who in this situation wildly exaggerate the tonal range that they think they can see. Try to think now in terms of relationships between tones rather than tackling them one at a time. Using gouache, I can achieve quite a good tonal range by having white and black paint on my palette and mixing steps in between. With care I can probably achieve about fifteen steps from the lightest tone I can make and the darkest. Of course, nature has infinitely more, from the brilliance of the summer sun to the deepest shadow.

As a practical demonstration of how this works, find a viewpoint with some sort of small obstruction crossing a distant view, a branch or a fence post quite close to your viewpoint would be ideal. In my case there is a fence post standing just beyond the hedge on which the drawing board is resting. I look at the point where the rising post crosses the fields near the horizon. What I notice is a revelation, albeit one I've marvelled at many times. Sliding my eye across from my close-up post to the most distant hedge line the difference is immediately striking. The hedge in the far distance has a tiny range of tone between its lightest part and its deepest shadow and the whole thing is very much lighter than my arm's length fence post.

In the examples here you'll see that I'm not worrying at all about drawing, but simply placing slabs of tonal paint against each other in a sequence taken from the landscape in front of me. Starting with a biggish brush, make large-scale decisions about simplest divisions of tone, then start to subdivide. looking for smaller components but keeping them within the broad context of the bigger divisions.

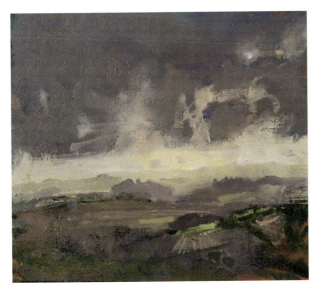

■ *Long View West, Eggardon*. Oil on board, 7 × 8 in (18 × 20 cm), Richard Pikesley. A tiny oil study, mostly about aerial perspective.

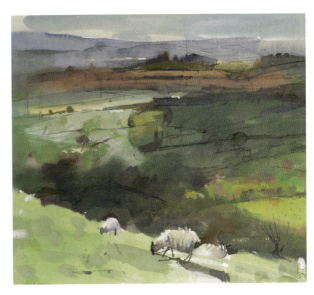

■ *Sheep, North from Eggardon*. Watercolour and gouache, 11 × 12 in (28 × 30 cm), Richard Pikesley.

■ *Landscape with a Draftsman*. Oil on canvas, 41 × 46 in (104 × 118 cm), Jan Both, Los Angeles County Museum of Art (www.lacma.org). Painted around 1645, this Dutch landscape shows both dramatic changes in tone and colour to represent spatial distance.

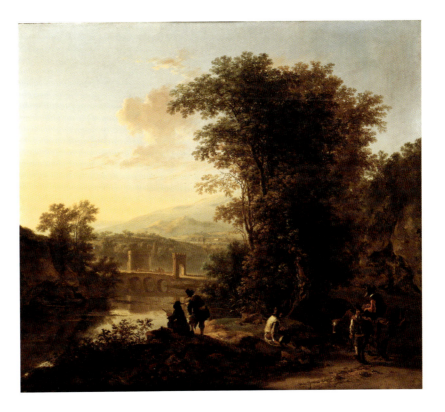

The strength of this effect will vary according to time of day, direction of sun and atmospheric conditions, but without fail, the perceived tonal range from light to dark diminishes with increasing distance. Later on, in Chapter 7, we'll talk about tonal pitch and how it is important not to start too light (or too dark).

AERIAL PERSPECTIVE – COLOUR

It's not just tonal relationships that are affected by increasing distance. A good understanding of what the intervening atmosphere is doing to degrees of light and dark leads us into the parallel effect that air and distance have on colour.

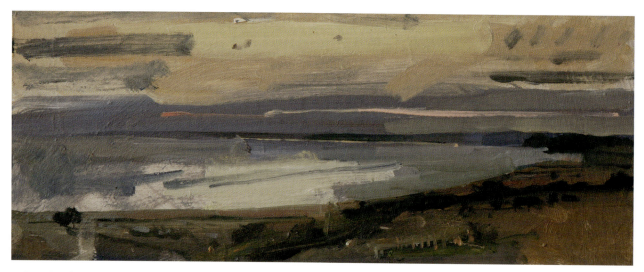

■ *Lyme Bay, Summer Evening.* Oil on board, 5 × 12 in (13 × 30 cm), Richard Pikesley. An open view to the west illustrating changes in colour as well as tonal range.

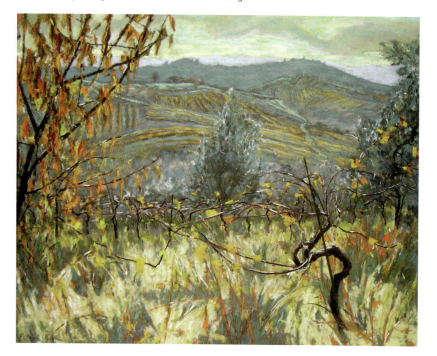

■ *Peach Tree and Vines.* Pastel, 30 × 38 in (76 × 97 cm), Patrick Cullen.

There's an old truism often applied to painting, that 'warm colours advance, cool colours recede'. As with many old chestnuts there is a degree of truth in this but it's not the whole story. Getting back to the hedge that we're leaning on and the field beyond it I can see a full spectrum of colour, both warm and cool in my immediate surroundings. But looking past my branch, and away to that distant view I'm aware that part of my colour world is absent from those parts that are furthest away.

I'll turn my head to look along the coast where headlands form stepping points going back into the far distance. Now I notice that not only is the range of light and dark becoming much more compressed as my eye travels back, but the colour world is changing too. Gradually the warm reds, browns and ochres are being eliminated as the world becomes more entirely blue.

How much do I need to include to make a painting?

The answer is usually, not everything. Working out in the open can be daunting simply because it may be hard to know how much of what is visible to use to build a painting. This of course is entirely your choice but here are a few thoughts to help you decide.

FINDING A FOCUS

It can be tempting to take on painting a grand view. But such views often lack a particular focus as everything is pushed into the middle or far distance. Also best avoided are viewpoints with two fairly equal focal points as these can lead to a sort of visual ping pong as the observer's eye flits between the two points. There will be much more on this in Chapter 10, 'Finding a Viewpoint'.

WORKING SIGHT SIZE

If I look past the sheet of paper on my easel and draw the bit of landscape alongside it on the same scale as I see the landscape itself, it is said to be 'sight size'. Whether we work on this particular scale is a matter of choice dependent on lots of factors but it is generally best to avoid working much over sight size. It can also be rather difficult to compress a wide angle view onto a very small format.

ANGLE OF VIEW AND PERSPECTIVE

With very wide angles or if I'm forced to turn my head, the rules of perspective may begin to break down. This is particularly challenging in a built environment with lots of man-made structures and straight lines. For the fun of it, and to see what's possible, try the following exercise.

Stand or sit somewhere fairly open in a natural rather than man-made environment. Rapidly draw or paint one of the views available to you from your chosen spot. Limit yourself to what you can comfortably see in one 'eyeful'. When you reach a point where you're happy to stop, turn a little so that you can see the next section from the same point. Start a second drawing or painting so that its left hand edge would join on to the right hand side of the first image. Try to work on the same scale as before.

■ Working sight size, the scale of the painting on my easel reads as the same as the scene I'm recording when viewed from my working position.

Keep going with more pictures until you have returned to your starting point. How many drawings have you made to get round a full rotation? When I tried this for myself, I was around the circle in six, rather wide angle drawings, though this would perhaps have been more comfortable in about eight steps. Placed edge to edge, these make a panorama and a very wide, shallow format. This in itself emphasizes another point: we generally choose to look at a fairly narrow horizontal slice of our visual world, just a little below and above the horizon. With this in mind, you could try to make another sequence, this time a vertical one, starting somewhere close to your own feet and extending up to the sky or tree branches above your head. Looking at my drawings or your own, notice how perspective only holds good for a fairly modest angle of view. The path that ran past me in a straight line curiously seems to double back on itself towards the same horizon.

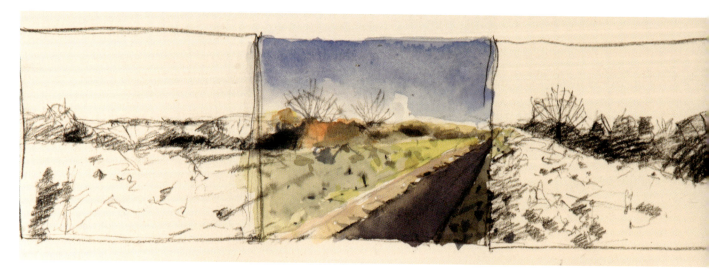

■ A sequence of six drawings recording a complete rotation.

VIEWFINDERS

If you've worked through the previous exercises you'll probably be wondering how to cope with such an overload of visual information. One answer is to shut most of it out and a simple way of doing this is to use a viewfinder. These can be purchased but they are rather expensive for such a simple piece of equipment and too small for painting through, though handy for making decisions about a view to choose and how best to frame it. I made mine years ago and they're a bit battered but very much part of my day-to-day kit. Simply consisting of a piece of strong card with a rectangular hole cut into it, mine can be held or placed a short distance from my eye to isolate a section of the landscape. I have several cut in various proportions but with a little ingenuity one could be made with one movable side to allow for any shape of rectangle. Mine just has a spare side taped into position using masking (drafting) tape which can be easily removed and repositioned. How big or small will depend on how far from your eye feels comfortable, but personally, I don't a find tiny one very helpful as its edges will be a long way out of focus when you look at the view beyond. Wedged between twigs of a tree or fixed to a cane pushed into the ground, or attached to the side of a portable easel, you'll need some way to support it in just the right place. I've painted mine matt black, as this too helps to isolate and reinforce the view beyond.

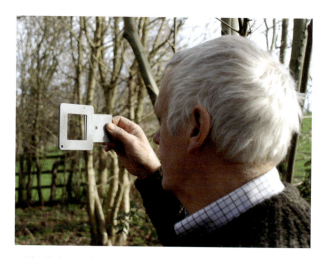

■ This little viewfinder is adjustable and useful for isolating potential subjects.

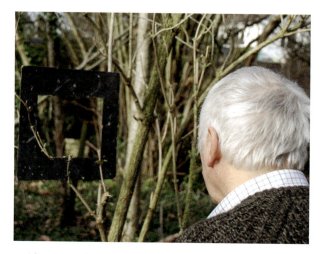

■ A larger viewfinder can be much easier to use.

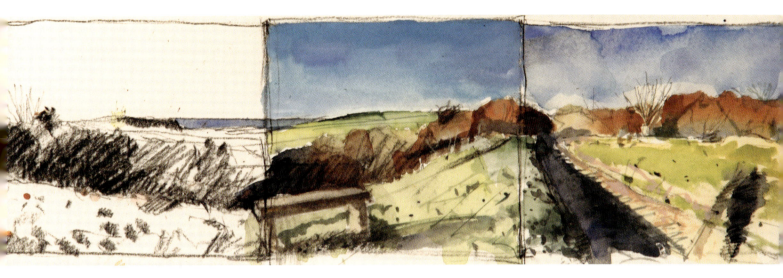

Using a viewfinder is a great way to focus in on a subject without too many distractions and also allows the eye to return to the right spot, particularly useful in a wooded landscape for example. It also allows the painter to play with numerous compositional possibilities within the same view, by taking in more or less, upright or horizontal shapes and different sections from within a wider view.

Try now to use the viewfinder to make as many versions of your immediate landscape as you wish. Using any of the drawing or painting materials we've mentioned so far, take some time to make a set of work which explores your immediate location.

So now you're a landscape painter. Keep the exercises you've done in this chapter; they are a good lesson in how you don't need a grand view, or elaborate techniques and that by working as simply as the situation allows there is less to trip you up or slow you down. I think you will quickly find that you are painting in your head even at times when busy doing other things. If this begins to happen, welcome it, as you will be better placed to see the visual possibilities of the world around you and open up visions of the extraordinary in places that will surprise you.

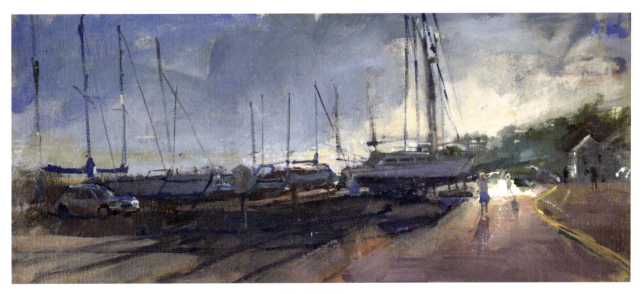

▪ *Boat Road, Winter Sun.* Oil on board, 7 × 16 in (18 × 41 cm), Richard Pikesley.

A PASSIVE EYE

When I was learning to draw and paint I was often told to look harder and it was some years before I realized that a too literal following of this advice could be very misleading. Much of the teaching in this book will keep coming back to the reality that for most of us, the mental maps we have for understanding the world around us have little connection with what we actually see. As my eye moves around the scene in front of me, the information being fed to my brain is constantly re-calibrated and my eye seems to want to telescope in to consider fragments of the view rather than the whole thing. Making judgements about drawing, as well as comparing colour and tones around a whole composition will rely on your ability to relax your eye into a more passive gaze, taking in the whole view before the fine detail. Only this way will you be able to assemble all the parts of your painting into a satisfying whole.

Even now, I sometimes catch myself focusing in to try to understand a particularly knotty part of the view, or manipulating paint around a small detail of a painting. When this happens, I make a conscious effort to relax my gaze and try to understand the problem passage as part of the broader whole. In reality, your eye must alternate between seeing the broad view, with a more searching effort to understand how each component relates to the whole. When I can, I tend to work standing up, and step back from my easel frequently to see what I'm doing from a little distance. This simple discipline helps me keep the whole scene in my mind's eye and errors and misjudgements can be more quickly adjusted. Working sitting down or in a situation where it's difficult to step back makes this process more difficult.

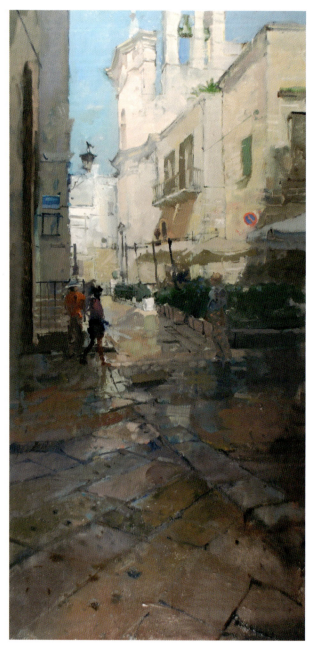

■ *Walled Town, Polgnano*. Oil on canvas, 36 × 18 in (91 × 46 cm), Richard Pikesley. This composition represents a fairly wide angle of view from top to bottom. It was necessary for me to relax my gaze to understand how the various elements of drawing and tonal pattern fitted together.

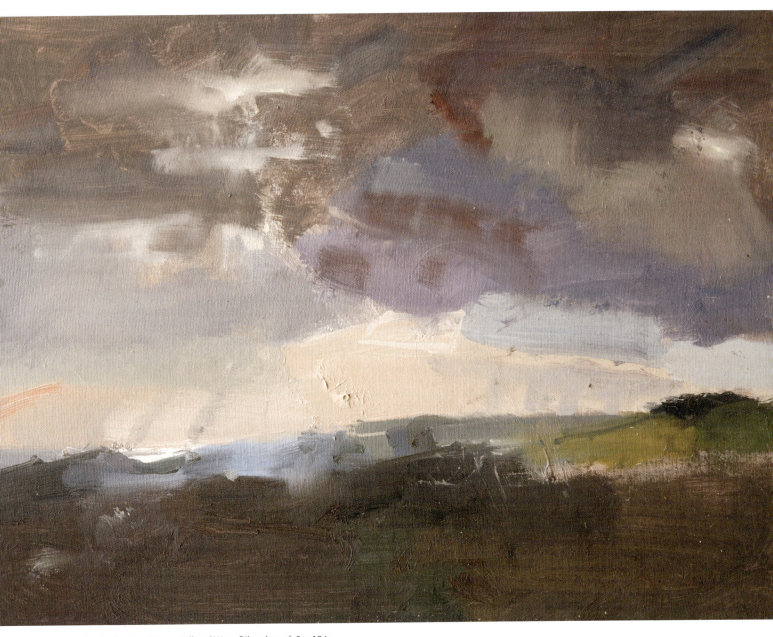

■ *Bonfire Smoke, Shipton Hill and West*. Oil on board, 9 × 12 in (23 × 30 cm), Richard Pikesley.

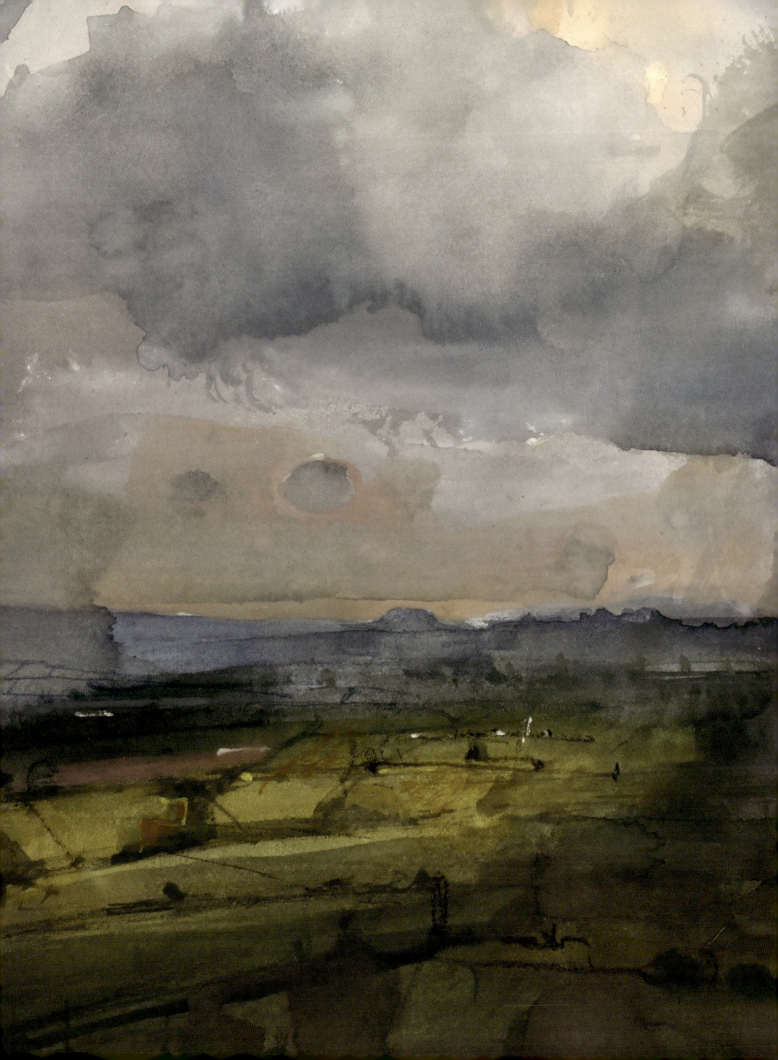

A Day in the Hills

I'm lucky enough to live surrounded by wonderful landscape, but the house and my studio are situated in a valley and for the purposes of this chapter I need to head uphill. I'll be on foot today so organize my kit to be easily carried. I won't need much: some sheets of a good, hard surfaced drawing paper cut to about A2 size and a couple of sheets of mid-toned watercolour paper, a lightweight drawing board and a selection of pencils and pens, a brush or two and tubes of Payne's Grey watercolour and white gouache should give me everything I need. I'll also carry a little folding stool; with luck I'll be able to work sitting with the drawing board on my lap, and save having to carry an easel. There's room for a couple of black cardboard viewfinders in different proportions, handy for isolating and focusing attention on a particular view. One additional small item which I always find useful is a plumbline, either the sort sold to help with your wallpapering or a simple weight on a bit of thread; you hold it up on your line of sight those how things line up vertically. Today I'm choosing to start working in line before later on moving into tone. I want to explore two different approaches and demonstrate how we never record everything indiscriminately, rather the character of the unfolding drawing or painting depends on the nature of the chosen medium or approach.

The same stretch of landscape seen on different days won't necessarily look the same. Weather, time of day or season will certainly influence how the painter will respond. Returning to look again at a view not only records the life of a particular landscape but also maps the artist's developing interest in different aspects of a familiar scene.

By travelling light, and with the focus on making drawings, I'll be able to work quite quickly and cover a lot of ground. I can keep moving and return home later with visual notes and references that will prompt return visits with all my painting gear and a plan.

■ *Rain Passing, Pilsdon Pen*. Watercolour (detail), Richard Pikesley.

WORKING IN LINE

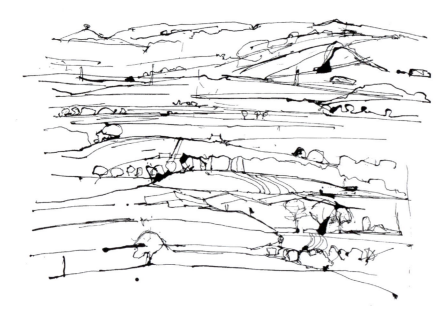

■ My pen blots and spatters as I keep the nib on the paper, mapping my way around the landscape.

I've come to Pilsdon Pen, one of the great Iron Age hillforts that command much of the Wessex landscape. As I arrive, a light shower keeps me sitting in the car for my first drawing. It won't last long but the broad view in front of me makes an interesting starting point. It's quite complicated with field boundaries marking out the valley below before the land rises to a hilly horizon with glimpses of the sea beyond.

I'm looking for a subject and how it will sit within the proportions of my proposed painting. Initially I'll make some line drawings without much measuring. These first drawings will be made without thinking of where the edge of the composition might fall, simply starting at a point that interests me and building outwards. Anything which will make a linear mark might be used – pencils, pens, a thin stick of charcoal, or a pointed brush and some ink would all be good choices. I'm using a simple pen dipped in waterproof ink, as it makes a strong line whose weight may be varied with heavier or lighter pressure. It's also such a strong mark it stops me being too hesitant at this stage. My dip pen blots and spatters, but I don't mind that. It makes me less precious about the drawing which is mostly a visual record of my moving gaze and thoughts as I begin to search out a subject.

Looking into the intricate pattern of hedgerows, it's easy to get lost in a lot of detail, so I try to notice how the main lines map out the three-dimensional character of the land and look for these before drawing in the connecting, lesser lines. I try not to go straight for the horizon line as drawing that in too firmly at an early stage makes it difficult to then establish a sense of space. However, taking note of any particularly eye-catching features along the horizon line gives me a reference point that I can return to, and also a useful point from which to 'hang' my plumbline and see how points line up vertically. Most of this view is away from me in the middle and far distance and although it makes a splendid view, for me it isn't quite the ideal subject. However, as I draw I start to see so much more and I think that with a more selective approach there is after all a painting here. By stopping to make a drawing, and so really looking, I'm starting to learn the landscape. The land falls away from me then across a flatter valley floor before rising again into the hills in the far distance. After about ten minutes I put this drawing aside to dry and notice another possible subject over some trees, which will give me a stronger foreground. Starting to map this out I am struck by the pattern made by the trees in the hedgerows, repeating

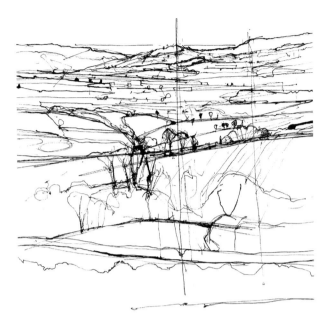

■ The top of the distant hill makes a useful point from which to hang my plumbline to check how things line up from top to bottom.

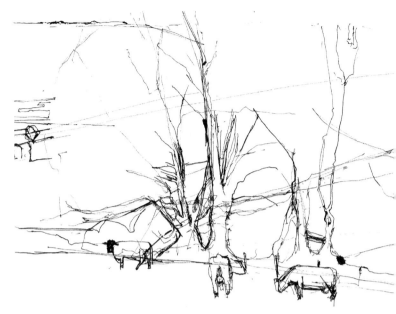

■ Moving on, the gaps between the dark trees and the black cattle catch my eye.

and getting smaller into the far distance. This is a spot to come back to.

The rain's stopped, so with these first drawings tucked away in my folder I leave the car and start to look around. With a little more height and all-round vision, a whole lot of options open up, so my plan is to walk, stopping to make a drawing each time something catches my eye. I'll look for foreground now as well as the big view; I want to get under the skin of what makes this place special. Drawing makes me slow down and really look. This is an ancient place, shaped by people and the way they've lived and farmed over thousands of years. It's high ground and commands big views in all directions; however, I think there's more to see here than the long view and although I know this place quite well I want to take my time and stop to draw whatever catches my eye.

It's still winter, and the bones of the land really show. There's a degree of transparency in the landscape now which will disappear once the trees are in leaf, and although it brings particular challenges I revel in the way that I can see the countryside through the gaps between limbs of trees. The main challenge of dealing with drawing the trees is how far to go in dealing with the smallest structures as I work from the big trunks

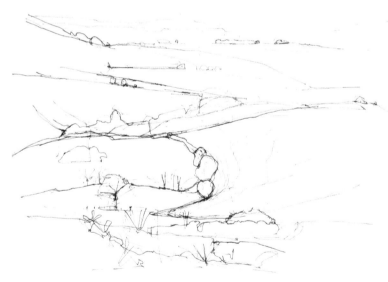

■ Just looking for the most important structural lines recording the folds in the hillside below me.

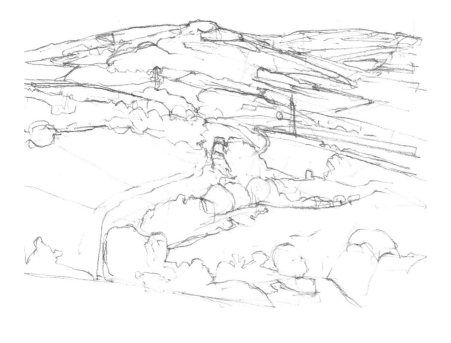

■ Switching to pencil brings a subtle change as its responsive marks give me a different quality of line.

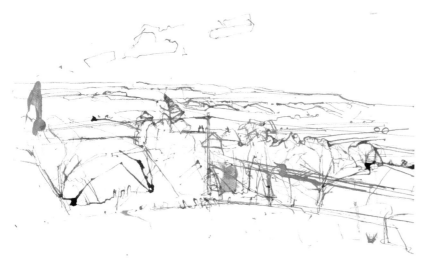

■ Working with diluted waterproof ink the line is less strident and will be easier to integrate when I work over it with washes later.

out towards the smaller branches and twigs. Once I'm painting, I can find ways of suggesting structure without itemizing every point, and while I'm drawing, I want to make an honest record and it is sometimes better to put a line where there's a boundary between an overall mass of branches rather than attempting to draw every twig.

WEIGHT OF LINE

A drawn line doesn't just convey information about the location of edges, however useful this alone can be.

Its quality – whether tentative or assertive, hesitant or downright brutal – has the capacity to say much about space and relationships within the drawing as well as speaking volumes about the mood of the artist. Different materials will naturally produce lines of various weights and thicknesses but it's important to know that you can respond as sensitively with a big brush loaded with paint as with the most delicate of pencil lines. In a well-made line drawing, the line will often swell and taper like the swirling lines of calligraphic handwriting. The edge of a hill will be here soft and at another point sharp and hard as the character of the contour changes. Some media

are better than others at responding to the pressure of your hand in this way. All sorts of dip pens are rather good at this, whether a metal nib or bamboo or quill, but there are also ink-filled pens sold for handwriting that have this quality. Draughtsmen's pens with tubular nibs to guarantee an absolutely even thickness of line can't respond to changes of weight and emphasis from your hand in the same way, though having a variety of these pens can be a useful way of varying how emphatic a line is within the drawing.

Sometimes too, written notes added as you make a drawing can be invaluable. As your eye bounces back and forth between the landscape and your drawing you will notice many things that may be quickly forgotten. A word or two jotted down on your drawing will remind you and can be a surprisingly good way to unlock visual memory later on.

Working this way I can quickly explore lots of different options. Each drawing becomes a sprawling maze of lines made with little thought of creating depth. This method enables an initial encounter with a chosen subject without the constraint of having to fit it in to a chosen size and proportion. It's a kind of rehearsal, or a first conversation with a subject that I may want to get to know a little better. As well as pen I may use another linear medium such as pencil or charcoal which can be pushed further into tone.

Once I've made half a dozen drawings I will start to give more thought to how each might sit within a frame, and a pair of L-shaped pieces of mountboard lets me explore some options. Once I've done this, considering each drawing in turn, I may have two or three viewpoints that I'll want to explore further, but for now I'll pick one and save the others for another day. Having adjusted the mountboard corners over my chosen drawing I draw a line on the study to mark the composition edge. With the little drawing marked up as a reminder, I can start work on a bigger scale on my next visit and this time make plenty of measurements and checks to make sure the drawing is correct.

With a new sheet of paper on the drawing board this time I'll work with my Indian ink diluted a little with distilled water (it can go rather grainy if you use tap water), together with a fine nib. By making the line a bit less strident I can keep the option of being able to add ink or watercolour washes later on, as Indian ink even when diluted will be permanent once it is dry and will show through transparent washes.

MEASURING

The reason for making measurements is to make sure that we keep proportions right throughout the composition. Even now after many years of work I still begin with a few simple comparisons of widths and heights. We constantly make assumptions about what we see and it's very likely that, faced with a receding landscape, whether receding hills or urban streets, we exaggerate the vertical component. Knowing that it's perhaps three miles to the horizon we tend to stretch this dimension, and a few checks, placing marks on the paper to represent where particular reference points occur in the landscape will give me a solid starting point. I'll deal with this process more fully in Chapter 5, but for now it's enough to know that with my arm fully extended I can make comparisons between different parts of the view.

LIGHT AND WEATHER, WORKING TONALLY

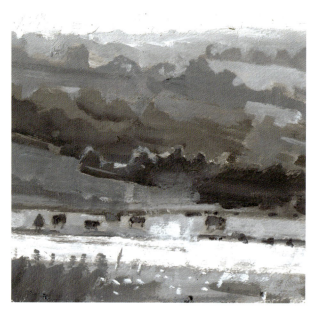

■ With no line and deliberately big clumsy brushes, I have only loose blocks of tone, but enough to convey a great deal of information.

In the previous section we began to create landscapes using just one element: line. Now we'll focus on degrees of light and dark, otherwise known as tone or value. As I've walked and drawn my way around this great hill I've arrived at a point where the land falls away to the north and the most exciting aspect of this new view is the effect of huge cloud shadows constantly moving across a vast landscape. These give me something to build a painting around in a landscape which is all still rather too 'middle distance' to immediately appeal otherwise.

As I switch from making linear drawings to thinking about and recording tonal pattern, I'm shifting my emphasis in the nature of what I'm recording.

There's a close relationship between our chosen medium and the way we perceive the landscape. With a pen in my hand which will make an incisive line I was looking for edges and boundaries; with a broader medium which will make tonal or coloured marks and put down blocks and sweeps of pigment I'm bound to see and record the visual world in a different way. We don't see the world with every edge bounded by a line.

Nor do we often see one object entirely without it being partly obscured by another. Rather than thinking of our subject as a collection of things, let's try to see the world as sensations in the eye.

Without line, and for now without colour, what are we left with? Enough, as we'll see. I can choose to work tonally in pretty much any medium. A single pale wash can be built up in repeated layers darkening with each step until the full range from light to dark is achieved. Alternatively a strong dark watercolour wash can be mixed to give maximum darkness then diluted with water to create steps. We'll look at both of these methods. Dry media like pencils, crayons or charcoal will produce a range of tone and the blackest of ink can be crosshatched to produce various degrees of light and dark. Working in oil paint, any dark colour mixed by degrees with white will produce a good tonal range. The same is true for water-based opaque colours like gouache and acrylics. I'll talk about each of these approaches in turn, but remember, this is as much – or maybe more – about ways of seeing as it is with the particular technique used to describe it.

DRY MEDIA

There are plenty of ways of drawing tonally, and one that I find very practical is using charcoal. This medium may be purchased in many forms ranging from fine sticks right through to hand-sized lumps. You will also find charcoal pencils on offer but I find these difficult to sharpen and I've wasted a lot of time trying! Charcoal can be pushed around on the paper to create finest lines right through to broad sweeps of thundering darkness. It will smudge as soon as you touch it and can be pushed around with thumbs, fingers or rags. However, when you've finished drawing you'll probably want to spray it with a fixative, which will preserve what you've done.

Used forcefully, charcoal on its own will tend to go pretty dark, though not quite fully black. It can be lifted or smudged using a fingertip or eraser so that dark areas

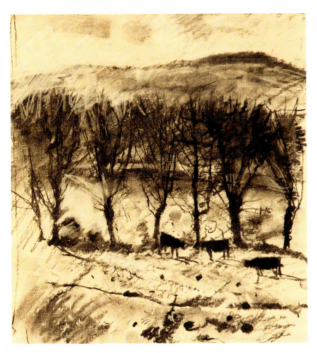

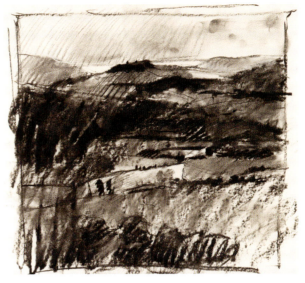

■ A very expressive yet simple medium, a stick of charcoal used with varying pressure will make marks from fine lines to thundering blacks.

■ An idea for a painting strikes me when I see black cattle grazing below the tall dark trees with a broad landscape visible through their trunks and branches. Charcoal is ideal for making a quick note.

■ Charcoal used on a good smooth cartridge paper may be worked further using finger tips and putty rubbers to lighten a charcoal mark and work from dark to light.

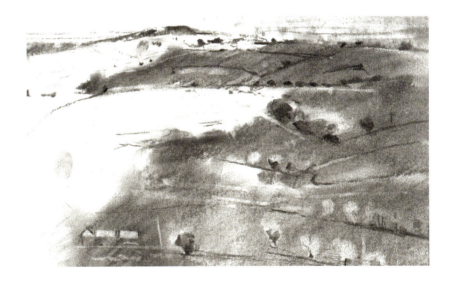

can be lightened. By working on good cartridge paper, using a soft putty rubber you can get quite a bit of control working light back into the charcoal marks. We can take things a little further by working over a drawing made in charcoal using black and white pastel or Conté crayon in its softer grades. This will continue to make clear marks beyond the point where the paper has become unworkable from too much charcoal and will add delicate tones at the top end and a serious black in the deepest shadows.

Remember to use a paper which isn't too smooth; the textured surface of Ingres paper is perfect for accepting the crumbly pigment from a soft pastel.

This is a rather forgiving way of drawing, and like oil paint, you can make substantial changes as you go, making it useful for days when the light is changing fast and it's a race to keep up. If the surface does become unreceptive, a spray of fixative will generally allow you to take things a little further.

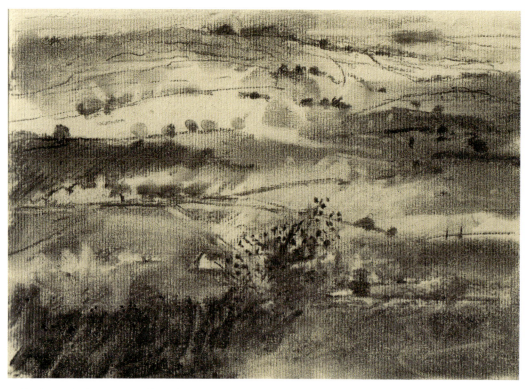

■ Used on grainy Ingres paper, I have the option to take a charcoal drawing a little further with other dry media.

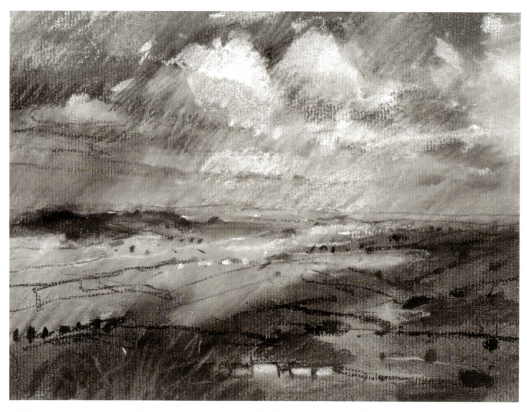

■ This drawing has been developed further by spraying with fixative, then using black and white pastel to chase the cloud shadows as they race across the valley.

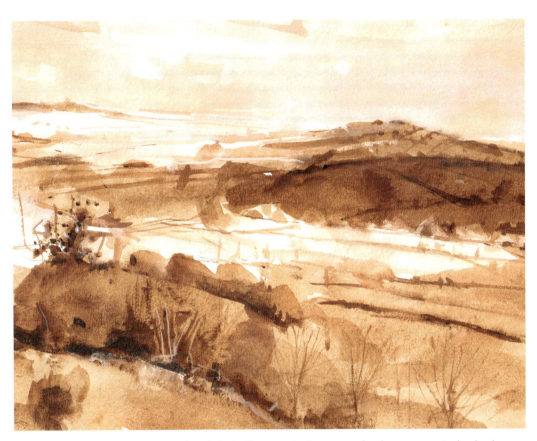

■ With just an earthy Burnt Sienna wash and a little white gouache I can respond to the movement in the cloud shadows, using semi-opaque washes with the gouache to get some light back.

WATERCOLOUR AND GOUACHE

With a breeze blowing and cloud shadows moving quickly across the valley below me I choose to start here with a tinted paper, Burnt Sienna watercolour and white gouache. Using this mixed approach I can lay in dark watercolour washes and work back into these dark masses using more opaque mixes with the white gouache. This gives me a very responsive way of recording changes rapidly. As I occasionally have to stop for a few minutes to allow a wet patch to dry, I have a second drawing on the go as well, and alternate between the two. What lies below me is the sort of broad view which on a fine day might be a bit featureless; however, as the shadows of the clouds wash across, effects like theatrical lighting are produced. A white house a mile away is suddenly lit for a moment and pulls my eye before disappearing into shadow as another section is lit up.

WEATHER

It's not a constantly bright, sunny day, and to my mind, all the better for painting. Although what I'm seeing changes very rapidly, I can stay in one location and a variety of compositional opportunities offer themselves in succession. It can be a nuisance when rain spatters a drawing, but a big plastic bag rolled up in my pocket is all I need to give my drawing a few minutes' protection while the shower passes. Uninterrupted sunshine may not have the visual drama of a day like today, but it does allow time to make a more studied drawing, or maybe to paint under trees where the effect of light will be at its most intense. Curiously, really dull days have their moment too. The normally rather extreme range from brilliant light to deepest shadow is compressed down to something more manageable at such times and with tones brought close together colour can quietly sing in a way it doesn't in really brilliant light.

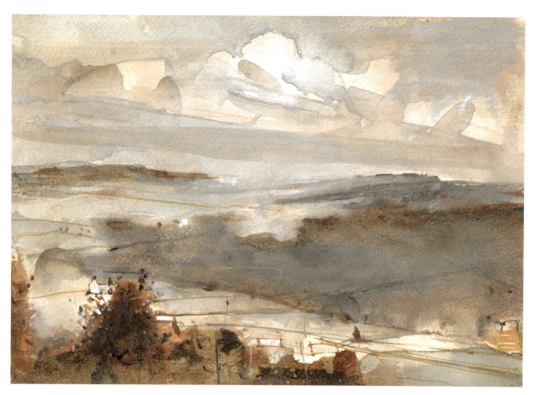

■ As the scene in front of me develops I start another drawing and notice how the angle of the cloud base is echoed by a diagonal between light and dark masses in the landscape.

DIRECTION AND STRENGTH OF LIGHT (UP-SUN, DOWN-SUN)

With a high viewpoint looking out over the surrounding countryside I can pretty much turn through a complete rotation and have something to paint at every step. For the moment, still thinking just about tone, turning my head to look at different angles to the direction of the sunlight clearly makes a big difference. The way we see the landscape is hugely influenced by how it's lit and especially where the sun is in the sky relative to the direction of our gaze. The strongest modelling and sense of a three-dimensional landscape will probably coincide with views lit from the side, especially noticeable when the sun is low in the sky, early or late in the day or in the winter. Notice too how whichever direction you look in there's a sort of rhyme between the various parts of the scene. Look for example at the cloud above the tree and notice how similarly they are modelled, lit as they are from the same direction. Now looking down-sun, with the sun on my back, reflected light blazes back at me and

I notice that where the ground falls away beneath my feet the foreground fills with shadow.

The cloud shadows reach like fingers across the vale landscape below and these suddenly become the main focus and I quickly make several wash drawings to try to catch their patterns. They're moving fast and the wash method described above allows me to float in the shadows with just a few landmark indications to orientate my eye as I work.

Turning away from my view to the north to look up-sun into the light everything changes again. Tones are simplified and compressed, the expected silhouette effect doesn't push everything down into blackness; rather there's a lot going on in the mid-tones and a sort of hazy half-light fills the shadows. Painting this effect can be very testing as the tonal range from light to dark is squeezed. Don't stare straight into a brilliant sun, rather use peripheral vision to notice its effect.

How light or dark to pitch the tonal range of a painting will be discussed at greater length in Chapter 8.

■ *Early Spring, Pilsdon Pen*. Oil on board, 16 × 15 in (41 × 38 cm), Richard Pikesley.

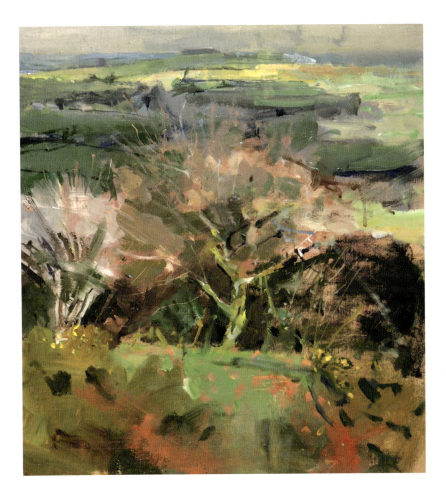

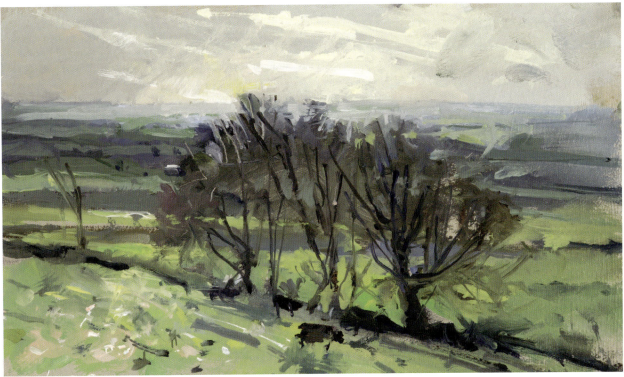

■ Looking into the light, masses are simplified with trees and cattle linked into a single dark shape.

Two ways with washes

Layered washes

This is a great way of making you think of the tonal steps from light or dark. You'll need a stout sheet of drawing paper or hot pressed watercolour paper, a couple of watercolour brushes, one large and one fine, and a nice dry warm day. Prepare a pot of watercolour wash, mixing a neutral colour with plenty of water. Now find a view which seems to have a wide range of tonal steps. Don't choose anything too complicated, as I'm not going to allow any pencil drawing or other lines. A viewfinder cut from card may help by isolating your chosen subject. Spend a little time looking at your view and decide where the lightest area lies. In your mind's eye identify where this patch of maximum light will lie within your drawing and leaving this area untouched cover the rest of the sheet with a single pale wash. Once this is dry, repeat the exercise for the next tone down. With this second wash dry repeat the process for the third tone and so on until the overlapping washes give you the full strength of the darkest parts of your view. This is quite a slow process, so not a method for windy days with rapidly changing light. The example here was made on a hazy summer afternoon when I was making drawings to decide on how to tackle a view of a valley with a meandering river running through it. With a steady light and the air warm enough to dry my washes I add layer after layer. The way the light reflects off one of the river's curves is my main interest and I keep adding layer after layer. As I do so, the close toned distant hills and their hedgerows are indicated early on while the drawing is still very pale,

whilst the dark, middle distance trees and the foreground field are gradually darkened. This is a really good method to make me think about the tonal sequence, in small accurate steps all the way from lightest to fully dark.

Washes, all of a piece

Another way to handle watercolour washes tonally is to use just one colour and dilute it to various degrees to create a full range. Choose a dark colour and mix with a little water to full strength. Move some of this wash onto another part of your palette or another saucer and add a little more water. Dilute again once or twice more until you have about five steps from palest wash down to full strength. As in the previous exercise, identify the areas which are lightest and leave these as white paper, then start to lay down washes in the five gradations to represent the tonal pattern of what you see in the landscape. Without the complication of thinking about colour or line, concentrate completely on tone. If you look at your view through the lashes of nearly closed eyes you can remove much of the colour, as in low light colour vision is much reduced. With practice, this technique can be developed to use wet-in-wet washes and to increase the number of tonal steps greatly.

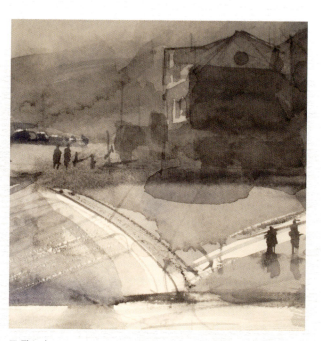

■ Built up with many layers on a day with steady light. The first layer covering everything except the strongest light, then subsequent layers applied to progressively smaller areas once the paper was fully dry. About ten or so layers were needed to create strong darks and complete the drawing.

■ This drawing across a harbour was made using the faster method with several pots of wash of different intensity brushed on in a single operation.

USING LINE AND TONE TOGETHER

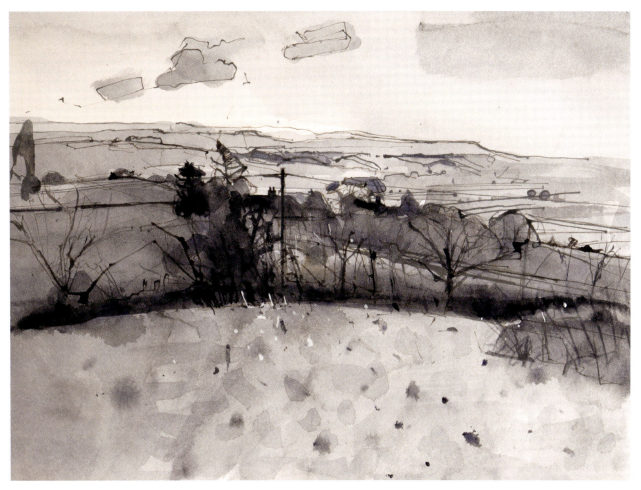

■ Returning to the spot where I made a drawing using diluted waterproof ink earlier in the day, I add washes of Payne's Grey watercolour with a little white gouache to re-state the lights.

There are good reasons to use just line or to think and draw purely tonal drawings, but often these methods will happily combine in a single drawing. As soon as you begin to make marks with a pencil for example, it's immediately obvious that it will produce a wide variety of marks, from lines, dots and squiggles to broad areas of tone. Making a drawing to record as much as possible about a location it feels very natural to combine these various languages within a single sheet. Many media may be used in this way, as well as pencils, charcoal, pastels and other crayons are all very versatile. Our line drawings made earlier using waterproof inks are ideal to work over using washes of watercolour as these won't re-dissolve the ink line which will remain visible through

the washes. Now returning to the spot where I made the more considered line drawing earlier in the day I can develop the drawing more fully by working over it with tonal washes.

OIL PAINT

Of course, I can also choose to use oil paint mono-chromatically and this can be a very good way of concentrating on the tonal effects of light. Simply pick a dark colour, ideally one that's not too powerful, and use it in conjunction with white. Light, tone and colour are closely interconnected, so as confidence grows with

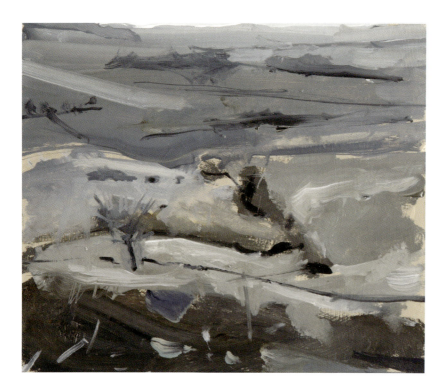

■ With just tone to consider, this monochrome oil study was painted very quickly.

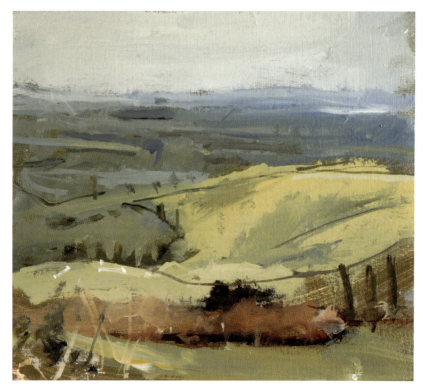

■ Painting with a very limited palette is an excellent exercise in seeing how much may be done with very little.

these monochrome studies it's a good time to move on into using a little colour. Painting with a limited palette will help reinforce the connection between light, colour and space. Here are two small studies: one is painted using just raw umber and white, concentrating purely on tonal relationships; the second introduces a little colour, with Raw Sienna, French Ultramarine and Indian Red along with Titanium White. It always surprises me how much is achievable with such limited means.

USING SKETCHBOOKS

Whilst the sequence of drawings of Pilsdon Pen were made on separate sheets of paper, I seldom go anywhere without a sketchbook in my pocket. There have been so many times when I've found an exciting subject quite unexpectedly and having a little sketchbook and a pencil allows me to make a note and a little drawing. Very often the best things to paint pop up when you're busy doing something else and it would be a shame to let these go unexplored. These days I won't cut up a sketchbook to remove sheets for framing and this is part of their secret as they preserve a period of work in the order in which it was done and keep it all together. For me they are a vital part of the painting process and get used in lots of different ways. I might use a page to make a drawn note of something I've spotted that might be pictorially interesting. On another occasion I'll have a book handy to make a note of quick lighting changes or some other incident during a day's work on something larger. I did

this on a winter day recently when painting in a location where seasonal rain had flooded the fields either side of a river, transforming the pattern of grass and hedgerows into a giant reflective mirror of flowing water. I'd set up an easel intending to paint two medium-sized oil paintings over the course of the day. Using my largest panels, about 18 inches across, I felt I could get a sense of the scale of the place but this size made me too slow to respond to quick changes of light. The sequence of sketchbook pages illustrated here show how the view changed through the day from silvery morning light through to early evening.

My sketchbooks are hardbacked, and filled with hot pressed watercolour paper. This gives me a surface which I can work on in a variety of media, including pencils and pens as well as watercolour and gouache. If you work mostly in pastels, charcoal or other dry media, there are sketchbooks made up with a variety of tones of tinted paper which are particularly good for these media.

■ Sketchbooks allow me to record and experiment with what I'm seeing at a particular moment without the pressure of having to make a painting.

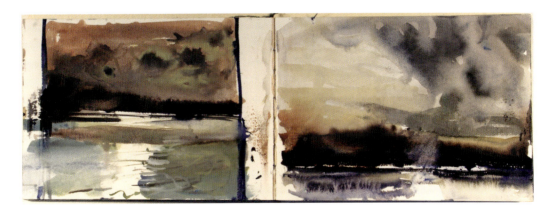

■ This image and the previous one are watercolour notes showing the flooded valley as the sun moved across the sky and behind patches of cloud.

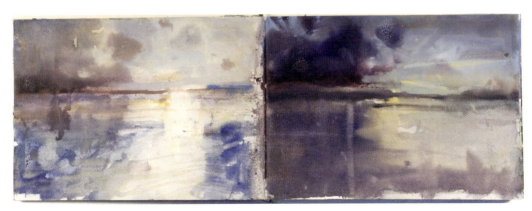

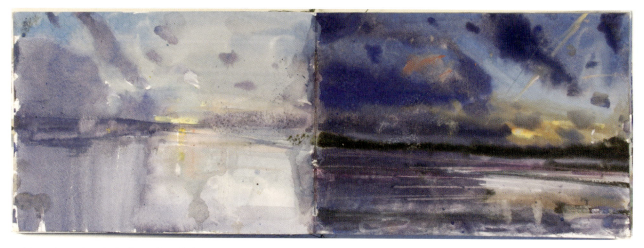

■ Towards evening the brilliant silvery light gives way to warmth and colour.

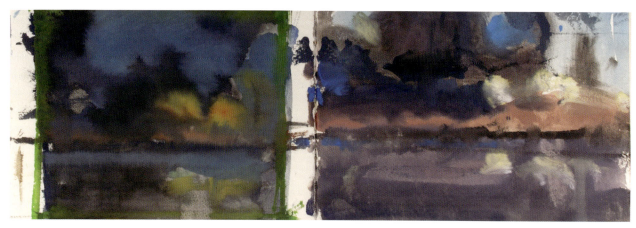

■ The final pages before it became too dark to continue.

BACK WITH MY PAINTS

A few days later I'm back to paint some of the subjects I found on my drawing day. I've waited for another breezy day with broken cloud so that I can try to catch some of the spirit I found here last time. The previous few days had been cold and this time there was the added bonus of a little snow lying in the plough furrows and around the edges of fields, but the most exciting thing was the colour. Winter is far from being a grey time for the landscape painter and the land in front of me sings with yellows and blue and russet in a way it never will in the summer when green predominates.

Having finished my first painting I move on, returning to the spot where I made all the tonal drawings on the previous visit. The slope of the hill falling away from me is again in shadow and cloud shadows constantly break up and then reconfigure the more distant view. Coming back to paint here, I realize that my day spent making lots of drawings and studies allows me to now work much more intuitively. When I stop to draw I look at the landscape in a way which is quite different from when I'm simply out for a walk, and even though this is a familiar painting location for me, drawing has allowed me to find subjects I might otherwise have walked past.

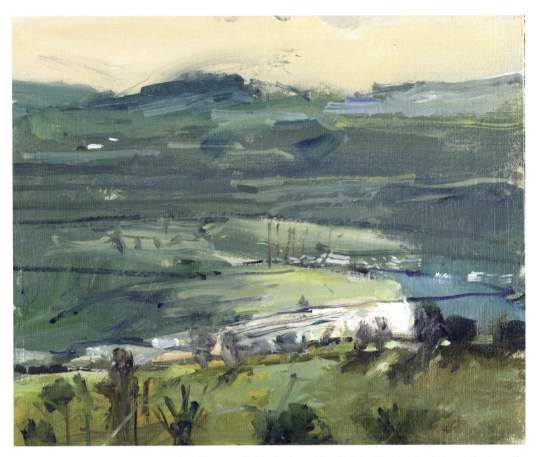

■ Looking south towards a hazy sun the hills are unified in shadow whilst the light fills the valley below, reflecting off the snow still caught in the plough furrows.

■ *North from Pilsdon Pen*. Oil on board, 15 × 16 in (38 × 41 cm), Richard Pikesley. Painted from the spot where I'd made the tonal drawings the previous week, I'm struck by the richness and variety of the colour.

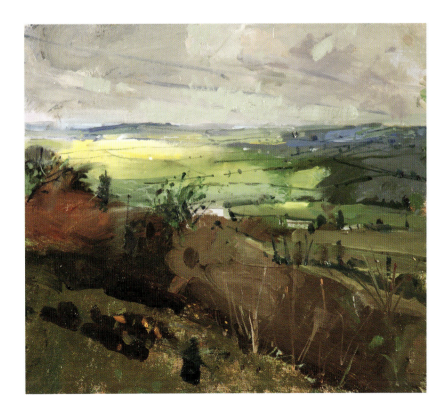

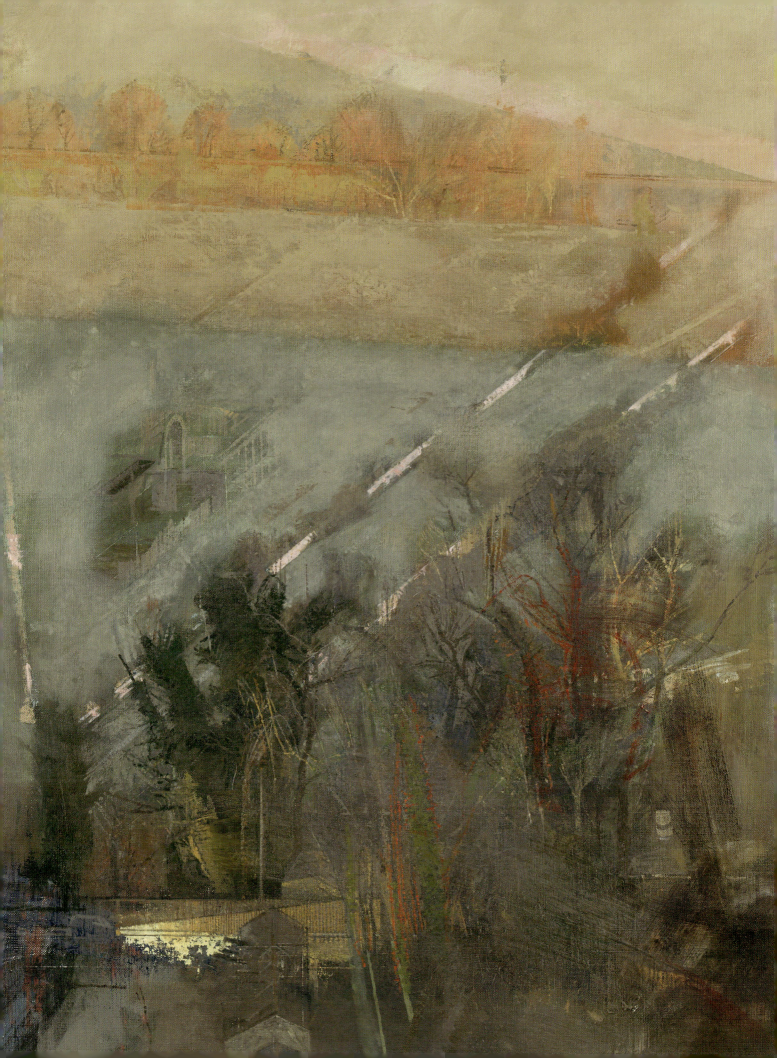

So What Makes Landscape Painting Different?

Chapter 3 might seem a bit late to ask this question, especially as you've already started to be a landscape artist. In the previous chapter we walked around a piece of English countryside that most people would have no hesitation in describing as landscape. Now is the moment to consider a broader range of subjects and approaches. Much of my own work, for example, is made at the water's edge. Living by the sea, the shoreline and harbours are a natural part of my visual world, whist painters who live in a more urban setting will have the city as their landscape. Cows and fields, boats and headlands, roadside vistas and skyscrapers, these can all be landscape subjects within a broader definition. The bigger difference is between outdoor subjects with a greater degree of depth and those like portraits and still life where as a painter you're usually within arm's reach of your subject. So for the purposes of

this book, I've chosen to interpret the subject much more broadly than a view of cows in a field and some distant hills, though there will be plenty of these along the way. In the real world, one category of painting tends to blur into another, but wherever you live, let's start with what you know, the landscape you see when you step outside.

The origins of landscape painting go back a long way, but in its earliest form it was largely there as a background to religious and allegorical subjects. The Dutch painters of the seventeenth century were among the first to place the landscape itself at centre stage. Driven by the rise of a picture-buying middle class, and freed from the limitations of religious and narrative subjects, these painters saw the whole world outside of the studio as a potential subject; in their work, paintings of sea and ships, streetscapes and cities sit alongside those of more rural settings.

In the twentieth century and beyond, artists have used a response to the natural world as a jumping-off point towards abstraction and a poetic re-interpretation of landscape.

■ *Looking Down Fields, Railway, River.* Oil, 26 × 20 in (66 × 50 cm), Paul Newland.

A WAY OF SEEING

■ I made this study of light through sycamore leaves by the side of the river in the following illustration, but is this landscape?

Unlike painting a still life or portrait, landscape may seem to simply refuse to be put into a frame and the issue of what to include and conversely, what to leave out, can't be ducked. Sometimes it's all so beautiful and interesting that it's natural to want to get it all in, but this certainly won't be a recipe for a great painting. We'll return to strategies for coping with the overwhelming character of painting in the landscape throughout this book, but it's important for you to be aware, right now, that you don't have to do it all! If a location looks particularly fruitful it may be much better to return a number of times to respond to different aspects of what you see in that first encounter.

In a way, it could be said that it is hard *not* to paint a landscape. One of the difficulties faced by painters trying

to create images which are entirely non-representational is that even a simple horizontal line across a sheet of white paper can so easily be read as a horizon, implying receding land below and sky above. Looking at painterly abstraction it is very hard not to respond to what appear to be spatial cues and to read vast depth where perhaps none was intended.

It might be more productive to ask 'what *isn't* landscape?' For me there's a fundamental difference between painting in close up, where physical characteristics of the objects being painted, their 'thinginess', if you like, have an overwhelming presence, and painting subjects at some distance, where the optical sensation of the whole scene becomes the main driver. Landscape generally fits into this second category, being about the wider, more

■ *In the Dart, Above Huccaby Bridge*. Watercolour, 11 × 16 in (28 × 41 cm), Richard Pikesley.

distant view. Especially since Impressionism, this view of landscape painting has been dominant. However, I may consider making very detailed studies of the world in close up when thinking my way around a wider subject. So if I choose to make a detailed study of the bark of a tree, or a close-up drawing of bricks in a wall, do these constitute landscape or are they something else? Well, maybe they aren't quite landscape but these studies can be a vital part of the process of burrowing into a subject.

Once, when teaching on a residential painting course, I had to find something useful for my students to do on a day when heavy rain made it impossible to work outside. The idea of 'indoor landscape' was born in that moment of panic, and pushing all the studio tables together and throwing bedsheets over them, I asked my students to scavenge for any interesting small objects that could be placed on clusters on the table, and a couple of desk lights for illumination. The group were instructed to get a low eye level and look across the table at the various objects and through the gaps, painting as if it was a landscape rather than a sequence of little still life subjects.

The paintings, and conversation that came out of this exercise, were extraordinary and taught me a lot about the different way of seeing and looking that landscape, even pretend landscape, demands. Without my opening remarks about wanting my students to paint what they saw as if looking through or over a landscape, I think the paintings they produced would have been far more about the individual things that were on the table. With a different mind-set, however, they produced work that was far more about space and recession, just like the more normal landscape of the outdoor sort!

In still life or portrait painting, one is more usually trying to deal with a relatively shallow space. In such a space the artist's eye can dwell on the edge of a jug or the portrait sitter's ear and move from point to point, refocusing slightly and produce an image where each part of the composition is a focused version of the reality the artist sees. Landscape painting is different in that the leaves on the foreground tree may be miles closer to the painter's eye than the fields on the distant horizon. Simplification quickly becomes a necessity, not

■ *Morning Table, Oak Leaves and Bronze*. Oil on canvas, 14 × 18 in (36 × 46 cm), Richard Pikeley. Clearly not a landscape, but this painting was made with a landscape frame of mind.

just because of the overwhelming amount of detail and complexity, but also because a complete and focused rendition of everything within that view is at odds with the way we see. Looking at the real landscape, I can if I choose, hop from point to point, re-focusing and re-calibrating at every step. The human eye is in this respect different to a camera in which the focus is set to ensure that just one plane is sharp while everything nearer or further is a little out of focus. To produce a sense of wholeness I have to relax my eye and do my best to consider everything at once. Don't underestimate

■ A photograph of objects in the studio that I might choose for a still life subject. Notice how shallow the space is, the proximity of the objects making us read them as separate things.

the viewer's ability to respond to what you've painted, the human brain really wants to de-code, it does it all the time, and the sploshes, dashes and squiggles on your paint surface will elicit a spatial response in your observer so long as you've been sensitive and honest with what you see and how you put it down.

Once you've experienced the transformation of what you see in landscape into paint it becomes an alternative way of seeing and a part of everyday life. Starting to imagine the three-dimensional world of solid reality transposed into paint on a flat surface quickly becomes a slightly addictive part of the daily routine. The simultaneous holding in your head of these two versions of what you see, or more likely, an alternation between the two, is, I think, common to many painters and makes working from, and in the landscape unique, in that it's something you can do in your head.

■ This landscape photograph is all about space and our reading of the view is more to do with optical sensations rather than individual objects.

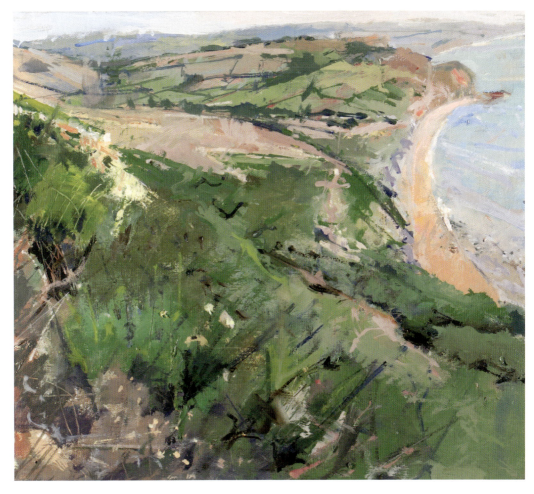

■ *East from Golden Cap, High Summer*. Oil on canvas, 16 × 18 in (41 × 46 cm), Richard Pikesley. This painting is as much about how the flat picture plane is broken up as it is about recording a distant view.

SIMPLIFICATION AND PATTERN MAKING

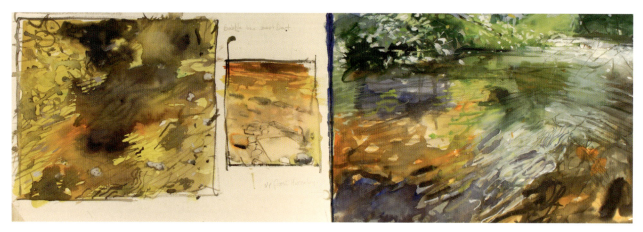

■ Sketchbook studies made before the River Dart painting earlier in this chapter.

My vision of how I want a painting to turn out is always very strong right at the beginning. Big brushes to block everything in gets me off to a flying start and makes me think in broad tonal patterns across the canvas. By focusing on these big light and dark shapes, I get a strong sense of how the design of the flat surface of the painting relates to the very three-dimensional world I'm trying to record. The strength and energy of what I do in these first minutes has to carry me through a potentially more tricky middle stage when my attention will be focused on smaller incidents and detail within the composition. If I'm not careful, these details can quickly get 'too big for their boots' so any way that I can keep in touch with that initial vision will help prevent me from getting side-tracked. Right at the end of the process, I'll be very pleased if I can get back to the sense of wholeness I had at the beginning, though now carried to a higher level. Quickly made, high energy studies made at the start can be an enormous help in sustaining you through what might be a lengthy process of making a painting, especially when working in the studio. Pinned to the side of your easel, on your line of sight, a little note made in a couple of minutes might carry you through weeks of work.

So the painter needs to develop a language in which there's a clear sense of hierarchy; the broad masses of tones and colour, and the bones of the composition will probably do far more to carry a sense of a seen moment which is at the heart of a fine painting than would an amassing of incidental detail. By cultivating a habit of seeing the world first in terms of how the big things fit together, it becomes possible to understand how all the smaller incidents and details fit.

Often, it's a matter of using these little accents as a way of making a counterpoint to the bigger, more static masses. How an individual landscape artist achieves this might well be a lifetime's work. Their method might be to work directly from the subject as faithfully as possible, or to work at one remove in the studio from drawings, other studies or photographs made on the spot. The desire might be to recreate that place as faithfully and completely as can be done, or weaving topography with fantasy to create something strongly rooted in reality but with a charge of the fantastical running through it.

■ Studies like this, painted very fast, are invaluable source material.

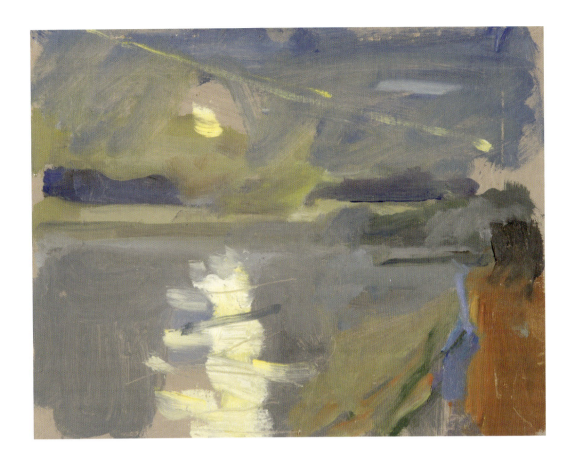

■ The energy and sense of wholeness and of a single moment can fuel me through a lengthy painting process which might follow.

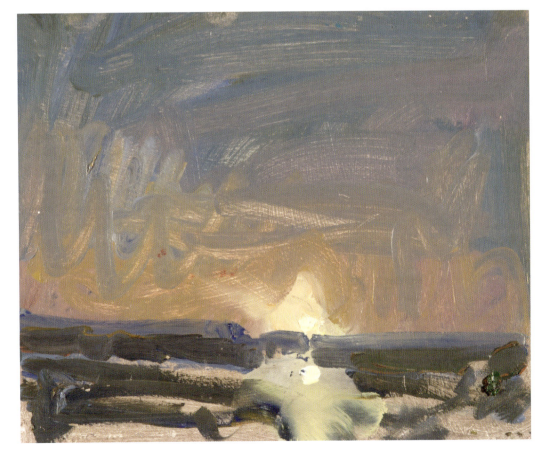

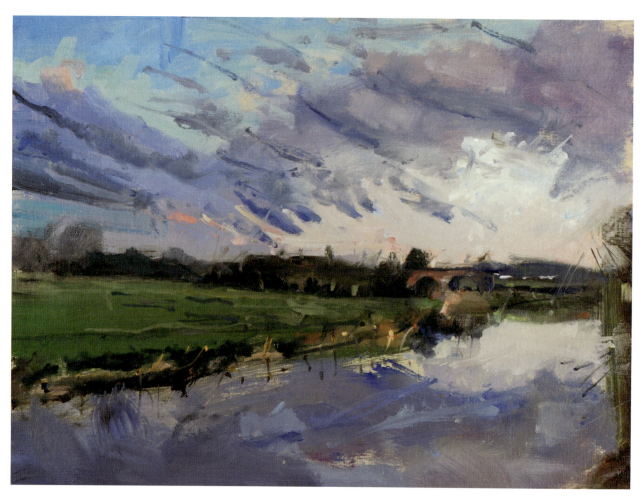

■ *Hardy's Stour, Dorset.* Oil on board, 12 × 16 in (30 × 41 cm), Richard Pikesley. Looking at the big things first. The main driver in this painting is the big angled mass of cloud and its reflection, broken by the big wedge shape of the field beyond the river.

Good painting of any sort usually has a sense of a simple wholeness. This is what we're trying to achieve but paradoxically arriving at this distilled simplicity isn't necessarily a trivial process and there's a lot to understand on the way to developing good instincts. It's taken me years to learn to trust my instincts and my very first contact with a new subject is often the one that really counts. I've had the experience many times of flashing past a view that's caught my eye when driving or on a train journey that's fired my imagination and that corner-of-the-eye sensation and its excitement is the memory I always try to hang on to. I know now that my response to landscape is visceral and immediate, but also that this momentary reaction can ebb away as I slow down to make a studied record of what I see. So my method

now is that nothing stands in the way of getting down that first response and many of my little oil on board paintings made on location are very much this first grab at a subject before other thoughts that may dilute that initial encounter start to get in the way. That first encounter, recorded at the necessary speed and with a lot of instinctive simplification is the vision I'll want to hang on to but what follows may well be days of work making drawings and other studies if I have any plans to take the initial visual idea further.

Painters may choose to refer back to the art of earlier times. Without even looking at the title of the painting by Louise Balaam it evokes memories of John Constable. Through the placement of the dark mass of trees and the river she creates echoes of subjects which were at the

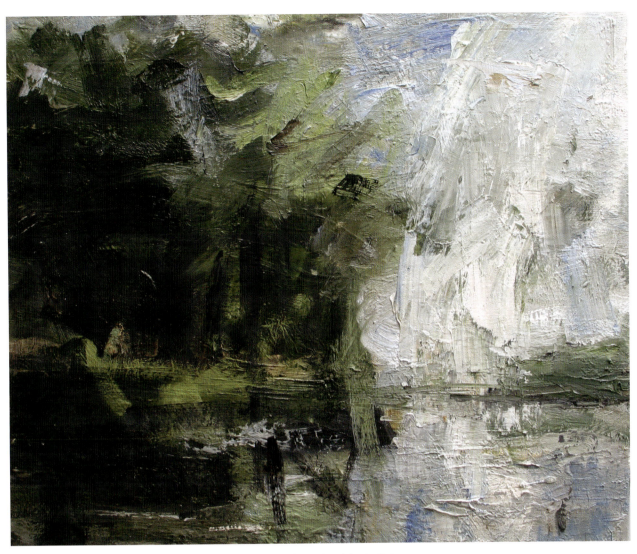

■ *Trees on the Edge of the Stour, Flatford.* Oil on canvas, 24 × 28 in (60 × 70 cm), Louise Balaam.

core of the earlier painter's work, but infused with her own way of working. She writes about the painting, 'John Constable has always been an artistic hero of mine – I feel his emotional attachment to this part of Suffolk shines out of his paintings. He would have known the River Stour so well, and I found the everyday landscape there thrilling to paint.'

However, there's often something slightly subversive in good painting. Things are not necessarily all that they seem and the painting may be more than just a statement of how a particular view looks. So the landscape, maybe even the close topographical representation of a particular place becomes a vehicle for telling another story. At the heart of good representational painting there's often a tough abstraction, and an image which appears to be

highly realistic has in fact been given a greater visual force by what isn't included. The 'corner-of-the-eye flash' described above is often a momentary wholeness which for me comes from only partly understanding what I'm seeing; I'm reacting emotionally to an arrangement of shapes, of light and dark and of colour before I fully understand what I'm looking at.

Unlike painting a still life, where working with an ultra-shallow pictorial space the painter can play with *trompe l'oeil* effects and literally fool the eye of a viewer into thinking the painted objects are real, no-one is going to be hoodwinked into imagining that they can step through the frame. However, there is a sort of suspension of disbelief when looking at a well-crafted landscape painting, that it does represent a vast area behind the

■ *Cows on a Burning Hill*. Watercolour, 26 × 35 in (66 × 90 cm), David Firmstone. Another composition made of big interlocking shapes, but with the tiny incident of the cows pulling your eye to the top of the frame.

frame. The painter can either choose to minimize this fiction of depth by emphasizing the flatness of the picture plane, or do his best to use paint in such a way as to support the illusion of pictorial space. For the onlooker, seeing a painting in a gallery, the tension between the actual flatness of the canvas surface and its illusion of infinite depth is highly enjoyable, a sort of tease in which artist and viewer conspire!

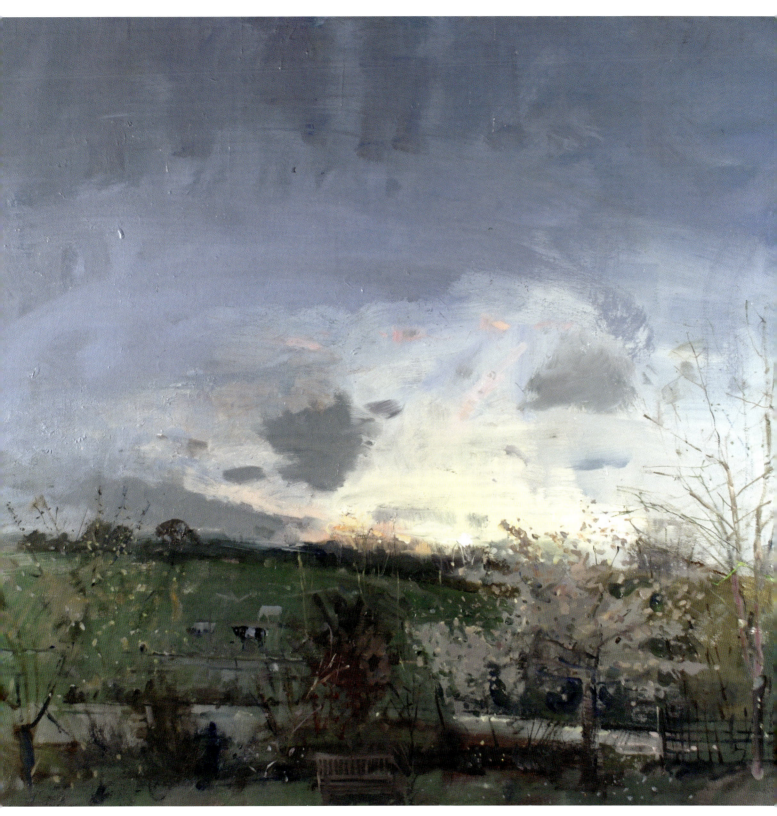

■ *Cherry Tree Ghost, Middlehill Farm*. Oil on canvas, 30 × 32 in (76 × 81 cm), Richard Pikesley. Painted a year after the cherry tree had been felled, and working from an earlier *plein air* study painted out of a bedroom window. This painting evokes more ghosts than just the tree. Do these feelings convey themselves in the painting?

WORKING IN THE LANDSCAPE: WEATHER AND CHANGING LIGHT

Poles apart from the controlled light of a north light studio, working in the open air is a constant lesson in coping with change. Of course, an artist might choose to only work outside in ideal conditions, but warm air and a clear blue sky don't guarantee a successful outcome. Indeed, variable weather and changing light that make me react and change direction are at the heart of my creative process. It really is worth working outside on a rainy day if between the showers you're given a dramatic sky. A road, wet after rain, might act as a blazing mirror as it reflects a backlit sun. A big puddle reflecting the view opens up compositional possibilities not available on a dry day.

DEALING WITH DAYLIGHT

The most startling difference between working in interior spaces and stepping outside is the extreme range of intensity of light that the painter has to deal with. With just those few colours on the palette, the intensity of midday sun and the deepest shadow have to be depicted in a convincing way. The quality of the light will also be very variable and sensitivity to its effects will allow the painter to achieve a sense of unity. Evening light, for example, may become quite red-biased, but because its onset is very gradual it can be completely missed by a painter working through the period when its quality is changing. Mist or low cloud may exaggerate effects of aerial perspective which are less noticeable under conditions of bright sunlight.

Painting outside through a long day often has its own rhythm. Through the middle of the day and into the afternoon the light might remain steady enough to divide my working into chunks of about an hour. I'll start with a stack of boards or watercolour paper and work my way through these as the light moves. Into the evening, however, is a different matter as the change starts to accelerate. I know that I'll have to work fast in the period up to sunset and if I'm lucky, get yet another sort of light after sunset, but before the daylight goes completely. My habit of laying out my palette the same way every time gives me precious extra minutes when I can paint instinctively and hope I've got the colours right! This spell into the evening is exciting because everything is transformed. I've talked elsewhere about tonal compression, and the way that the falling light simplifies what you see into bigger tonal blocks may reveal a stronger design than the same view with plenty of detail in full sun.

I get very excited when it snows and love the transformation a covering brings to the most familiar of landscapes. For example, painting on a snowy day is a great teacher of tone and colour. The assumption that snow is white is quickly abandoned and all the effects of lighting and space are somehow seen at their simplest and most apparent. I also have to admit, I enjoy working into the light and days with a low sun are a bit special. Right through the winter, with the sun low in the sky, its low angle throws everything into relief and reveals a beauty quite unlike the high sun of summer. But what about dull days? Well, these too have their own rewards with a steady light that may give the painter a longer window of time to work before changes are noticed. The extremities of brilliant light and darkest shadow won't be seen but there can be a sort of envelope of light and a closing up of tone which makes the colour quietly sing. It can be at this time that outdoor light most closely resembles the quieter tonal range of the studio. Often too, a roof of cloud creates a more directionless light and what you see will change more slowly, allowing for a more studied response.

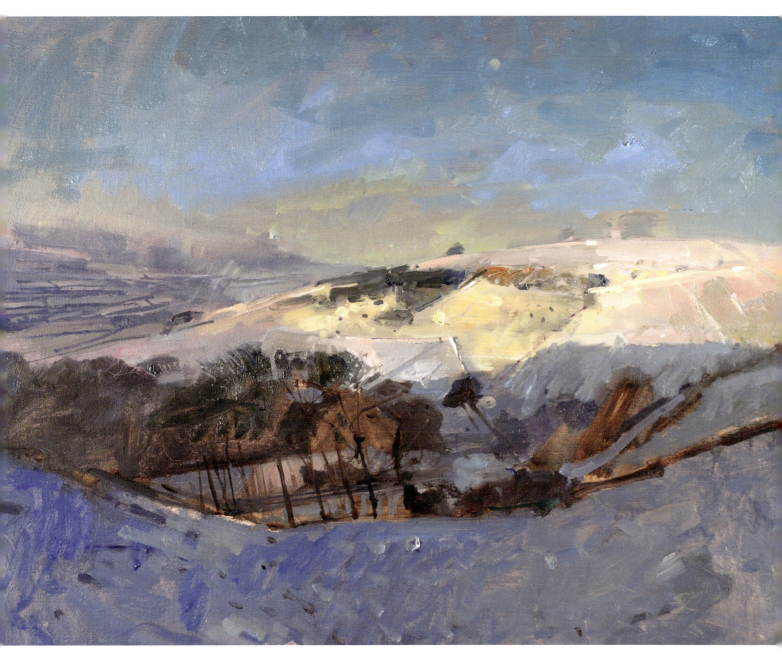

■ *Snow Fields and Rising Moon, Dorset*. Oil on canvas, 20 × 26 in (50 × 66 cm), Richard Pikesley.

APPROACHES TO LANDSCAPE PAINTING

Of course, there are many ways of painting landscape apart from the painterly, naturalistic approach. For some artists, the painting tells a story and is driven by a narrative. Some, like David Firmstone, will knit together elements drawn from nature with other threads from dreams or stories into a poetic response to landscape. For others, the image is built up from an accumulation of detail. The urban landscape of Melissa Scott Miller shows paint used in a highly descriptive way and it's a delicate balance which allows the main structural blocks of the composition to be read amongst such a wealth of incident.

Comparing Scott Miller's work with the paintings of Louise Balaam, their differences highlight the approach and aesthetic of the two artists. Balaam's work is raw and supremely energetic and often in even quite a small painting she gives a sense of the infinity of space and its continuity through the land and sky.

URBAN LANDSCAPE

The word 'landscape' carries connotations of the natural world, but as most landscape has been shaped by human activity there's perhaps not much to separate painting in a fully urban setting from any other choice of subject. And as most of us live in towns and cities, considering these exciting subjects opens up a wealth of possibilities. Within most cities there are green spaces and open vistas. Many of our cities are built on rivers and these too will open up wider views. These quieter spaces can be less intimidating for a novice painter than setting up an easel in the high street. Another factor is that, unlike painting in deep countryside, there will be people, cars, noise and movement in the town and all of these open up a wealth of possible subjects to explore. As you'll see from the examples shown here, there are many ways of tackling these subjects and every artist will find a

■ *Fifth Avenue from Washington Square, Before the Hare Krishna Parade*. Oil, 12 × 16 in (30 × 41 cm), Peter Brown.

■ *Winter Backgardens, Islington*. Oil, 40 × 48 in (103 × 122 cm), Melissa Scott Miller.

■ *Patterns of Cloud from my Studio Window, Peckham*. Watercolour, 22 × 30 in (56 × 76 cm), Sophie Knight.

different way in. For Peter Brown, painting in New York, the soaring perspective of Fifth Avenue is softened by the trees and forms a huge but enclosed space. Repeated yellow notes of the taxi cabs hold your eye for a moment as it races to a distant vanishing point and brilliantly stop the composition splitting in two.

Melissa Scott Miller's paintings of London are instantly recognizable and no one paints quite like her. At first sight they appear to be all about the detail, recreating

the visual world of London one brick at a time. However, embedded in the detail there's a very strong structure and I love the way that there's often a human element and their life is woven into the fabric of the painting.

In Sophie Knight's watercolour of a view from her studio, the urban scene is confined to a narrow band at the painting's lower edge, tied into the sky by the placement of the two cranes. I love the way this painting finds the magic of that sky in such a familiar urban setting

■ *Last Light, Summer Evening, Weymouth Harbour.* Oil on canvas, 16 × 18 in (41 × 46 cm), Richard Pikesley.

COASTAL LANDSCAPE

There's an excitement at the water's edge, a boundary between two worlds and for me one of the most fertile of subjects. Just as the river or green space in the city, the sea opens up big spaces and there's often a reflected light bounced off the sea. That's part of the special draw that some places have on painters. In St Ives, just as in Venice, there's often this sense of light bouncing up from below and a particular intensity that's hard to find inland. I live a mile from the sea and painting along the coast here is something I can do almost daily, and yet it never loses its pull. For others who are land-locked far away from the ocean it has the charisma of being somewhere special. In mid-summer, when the rural landscape may be relentlessly green, there's always colour, life and variety at the seaside, and in winter too, there's always something to see and paint. Subjects might be jam packed with people and movement, full of boats and sparkling water, or something far more elemental in the meeting of land and sea.

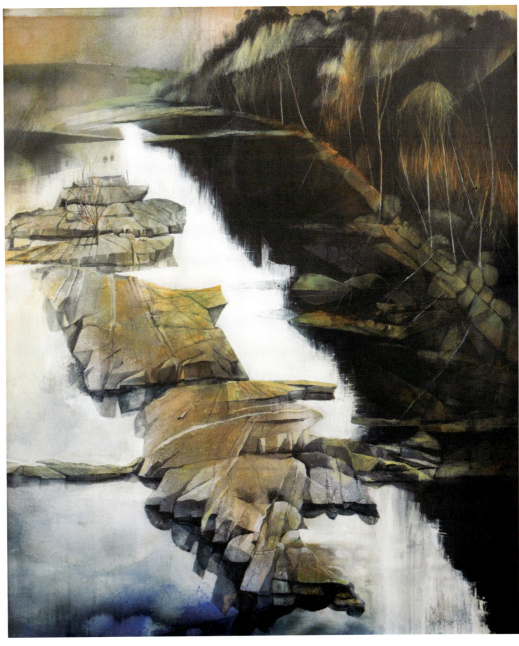

■ *River Gardon at Dions, France.* 39 × 35 in (100 × 90 cm), David Firmstone.

LANDSCAPES OF THE IMAGINATION

For some, the landscape is seen and absorbed only to be transmuted in the studio by imagination, memory or dreams. David Firmstone deliberately uses ways to extend and disrupt the emerging image. As well as working *en plein air* for weeks on end and on huge sheets of paper, discovering, as he's said elsewhere 'the fabulous mark making qualities of rain, toilet paper and the end of my shirt' he has other ways of discovering imagery. By pouring paint or soaking it in a bath to remove colour, the development of the painting may take some surprising turns and ignite the power of imagination to take the image in a new direction. David calls it 'drawing with the pour'.

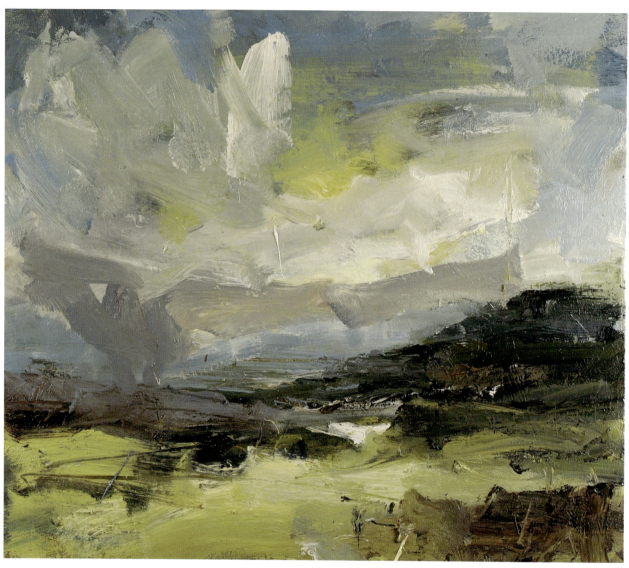

■ *Bright Sky, Carn Ingli*. Oil on panel, 28 × 31 in (70 × 80 cm), Louise Balaam.

WILD PLACES

There are places that seem so elemental that the only way to respond in paint is to strip everything back to what's absolutely essential. These paintings may be rather raw and unconcerned with topographical detail but they have the big things: space, energy and light. Painting in such places is thrilling, but challenges the landscape painter with the difficulty of trying to convey a sense of their vastness. There will be fewer clues to give a sense of scale as are usually present in a more domestic landscape.

BEING A LANDSCAPE PAINTER

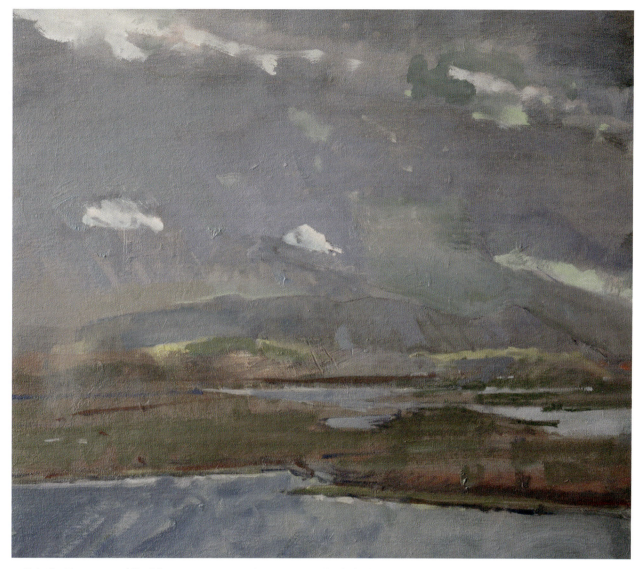

■ *Hebrides, Mountains and Sky*. Oil on canvas, 18 × 20 in (46 × 51 cm), Richard Pikesley.

Working outside, you are in a much less controlled environment than when painting in a studio. Enjoying the sunshine when it comes, or grappling with wind and rain are all part of the process. You'll encounter people too, and the conversations and their local knowledge can help unlock the landscape for you and give you a way in. This constant element of surprise and, hopefully, delight is a vital part of the creative process and stops you working in a formulaic way by making you deal with what's before your eyes.

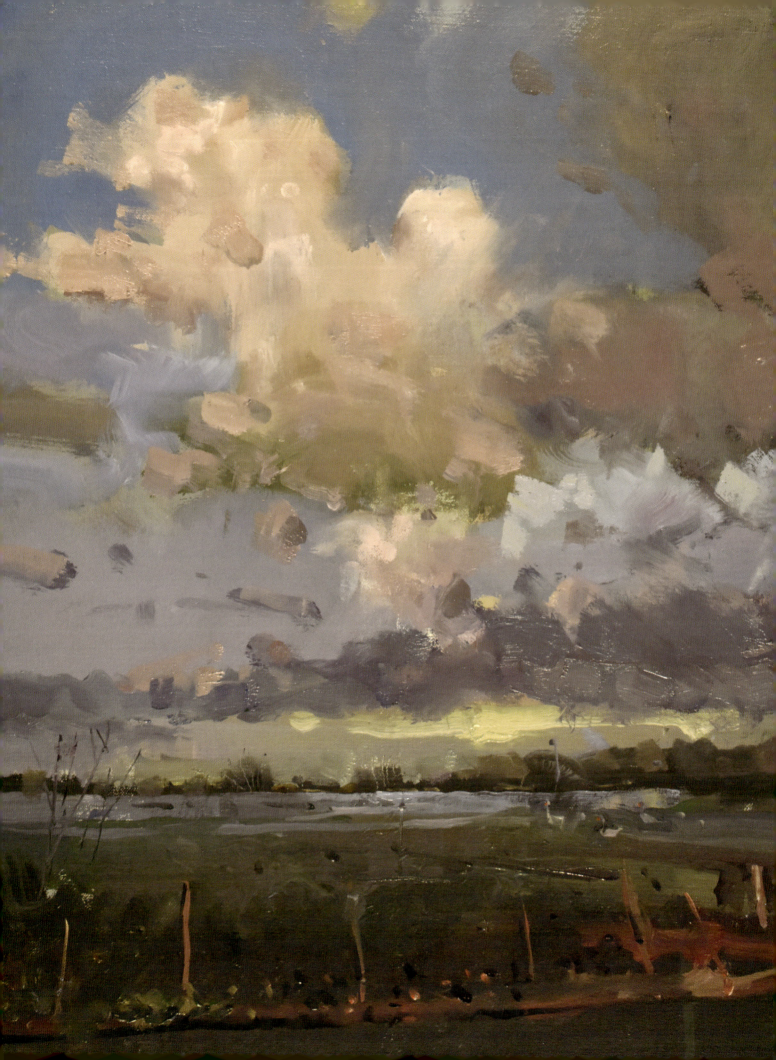

A World in Colour

*Colour in the shadow must be
the sister of the colour in the light.*

– Walter Richard Sickert

Once again, it's all about relationships. Learning to make colour sing is one of the most exciting parts of becoming a painter. Our approach to colour was transformed around the time that painters began to work outside, directly from observed landscape. The Impressionist revolution was also prompted in part by the availability of oil paint in tubes; before their invention, colours were prepared in the studio each day and the materials of the painter were far less portable. A visit to any art shop will quickly demonstrate the bewildering variety of colour that is available in each medium. The names of these colours are often derived from the pigment or mineral from which they are made and can be very off-putting to a novice. By following the advice in this chapter you'll have a starting

kit and enough knowledge to develop your colour choices in the future. Use of colour is something that's very personal to individual artists and two or three painters painting the same view will show variety in the way they recreate the colours they're seeing. Relationships between colours is the key to this: one landscape artist may push towards a cool palette and another warmer; and degrees of light and dark will vary.

Tubes and pans of colour are just the starting point for mixing and it's rare to use a particular pigment in its most intense form straight from the tube. Even when using a very limited palette with just a handful of colours, the range of mixes available is huge and the variety of effects that may be produced from such limited resources still sometimes takes me by surprise.

Whether you work in oil paints, acrylics or watercolour, the pigments in each are broadly the same, only bound into usable paint by a different binder. The fundamentals of colour mixing are the same, whatever your chosen medium.

■ *Frome Valley, Flooded River and Swans*. Oil on canvas, 20 × 16 in (51 × 41 cm), Richard Pikesley.

THE UNITY OF COLOUR

I want to lead you to an understanding that through the use of a familiar palette, all the colours that seem so different are connected and linked. The vibrant colours that we squeeze out of the tubes are just the extreme end points of a continuity that stretches across the spectrum and from the most brilliant white to the darkest neutrals.

I'm going to start with gouache, because it's opaque and controllable and an easier place to start than transparent watercolour. But if you don't have gouache, most of this will work well using oils or acrylics. There will be much more information about materials later on in Chapter 6. Some of the examples that follow use photographs of my palette with colour mixing in action. This is where you'll learn most about colour, and this is the way I teach when working with students.

■ Just these three colours of gouache, three primaries plus white, are all we need to start with.

■ By mixing between each primary pair I can produce three secondary colours.

PRIMARY AND SECONDARY COLOURS

When using pigments, as opposed to light, we think of three primary colours as the basis for all of our colour mixing. Red, blue and yellow, mixed in different proportions, are theoretically capable, with the addition of varying amounts of white, of duplicating any colour. So why might we need more pigments than these four?

Well, to understand this you need to know that pigments don't necessarily quite coincide with theoretical primaries so it will be enormously helpful to have different versions of each colour. For now though, let's assume that we're just using three primaries and white. It's well known that mixing two primaries together will create three secondary colours, orange, violet and green. These will vary enormously from orange made with lots of yellow and very little red, right through to a version with mostly red and just a touch of yellow. Repeating this for each pair of primaries and using white to lighten the resulting hues, there are already hundreds of different colours available to us.

But it's the next stage where all the magic happens. In terms of practical painting, the importance of understanding greys and near neutral colours shouldn't be underestimated. The Impressionist painters realized that using black to 'grey' colours down produced a sort of monochrome colour cast over paintings which was quite unlike how colour is seen in nature. Along with nineteenth-century colour theorists, they worked out the importance of mixing neutrals from pure colour. And not just the greys but every step along the gradation from the pure hue to the point where there's no distinguishable colour. To understand this fully you need to see how it works in practice, but first, we'll rearrange our colours into a colour circle. Just a rainbow of colours bent around to make a circle, so that the progression through each of the primaries and secondary colours, red, orange yellow, green, blue and violet, leads us back to red.

COMPLEMENTARY COLOUR

If I take two colours that are opposite on the colour wheel and start to mix them together, something extraordinary happens. At some point, as I vary the quantity of each of the two colours chosen as my starting point, the colours will cancel each other out and produce a neutral, though it won't necessarily be quite like the grey that's produced when I mix black and white. I can repeat this with any pair of opposites and achieve a similar result. These opposite colours are known as complementary pairs.

So, we can use the complementary of any colour to reduce its intensity all the way down to grey. The colour of a green tree in sunlight alters as it moves round towards the shadow side, as its intensity reduces, and we can mimic this in paint by adding a little of just the right red to the mix.

But there's another way of thinking of complementary pairs, and it's most easily understood by thinking just in terms of primary colour. We've already established that if I mix blue and orange together, at some point I will create a complementary grey. Another way of describing 'blue + orange' would be to say 'blue + red + yellow'. Exactly the same is true for any other complementary pair, which turns out to be a mix of the three primaries. So now think instead of a colour circle or wheel, try to imagine this as a colour disc, the intense hues of the pure primary and secondary colours form its skin, right in the middle it has a grey centre and any point between the surface and the centre there's a different colour pitched somewhere between the most intense hue and a neutral grey. Using colour naturalistically will involve spending most of your life towards the middle of this disc where colour is de-saturated and reduced by light and distance. When you can, just occasionally, allow yourself to use the brilliant colour from the edge of the disc, their intensity will be all the more telling!

It's no accident that John Constable chose to paint so many of his little direct landscape studies over a brick red underpainting. As well as usefully dropping the tone of the white ground, the flecks of red underpainting peeking through between the greens gives the colour an energized feeling that comes from small amounts of one colour in amongst a large area of its complementary.

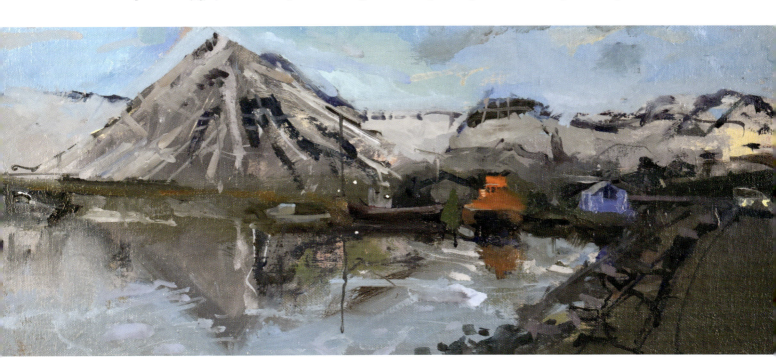

■ *Iceland, Orange and Blues*. Oil on board, 7 × 16 in (17 × 41 cm), Richard Pikesley.

COLOUR IN PRACTICE

So let's try out some of these ideas. To keep things simple, we'll use just four colours; white, blue, yellow, and red. Using 'real world' paints, anything we choose will be slightly different from the optically perfect hue, but we can get pretty close.

I would suggest using either gouache, oil paints or acrylics for these exercises, and choose primaries that don't tend towards their secondary neighbour; so, for example, select a blue that has neither a violet nor a greenish cast. In oil paint, Chrome Yellow, Permanent Blue and Bright Red might be good choices, along with Titanium White. Whichever medium you choose, first paint yourself a simple colour wheel using just your three primaries. In my example I've used designers' gouache in Primary Red, Primary Yellow and Primary Blue. My wheel has twelve divisions of the circle which allows a centrally placed secondary colour between each of the primary pairs with an additional step between each primary colour and its neighbouring secondary.

Beneath this, try painting three strips working between complementary pairs; blue to orange, red to green, and yellow to violet. You may find that you need a couple of goes using different versions of your mixed secondary before you get an acceptable neutral. By doing this, you quickly realize that by tweaking the secondary one way or the other, you create a whole new palette, subtly different from another version. The near misses are also interesting and useful as they will suggest sequences of colours that come close to grey but still retain a colour cast. Although the red to green sequences will appear to all be close to the same tonal pitch it will be noticeable that when traversing from yellow to violet there's

■ Placing blue at one end of the row and my secondary orange at the other, the colours de-saturate towards the centre of the row passing through a neutral. I've added a little white to these sequences to make the colour change more visible.

■ Using red and green this time I can repeat the exercise.

■ Bent round into a circle our row of primary and secondary colours becomes a colour wheel.

■ With yellow and violet there is a more extreme tonal change as I move along the row, but the sequence still goes through a neutral grey.

a descent in tone throughout the sequence. The next step would be to repeat this exercise using white added to each of the three primary colours before you start to blend complementary pairs.

Now look out of the window, or take your paints outside, and have a go at recording the landscape you see just using the three gouache primaries and white. Whilst you probably won't be able to record exactly the colour you see with this limited range, you may be surprised at how close you can get and different versions of a limited palette are a great way of building your colour fluency and have the added attraction that these few colours will naturally create a natural harmony of effect that can be more difficult to realize when using a more extended palette.

I hope by now it's clear that colour isn't just about brilliant hues and unmixed paint straight from the tube. Painting in the eighteenth century, the French landscape artist Jean-Baptiste-Camille Corot created work of great beauty that came from an exquisite understanding of colour and tone and which wasn't matched until the Impressionists a couple of generations later. A lesson on so many levels, his *Seine and Old Bridge at Limay* is a wonderful essay in restraint, coupled with a bold composition that fills the foreground with a bush and blocks off the left side of the view with trees. It works magnificently and in no small measure this is due to the feeling of the whole scene being bathed in the same silvery light.

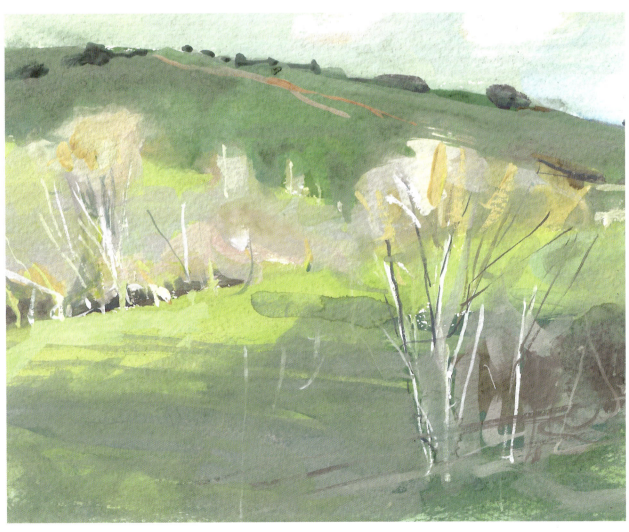

■ Painted in gouache with just my three primaries and white, this is the view from my studio window.

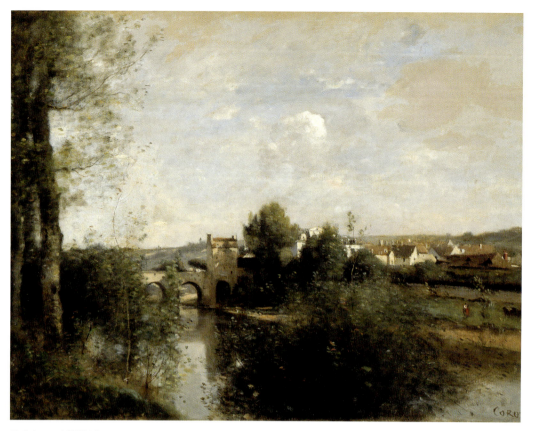

■ *Seine and Old Bridge at Limay.* Jean-Baptiste-Camille Corot (France, 1796–1875). Los Angeles County Museum of Art (www.lacma.org).

DON'T NAME COLOURS

There's a natural tendency for an inexperienced painter to want to comprehend each step of mixing colour using verbal language. This can be useful during the initial stages of working with colour mixing, but I think should be set aside before it gets too ingrained as a habit. I do need to know that I'm mixing a little orange into the blue of that bit of sky, and that I'm doing it because I need to lower its intensity by de-saturating the full strength of the tinted hue, but the sooner the process is internalized and instinctive the better. The problem with naming colours in your head while you're mixing is twofold. In that moment of looking at a patch of colour and trying to replicate it, giving it a name will make you look at it on its own rather than as part of a cluster of related colours emerging on your palette, and by giving it a name 'bluish, purple-grey', you'll almost certainly exaggerate when you then mix, as you'll be mixing the verbal idea rather than the colour sensation. Putting in this unnecessary step of describing what you see in verbal language just gets in the way, and over-complicates what should be a simple three-way conversation between yourself, your subject and the emerging image.

THINK RELATIONSHIPS

This could almost be a motto for the whole world of visual art, but I'm applying it just now to colour mixing. It's impossible to paint coherently by looking at each patch of colour and trying to replicate one at a time. When I'm painting I will constantly create puddles of colour on my palette, making three or four that each touch their neighbours. My head is bobbing up and down as I look down at my palette, then up at the colour sequence in the view and then at the surface of my painting as these blobs and patches of colour are lifted onto its surface by

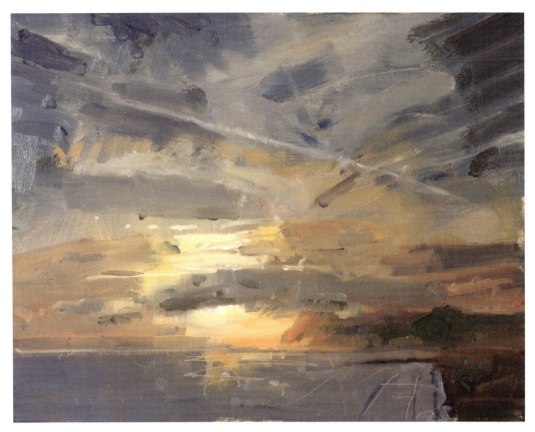

■ *Towards Golden Cap, Summer Evening*. Oil on canvas, 14 × 18 in (35 × 45 cm), Richard Pikesley. Painting fast, almost at the moment of sunset, working intuitively with colour saves me vital minutes.

my busy brush. This quickly becomes second nature and is at the heart of a sort of three-way conversation between the subject, my palette and the developing painting.

Some painters will spend time mixing families of colour on their palette before getting to work on a painting. For myself, I'm always in a rush and this usually means that I develop my puddles of colour as I go. It can, however, be a very useful exercise to try to record families of colour that you see in the landscape and note these down as a study, without any drawing or reference to what you see apart from the colour relationships. As part of the process of accumulating information it can be really useful to make these colour notes, in which I don't pay much attention to any other aspect of a subject. These little accumulations of patches of paint won't concern themselves at all with drawing, or composition or any of the other components of a finished painting. Oil sketching paper or watercolour paper appropriately primed and coloured form an ideal surface to work on

in oil paint and once dry can be stuck into a sketchbook along with other drawings and studies. It's important to remember that the point of doing this is to record the colours you see and not an object's local colour. Local colour would be the colour of a patch of grass, seen from a close distance and evenly and directly illuminated, whereas perceived colour is, for example, about how you see that patch of grass from half a mile away, backlit, or in shadow. Remember too that when looking at colour try not to focus on just one area but examine how the various colours relate to each other within one 'eyeful'.

PLAYING WITH COLOUR

Great colour is not just about knowing the rules. Sometimes a little bit of magic appears as if by accident or a gift, and to be open to this happy event you need to foster a spirit of watchful playfulness.

As work continues, colour puddles develop on the palette.

A colour study painted straight from the landscape. Simply built around clusters of colours as I see them in front of me, drawing is completely ignored but I try to place my colours in about the same proportional areas as they occupy in the view.

By tweaking colours with white to bring them close to the same tonal pitch they gain extra vibrancy.

So, initially just with our four colours, start mixing puddles of colour on your palette. You'll find it helpful if your palette is a mid-tone of some sort rather than white. For oil paint, mine is plywood, coloured by years of pigment but scraped down every few days. If yours is brand new, or maybe a sheet of glass with coloured paper slipped beneath it, it will work just the same, giving you a better ground on which to read the colours which won't now be thrown into silhouette by a white background. Using a glass palette with coloured paper can also be helpful when painting in gouache. Just using these four colours, try mixing them in as many different combinations as you can. I think you'll be surprised at the variety of colour and intensity that can be produced starting with such simple materials.

Next, try making new puddles of colours which are as close in tone or value as you can get them. Try mixing complementary colours with varying amounts of white added to match their tones and place them next to each other. You may notice that you get a sort of shimmer where these colours are closely judged.

You can just keep all of this on your palette or transfer the colours onto another surface, perhaps a sheet of mid-toned paper if you're using water-based paints, or a sheet of oil sketching paper previously primed with a wash of diluted oil paint to tint it.

PURE COLOUR, TONE AND THE IMPRESSIONIST REVOLUTION

Before Impressionism, space in paintings was mostly represented with light and dark. The Dutch landscape painters of the seventeenth century knew that if they cooled the palette with blue into the far distance they could create a greater illusion of space, and great painters like Turner used colour to create vibrant spatial effects. However, the core of the earlier method was tonal, and revolved around a studio practice that through the building of paint surfaces through layers of transparent glazes which made the darks ever darker, along with opaque lights built from flake white, often using impasto to further catch the light and enhance the black and white drama. But the revolution in French painting in the mid-nineteenth century, along with the development of portable colour in tubes and scientific understanding of how colour works, all contributed to changes in the way we see and depict the visual world. When Monet and his friends went out into the fields and used their eyes to understand what they really saw, they were turning their back on hundreds of years of tradition.

THE BUILDING BLOCKS OF COLOUR

Although for convenience it's been easier to talk about colour and tone as separate subjects, it's important to understand that they are closely related. As a landscape painter, it's vital to have a feel for this relationship. Very rarely will you squeeze colour from a tube and use that colour straight onto a painting. If you do, you'll find that the colours fall into a broadly middling range of tones. The tube colours give us the starting point from which we can build a breathtaking variety of colour worlds. Using the fat of the palette, the middle band of tone where not too much white is added, is where the richest seam of colour lies. If a lot of white is added to drive the palette up to a high tonal key, the result can be rather insipid with all the colours strongly tinted. Similarly, trying to create a balanced palette with the darkest colours available is difficult as one area of colour, yellow, is just too pale, although using a transparent yellow such as Transparent Gold Ochre or Indian Yellow can help.

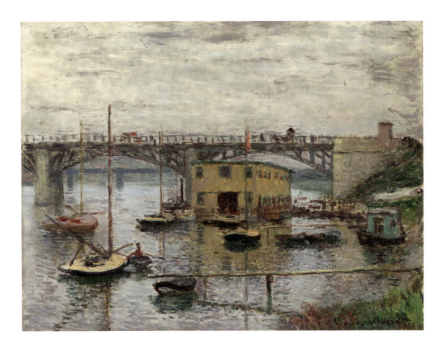

■ *Bridge at Argenteuil on a Gray Day.* Oil on canvas, 24 × 32 in (61 × 80 cm), Claude Monet. (National Gallery of Art, Washington, Ailsa Mellon Bruce Collection)

A harmonic group drawn from a limited range of the colour wheel.

Taking pure oil paint straight from the tube it is clear that there's a big range from palest to darkest.

Dissonant colours placed out of their natural tonal sequence.

To demonstrate this range of tones within the tube colours, start by taking a sequence of hues of the primaries and secondaries arranged from lightest to darkest. The easiest way I can do this is to squeeze out a little paint from my tubes of oil colour; it is clear that some are lighter than others. The yellows are palest, oranges and some of the reds and greens in the middle, blues next, then the darkest purples and Terre Verte green. I can lighten the tone of all apart from the palest yellow to bring them up to the same level.

HARMONY AND DISSONANCE

Colours in relationship to each other that are taken from a restricted arc of the colour wheel, or a family of mixed colours with one component colour in common, are said to be harmonic and can be built up to produce a tranquil, calm character. There are times when daylight takes on a particular colour such as towards sunset and the unifying quality that this brings can give the subject a compelling sense of space built from just a handful of closely related colours. Be careful not to fall into a formula when painting at these moments; there will be notes of comparatively cool colour and also minor colours from outside the harmonic group which will help keep things alive.

Dissonant colours are those which in a relationship, reverse the natural tonal order, for example, painting a yellow as dark as you can get it, up against its complementary, violet, tinted up lighter than the yellow with lots of white. Such colour combinations are more strident and can be used for their unsettling feel. These colour combinations can add a visual fizz and energy and are an addition to the emotional language of a painter.

CAN'T PAINT GREEN?

I'm going to use one particular common difficulty to try to illuminate the whole area of colour mixing for painters. The 'problem' of green is a great way to illustrate the variety of colour which may confront you as a painter. More than any other complaint that's been offered to me as a teacher of landscape painting is the cry 'Oh, I just can't paint green'. By mid-summer, the spring growth on the trees and fields can appear to solidify into a wall of green. It's quite understandable that painters whose understanding of colour isn't fully developed may struggle a bit when faced with this, but there is a way through the green maze, and if you understand this bit, it will give you a good foundation in practical colour mixing.

Standing out in the open, surrounded by a green landscape, at first sight you may think it all looks the same. A sensitive eye will quickly see that there's variety here and that it has its own logic. The colour we see depends on how the light hits the surface and comes to our eye and a tree that at first sight just appears solid green may have some areas where the sunlight is reflected from its leaves as well as other parts where the light shines

■ *Rowan Tree, Dartmoor*. Oil on board, 8 × 10 in (20 × 25 cm), Richard Pikesley.

through them, giving a quite different colour effect. The tree will have areas that are strongly lit and others that sit in shadow, so how does the colour change as your eye traces a line from lightest to darkest points? It is likely that the purest green, though not by any means a 'straight from the tube' colour, will be somewhere in the middle of this range, and the colour becomes less saturated as you move towards the highlight. In these bright areas there will seem to be quite a bit of white in the colour. The darks, however, don't just become greener, but are neutralized with the colour becoming less intense as your eye travels into the shadow. Earlier painters had always used black to darken their shadows but when artists started to work from nature in the open air they realized that using black cast a grim stain across their paintings that was quite unlike nature. Nineteenth-century colour theorists and the French Impressionist painters worked out that as the colour darkens it takes on some of its complementary. This means that our green tree will have shadow that descends into a mix of green with some sort of red. This mixing across the colour wheel is the key, and it quickly becomes second nature to darken a bright colour by introducing some of its complementary and there is therefore a family relationship between the colour in the light and that in the shadows. This is also how you de-saturate any colour to make it less intense; so for example, an overly vibrant pink can be taken down a notch by mixing in a little green. Adding enough of just the right green will ultimately take the colour down to a completely neutral grey, and add a little more and our pink is now the subtlest of grey-greens.

An important lesson to take from all of this is that in the visible natural world we are very rarely seeing the most intense hues that you might find in a tube of oil paint. Almost always the colour you see will lie in the area where colours merge and neutrals and near-greys predominate. If I extend the idea of the colour wheel to create a colour disc, it becomes apparent that with a naturalistic approach to landscape painting I'll be much more concerned with the middle of the disc rather than its brilliantly coloured outer band.

■ Light transmitted through these sycamore leaves is a completely different colour to the cool light bouncing off their surface. What you see from a distance may be a mixture of these two effects.

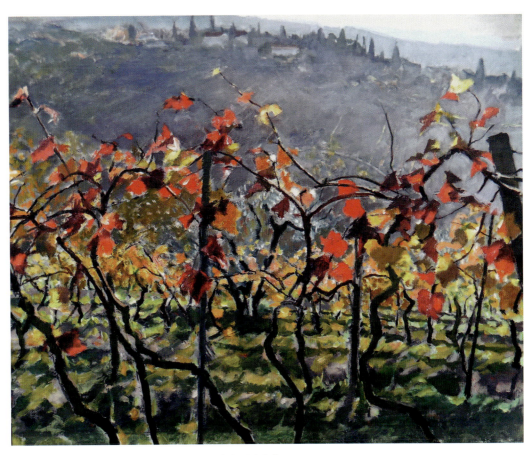

■ *Early Morning Vines*. Oil, 15 × 19 in (38 × 48 cm), Patrick Cullen.

But back to our tree. We've worked out that while it has some areas where it looks pretty green, much of its mass is either tinted up towards white or darkened by adding its complementary. The next step is to appreciate that there are lots of other things going on that add to the variety of colour that we see. Different species of tree will be different sorts of colour, from blue-green right through to near yellow. Remember too that light bounces about, and a colour that's strongly lit by a very bright sun will reflect that colour onto nearby structures. I've seen a brilliant yellow crop of rape illuminate the underside of trees along its edge with reflected light. Clouds above a bright sea will be illuminated from below by reflected light from the sea's surface. Gaining sensitivity to such effects will come with practice and with cultivating a way of working where you look for the sensation and relationships without ever naming the colour. Walter Sickert, writing about the Impressionists at the turn of the twentieth century, knew about colour and had studied much earlier Venetian painters, dismissing the turgid brown shadows of an earlier generation when he said, 'What is it that Pissarro, Sisley and Monet have had to remind us? They have had to repurge painting of the hollow brown shadows. They have had to point to the Venetians, and recite again this law: if you use colour at all, it is written in the mysterious and immutable laws of harmony that the colour in the shadow must be the sister of the colour in the light.'

Knowing the rudiments of complementary mixing, together with a sensitive eye, is all you need to navigate the green maze. The experience of looking at a patch of colour is always affected by what's going on around it and it is common practice for artists to work on a coloured ground and to choose its colour to be broadly the complementary of the dominant colour of the subject. So for green landscape, painting over a reddish or pink ground colour and allowing flecks and specks of this colour to remain visible between some of the paint strokes will give the painting an extra vibrancy and appears to help all the different greens sing together.

A NOTE ON WATERCOLOUR

A common theme in much of the above concerns mixing colour on a toned palette and applying it to an already darkened ground. For gouache, acrylics, and oil paint there are good reasons for doing this: palette and ground provide the same tonal context and this enables the painter to start with mid-tones and push up into light and down to the strongest darks. With pastels too, although there's no palette to mix on, working on darker coloured papers helps to get everything singing right from the start. Watercolour is different. These colours rely on transparency for their effect and their colour can only be read by mixing on a white surface, typically white ceramic or plastic. Because generally quite small amounts of colour are mixed at one time they can be more challenging to mix precisely. Because of this it may be easier to become thoroughly familiar with a limited palette before adding additional pigments. Another big challenge with watercolour is judging how dark the transparent mix on the palette will be once brushed out onto white paper and allowed to dry. Washes will typically appear lighter once fully dry so the painter may have to compensate by using stronger mixes than might be expected. Dealing with this is something that comes with experience. Trial and error combined with intelligent guesswork will get you a long way.

LAYING OUT A PALETTE FOR OILS

When I do a day's teaching, I think people are sometimes a bit shocked at the amount of oil paint I squeeze out onto my palette before setting to work. On such occasions I've seen some of my students just squeeze out blue and yellow and a bit of white on their palette because 'it's all green isn't it?' Well, there may be lots of different colours on the palette, but their job is to create a coherent visual world. So let's keep things simple to start with.

I always lay out my palette in the same way. This isn't just laziness or a lack of imagination; it can really help. I'm always in a hurry when I'm painting, conscious that a cloud will at any moment cover the sun, or what I'm seeing could suddenly change in another way. With my colours arranged always in the same order and the same place on the palette, my hand knows where to go without my eye having to find the colour. It almost doesn't matter what particular logic you use to organize your colours, but for what it's worth, this is my way.

I squeeze out colour in blobs along the back edge of the palette, leaving plenty of space towards the front free for mixing my puddles. Reading from right to left, I start with Titanium White, followed by Cadmium Lemon, Cadmium Yellow, Yellow Ochre, Cadmium Scarlet, Rowney Rose (Quinacridone), French Ultramarine, Winsor (Phthalocyanine) Blue, Opaque Oxide of Chromium, Terre Verte, Raw Umber. Laid out like this, the colours form a rainbow sequence, like a straightened-out colour wheel. Each primary or secondary comes in two or more 'flavours' – warmer and cooler – to create different families of mixes. As well as placing the colour in a natural sequence for mixing, with a natural affinity to the colour wheel, they are also running broadly from lightest on the right down to darkest on the left. Much of my painting happens at the end of the day in quickly failing light. Knowing exactly where each colour lies gives me a few precious extra minutes as the light drops beyond the point where I can distinguish colours on the palette. Being right handed, I place my dipper filled with turpentine or painting medium on the right hand side so that my hand makes the shortest journey when picking up paint with the brush. While we're thinking about colour layout, it is worth mentioning here that whether you're painting on the spot or in your studio, you need your palette where you can see it without having to swing your gaze too far from subject to painting and down to palette.

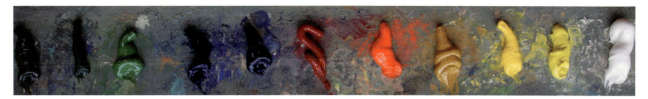

I always lay out my colours in the same order.

COLOUR: FLAT, MIXED OR BROKEN?

Part of the legacy of the Impressionist painters was their realization that colour could be exploited in a more vibrant way by placing small patches of various saturated hues in close proximity and letting the viewer's eye mix the colours. Used in a rather informal way in the work of such painters as Claude Monet, the method was pushed and further codified by Georges Seurat. Looking at his work in any of our major collections is a revelation, as you first see the painting from a distance and then move up close. In close up, all you see is brilliant coloured dots but as you move further away your eye and brain create a vivid and convincing picture. In many ways Seurat's paintings aren't naturalistic, as he combined colour that appears to swirl and dissolve with heroic composition based on classical precepts. The Impressionists understood that we don't see everything surrounded and separated by a bounding line; their painting is much more about the way the world is laid out on our retinas, as a sensory experience rather than a collection of things. In painting, for example, a blue sky, we might decide to mix various colours on the palette to create a carefully gradated sky as it moves from less to more intense and from darker to lighter. Or we might do some of that in the viewer's eye by placing individual touches of slightly different colours, building a similar effect by different means. Scale plays its part here too, and these methods of optical colour mixing work best on bigger paintings that will push the viewer further back to view them from some distance; this also allows the painter room to place lots of small, related touches.

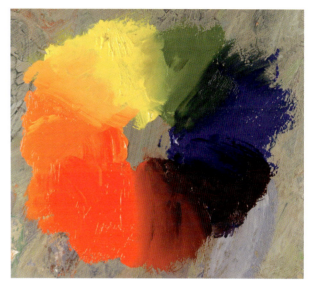

A simple colour wheel in the corner of a working palette is a great reminder.

Study for *La Grande Jatte*. Oil on wood, 6 × 10 in (16 × 25 cm), Georges Seurat. (National Gallery of Art, Washington, Ailsa Mellon Bruce Collection)

■ *Flood at Port Marly*. Oil on canvas, 18 × 24 in (46 × 61 cm), Alfred Sisley. (National Gallery of Art, Washington, Collection of Mr & Mrs Paul Mellon)

The dance and shimmer of colour across the surface of a canvas or in a pastel drawing gives the painter's response a sense of movement and the emphasis on these broken touches, rather than a hard bounding line, opens up space in the painting. By making a continuity across the drawn edges, space begins to flow rather than meeting a barrier at every edge.

However, it's easy for the surface of a painting to have so many various touches of colour that it appears indecisive and becomes a bit of a muddle, and if this begins to happen it can be good to simplify and think about larger areas of near flat colour alternating with smaller marks. Notice I said 'near flat colour' for as John Ruskin pointed out, there's always gradation and for example, what appears to be a uniform sky is changing in colour and tone, however imperceptibly, as your eye travels across it. Colour organized into bigger shapes has a quite different effect than the broken colour described above and simple colour harmonies painted in broad patches can be particularly effective when smaller notes of colour foreign to the prevailing harmony add a little spice.

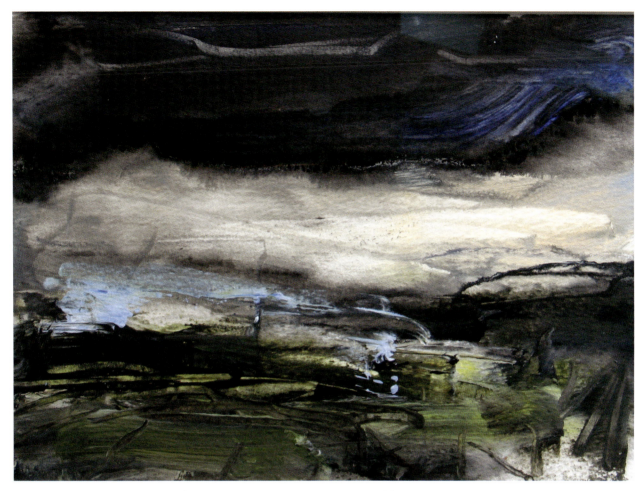

■ *Deep Deep Blue, Storm Coming*. Mixed media on paper 7 × 9 in (17 × 23 cm), Louise Balaam.

THE POWER OF COLOUR

Much more than drawing or composition, of all the elements of painting, colour has the power to work on us directly and move us to a strong emotional response. Its use can be quite intuitive, an immediate expression of the artist's feelings that can then communicate itself to anyone who ever looks at the painting. Louise Balaam's little mixed media *Deep Deep Blue, Storm Coming* has for me a profound sense of menace and beauty which belies its tiny scale.

Of course there's a close relationship between colour and effects of light. This may be at its most apparent early or late in the day when the sun shines more weakly through a thicker layer of atmosphere. Painting at the site of a white mosque in central India, I had the experience of watching it dissolve into the dusk as the building was bathed in a pink light at the moments around sunset. The watercolour I produced was simply and quickly painted and the close toned washes haven't become too muddy or strident from over work.

Again at dusk, painting on a hill overlooking a plain still lit by the evening sun as the ground around me fell into shadow, I experienced a reversal of the expectation that warm colours would give way to cool ones with increasing distance. A good lesson for me in painting the landscape as I saw it rather than painting what I expected to see.

■ *Sun and Moon, Bibi ka Maqbara.* Watercolour, 14 × 21 in (35 × 53 cm), Richard Pikesley. For just a few minutes at dusk, this white building was bathed in a warm pink light.

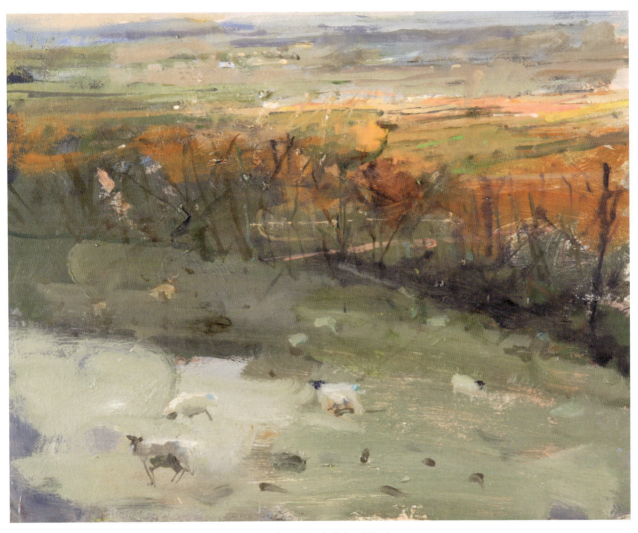

■ *Last Light, Grazing Sheep, Ham Hill*. Oil on board, 10 × 12 in (25 × 30 cm), Richard Pikesley.

■ Mixed neutrals on my palette. Gaining the ability to mix across the colour wheel, from the most brilliant down to near greys is a big step towards working with confidence from the landscape.

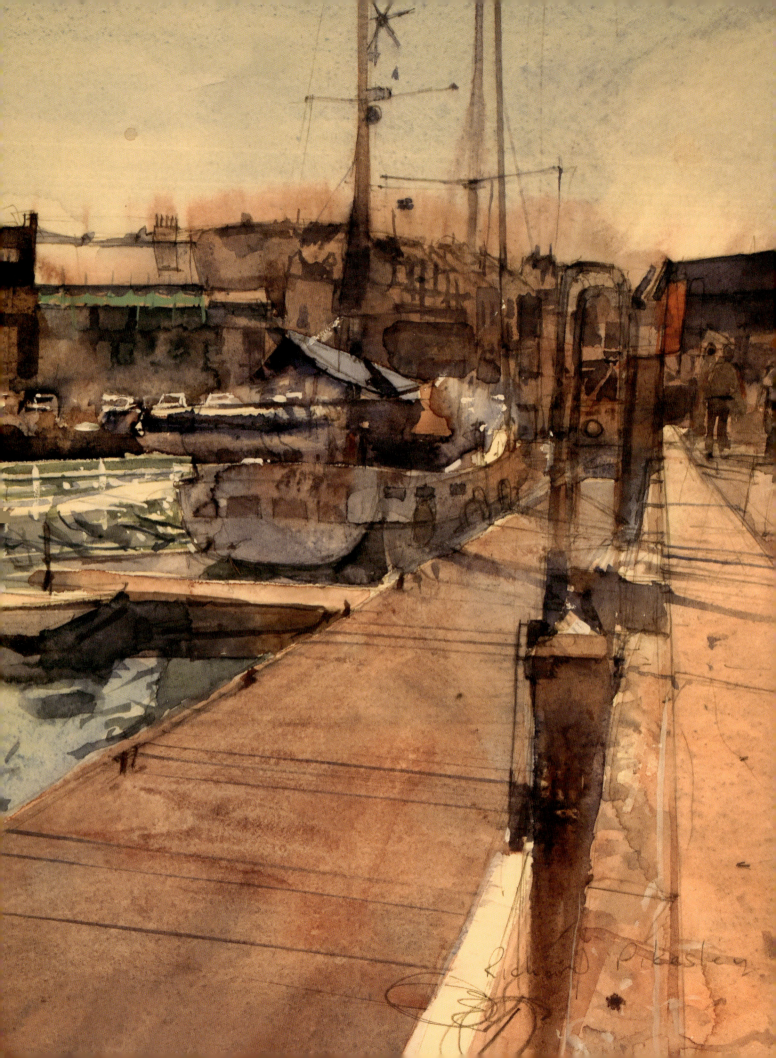

Richard Pikesley

Drawing, Line, Mass and Defining Space

L earning to draw well is fundamental to becoming a good landscape painter. And yet it is this skill that may appear to be the most daunting to the aspiring artist. Very little of what is required is about 'pencilcraft', though the facility to say a lot with simple means develops over time. Gaining a few simple skills at an early stage is a very worthwhile investment of time and effort.

Every time we make a drawing or a painting from life we create an abstraction. Each medium and method propels us to be selective about which bits of information are carefully recorded, and also what, for the moment, may be ignored. Some drawing media are about the simplest method of creating an image and yet a humble pen or pencil can convey so much with so little.

The motto for this chapter should perhaps be, 'Believe your eyes, not your treacherous brain'. Our brains do a great job of allowing us to interact with a chaotic and confusing world, but as you learn to draw you need to put more faith in understanding exactly what you see. Understanding where the pitfalls might be will go a long way towards avoiding them. Human eyes aren't exactly like cameras and standing still and looking at a view our eyes tend to hop about from point to point within that view and at each resting point will re-calibrate. I remember as a young artist being told to look harder, and to me this meant staring at each detail in turn in what I'll call 'telephoto mode'. I'm now convinced that to draw well you need a more passive eye that will happily sit in wide-angle mode and allow you to read relationships of line and tone across the whole field of view. Happily, by starting with the biggest relationships and working towards the finer detail, we can ensure the accuracy of what goes down on paper in a way that is quite impossible when piling one observed detail onto another one.

■ *Nefertiti, Weymouth Harbour*. Drawing and watercolour (detail), Richard Pikesley.

DIFFERENT SORTS OF DRAWING

 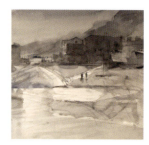

■ Drawing is so versatile, and what I record with each one is completely bound up with my choice of medium and how I choose to use it.

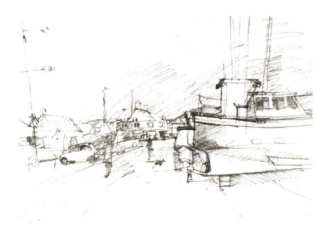

■ The strong shapes of the keels of boats out of the water for the winter gave me the starting point for this drawing, and as it developed I began to add a little tone to my pencil lines. Pencil and paper, the simplest of materials, are sometimes all I need.

We've already discussed how a firm grasp of drawing skills underlies the development of any landscape artist. The core skills aren't complicated and it is well worth investing a bit of time and effort into establishing these early; it will save a lot of time and trouble later on. However, even once this skill set is second nature, it's still worth considering how drawing can be used within the painting-making process in lots of different ways, and these drawings will look different because they're doing different jobs. Drawing is your most important research tool when you are in the business of making paintings. It is a way of asking yourself, 'What exactly am I seeing?'

As different types of drawing reflect different intentions, so will your choice of media and approach. Some drawings are made as finished works to stand alongside paintings as a complete and considered response. Others, probably the majority, are made along the way to producing a work in another medium, as a way of thinking visually, giving yourself the feedback of an image emerging rapidly at the tip of your pencil, or as a way of selectively recording a particular set of facts about a specific place. As well as being a separate discipline, drawing is also very much part of the process of painting whenever the artist makes decisions about edges and boundaries and just where each touch of paint is applied. There is even a sort of drawing that may happen entirely in the painter's head without drawing marks appearing at all. For anyone using a pure watercolour technique where areas of white paper are reserved, a brush stroke must be placed to work around these white gaps. For the oil painter too, drawing in one's head is a vital part of the shorthand of painting fast in front of the subject.

Painting landscape makes you realize pretty quickly that you have to consider everything within the frame of the picture plane. The sense of space which is created within the painting will be lost if there are gaps or holes in the spatial logic. Drawing doesn't necessarily imply this restriction and while a drawing might explore the whole scene, it may also be a way in to understand how individual parts of the subject are structured. Just like a musician rehearsing a particularly tricky sequence of notes, one small part of the subject can be studied and understood as part of the journey towards completing a painting, or just getting to grips with an unfamiliar location.

I've realized that I sometimes make a drawing which I never even glance at again, and yet it's been a vital part of helping me crystallize my ideas about a subject and it's made me look. Any medium might be used to make a drawing and the distinction between drawing and painting can be more a matter of intention rather than just the materials used.

MORE ON MEASURING

The image of an artist holding a pencil at arm's length is perhaps a bit of a cliché but I'm always surprised at the reluctance of students to try this simple technique. I still measure carefully and frequently in the early stages of building a painting and know I would be fooled into making many elementary mistakes if I didn't. Once again it's all about relationships, how a view is divided up into proportions and is really a simple method of surveying. Above all, remember it's a way of comparing a whole set of dimensions and enables you to draw what you see on any reasonable scale and not just at sight size. This last point means you can take quite a big view and reduce it to a small scale, something very tricky to do just by eye, or enlarge to fill a big canvas.

The technique is about establishing proportions so firstly establish what in your view will be your basic unit. Ideally it should be something whose size is fixed rather than, for example the distance between two branches which are blowing about in the wind. Choose something easy to come back to with your eye that is neither too large nor too small to measure comfortably. Make sure too it's something that will still be there when you finish the drawing. I remember making the mistake of using the width of a car windscreen as my basic unit, only to have the car drive off with my drawing half complete. When you do this, your elbow must be locked so that your arm is straight, and the pencil perpendicular to your line of vision and not tilted away from you. Remember too that you can turn your hand to compare heights with widths.

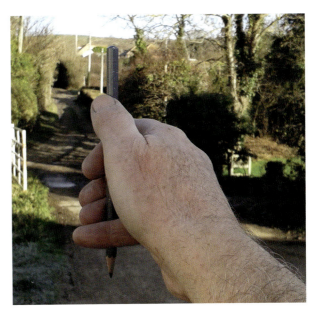

■ To measure, first remember that the object is to *compare* dimensions. Using the end of my pencil, the gap between its top and my thumbnail, I measure the height of the post to compare it with something else.

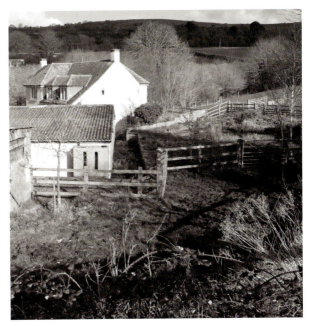

■ This is a photograph of a landscape with buildings. As a composition it appeals to me for the way that from a fairly high viewpoint, the buildings and surrounding landscape make clearly defined shapes, a good subject to demonstrate measuring with a lot of crisp edges to measure from.

Measuring

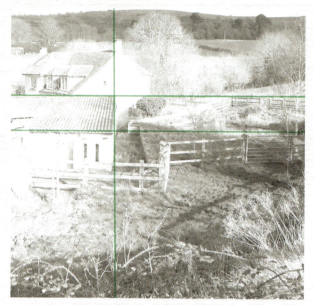

Step 1. Begin by deciding on a basic unit. Look for something in your field of view that is a permanent feature and is neither too big nor too small. It should be a feature that is either vertical or horizontal and has clearly defined ends. If we were figure drawing the height of a head from chin to crown would be a likely choice. Make sure it's something that your eye can return to quickly. I will take the height of the shed roof as my basic unit.

Step 2. I use my basic unit to compare with other dimensions within my field of view. The drawing will initially consist of only vertical and horizontal lines with others being added as my mesh of points grows. I will start by establishing a scale which will allow the drawing to fit comfortably on my sheet of paper which is a little over size.

Step 3. The drawing expands as I keep comparing my basic unit to, for example, the distance between the two chimneys. As more points are established I can begin to fill in some of the gaps 'freehand' with greater certainty.

Step 4. With most of the main lines in place, this drawing could be taken further with the addition of tone or colour, or the design could be transferred onto another surface ready to start painting.

So learn to measure and not be self-conscious about doing it. The constant practice will in time make your eye more accurate in your initial assessment of what you see, but be aware that certain things will trip you up if you don't make some initial checks. Drawing is surprisingly forgiving. I've often noticed that if I correct a line that's clearly wrong my eye will go to the corrected line and not notice the howling mistake. You certainly don't need to rub out all the time, and indeed, the wrong line needs to be there so that you can correct it. Going back to a clean white sheet of paper means you'll probably keep making the same mistake! And if you get the scale a bit wrong and want to include something that won't quite fit, well, you can just glue another piece of paper on at the side and make your drawing bigger.

DIVIDING UP THE SPACE: BIG SHAPES, LITTLE SHAPES

When you've made a drawing using the measuring technique described above you may well notice that the line drawing you've created has a mixture of large and small enclosed shapes and that the larger shapes tend to describe the space close to you. Take note of this because this sort of relationship is strongly suggestive of the illusion of three-dimensional space.

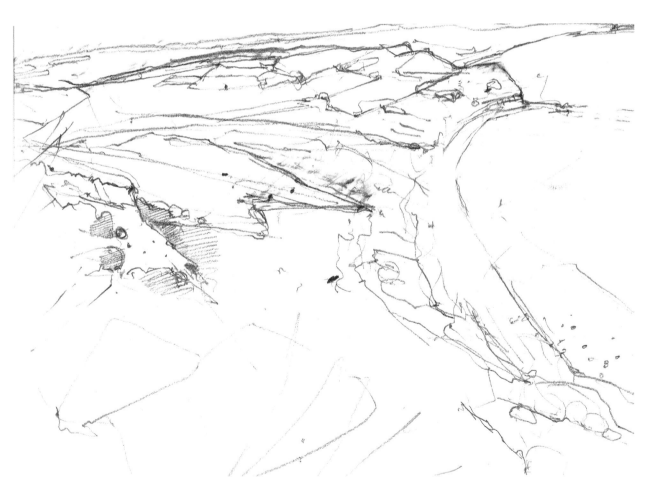

A drawing made from a high clifftop looking back along the coast. The big open shapes of the foreground give way to smaller, more intricate enclosures as I look towards the horizon.

WORKING DRAWINGS

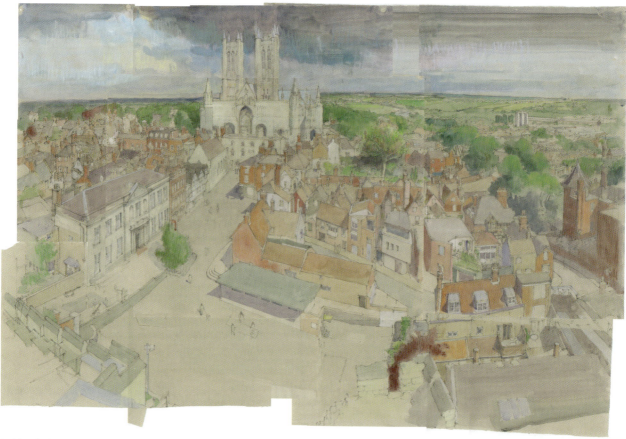

■ Lincoln Panorama drawing. Drawing and watercolour, 36 × 45 in (90 × 114 cm), Toby Ward.

When artist Toby Ward was asked to paint two large panoramic paintings of the city of Lincoln, his starting point was to make drawings. The big drawing illustrated here is in fact made up of a number of separate views stuck together to make one wide-angle composition. One of the biggest challenges of the subject was getting the perspective to appear consistent in spite of the artist's eye having to turn a little to make each drawing.

Toby said of the experience:

I began this drawing right in the middle of the cathedral, where the street meets the cathedral gate, and then worked outwards in all directions until I reached my predesignated right and left of arc, which were the conical topped tower on the

right and the pale building just below the horizon on the left. Drawing out to the left was no problem going horizontally but as I came down into the left foreground the problems started to occur. As I slipped out of my original cone of vision the buildings start to distort in order to occupy the correct space dictated by the original drawing on the first sheet. So they had to become slightly out of proportion. It then becomes a judgement call as to where this distortion comes in. In this case the fine classical building on the left is longer than in reality, as is the wall that connects it to the castle in the bottom left corner.

The real challenges started to arrive as I drew across to the right and down into the right bottom corner. The houses on the diagonal street

get progressively a little wider than perhaps they were, ending up with the orange-roofed house near the bottom right corner, the proportions of which I had to alter in a number of ways. Thankfully the anonymous grey roof right at the corner could absorb quite a bit of change without calling attention to itself. The battlements in the foreground were an ideal device to set off the rest of the composition and could be manipulated to work. The open ground in front of the flat green roof structure (one of the possibly few public toilets to be memorialized in paint) became larger due to all this distortion but in the oil painting that resulted from this I put a market place. Many of the houses in the centre right of the drawing had to be elongated a little but not so much that they lost their likeness.

One of the other challenges with this drawing was putting the colour on. I was perched on the castle turret with no room to use watercolour with any ease so most of the colour was added afterwards from memory. I think the final drawing was made up from seven pieces of paper and the resulting size was 90 × 114 cm. Each piece was worked on in isolation due to the lack of room for a large drawing board on my small, precarious and rather windy vantage point.

My own working method is often to make a careful working drawing following on from a quickly made colour study in oil or watercolour. I made a series of drawings around the Mediterranean town of Ponza, knowing that I would be unlikely to return, so the drawings had to carry all the information I might need later. Another of my drawings, made perched on a cliff edge in Dorset, was about getting a sense of the light and shadows on the brilliant chalk stacks, so charcoal was an appropriate medium.

■ A carefully measured drawing to record as much information as possible to use later.

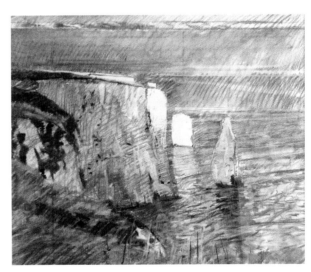

■ The choice of charcoal for this drawing gave me an instant way in to the fall of light on the cliffs and the sea which I felt were at the heart of this subject.

MIXED MEDIA DRAWING

As the name suggests, this is pretty open ended and there are plenty of ways that media may be used together. With some knowledge of how a drawing might be made in a single medium, a little imagination will quickly find ways that their virtues can be combined in a more complex way. A drawing doesn't have to be solely about line or tone and typically when I am gathering information I'll move between different processes according to what I'm trying to record. A sheet of paper and something as simple as a soft pencil and you have enough to produce a sheet of studies which tells you lots of different things about the subject.

A line drawing in pencil might include areas where the artist moves into tone to give an idea of texture or how the light is falling. Pen and wash, where a pen line in waterproof ink is laid down first and allowed to dry, followed by tonal washes, is a good way of separating out linear drawing from thinking about light. The drawing you make will allow both elements to be fully visible and carries lots of information. Mixed media might cover the combination with all sorts of dry materials such as various pencils, pastels, charcoal and chalks, with wet media like watercolour and gouache. Make sure you start with a paper robust enough to take some punishment and see where your imagination takes you.

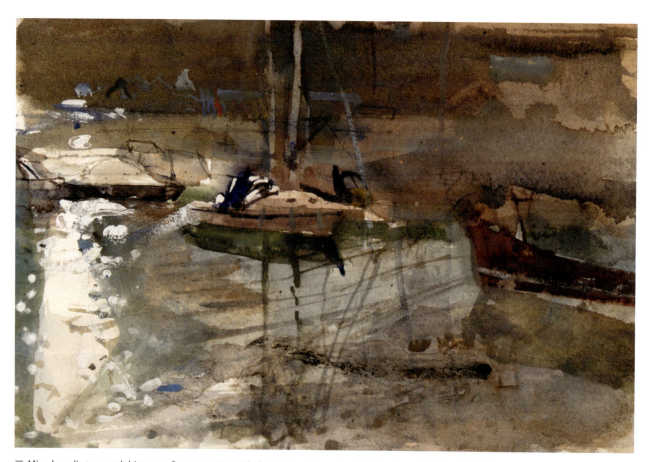

■ Mixed media to speed things up. On an evening with the light coming and going I had to grab this splash of brilliance while I had the chance. A pencil start, followed by simple watercolour washes and some stabs of white gouache and soft pastel to re-state some of the lights.

SEEING THE BIG TONAL PATTERN

The fall of light across a landscape produces patterns of light, dark and mid-tones. If I look hard at one detail of my landscape subject my perception of the lights and darks within that small area will probably be exaggerated. Try to avoid this by letting your eye take in the whole subject and decide where the broad blocks of light, darks and mid-tones lie.

Tonal variety in drawing might be largely a response to the way a subject is lit, but remember it may also be due to changes in local colour. If I place two sheets of paper, one white and one blue, so that they are equally lit by the same lamp, the blue one must be drawn darker. Within a landscape there may be dark trees and pale hayfields. These individual features even under the same lighting will be lighter or darker within a monochrome drawing, and lit by the same light source the variety of tone shown by each patch will be within its own range. This will be important when you come to paint; the lightest point within a mass of dark foliage may be darker than the shadow on the pale hay field.

One of the big benefits of making lots of drawings is that it enables the artist to make a quick response to the subject to grasp it as a whole, but with fewer technical concerns or kit to get in the way. Just as a pen in my hand has me looking for boundaries and flowing lines, a brush encourages me to think in tonal and colour masses which form a counterpoint to the linear design. Using a brush to make rapid tonal studies is a great way to tackle the whole subject in terms of the major masses of lights and darks which will be at the heart of the more worked-out, finished painting to follow.

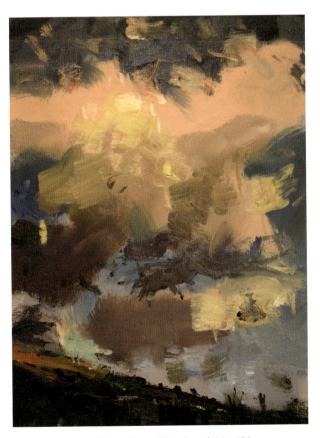

Rags and Tatters, Marrowbone. Oil on board, 16 × 10 in (41 × 25 cm), Richard Pikesley. Wind blown cloud and a strongly tilted horizon combine to make a striking tonal pattern.

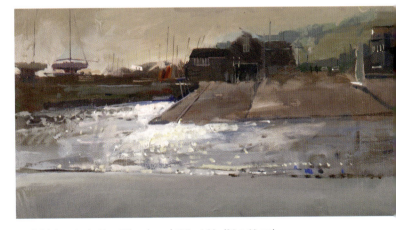

Cobb, Late in the Day. Oil on board, 8.5 × 16 in (21 × 41 cm), Richard Pikesley.

Step-by-Step

Tonal pattern

Step 1. Using acrylics I make a mix of Ultramarine and Burnt Umber on my palette. Mixing with white I first establish three or four broad bands of tone running back to the horizon. I'm looking for the big tonal masses and not worrying at all about any detail.

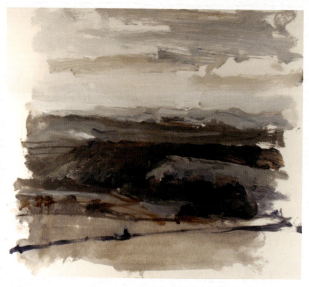

Step 2. The sky is very much part of the feeling of recession and certainly not just a backdrop, so it's treated in the same way as the land and blocked in simply. Now I'm beginning to subdivide these broad sweeps into smaller cells. The first of the field boundaries is also indicated. I've just noticed two distant bonfires and try to show a smudge of smoke for each.

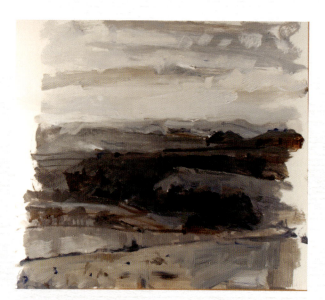

Step 3. Focusing now more on the horizon I'm aware of just how tiny the tonal step is where land and sky nearly merge. As the landscape recedes the tones lighten and divisions get closer. Small adjustments now moving tones up or down a little as my eye hops from my little painting to the landscape and back.

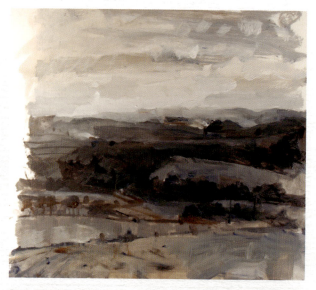

Step 4. As rain clouds move in the distant sky the back edge of the horizon disappears and then comes back into view and a few further adjustments take this little study about as far as I need it to go. Acrylic is a great medium for this sort of work as I can work wet in wet if I'm fast, or slow down and apply washes over the dry surface. The study has taken me fifteen minutes, and I can now start on a larger painting with more certainty about what I'm trying to achieve.

PERSPECTIVE

Using perspective is easier than you may think! A little time invested in really understanding the subject will give your paintings a sense of being grounded and secure in a way that simply won't happen if the subject is avoided. There are two forms of linear perspective which are useful to us here, I'll start by describing the simplest one.

Single-point or square perspective is a way of representing the world using the simple fact that the objects we see appear to be smaller when they are further away. That this happens in a regular and predictable way is the key to understanding how it can be used to understand and describe what we see. Painting landscape you'll often be in a situation where there are no straight lines or right angles, and the world you see doesn't look like a perspective diagram. However, a grasp of the basics will help you paint what you see with real authority, so forgive

me if we seem to be stepping out of the real world for a moment to look at things simplified.

Although not a landscape setting, one of the best places to learn about perspective is sitting indoors, ideally, and a space that allows you to see along through a large interior space. For this drawing I'm sitting comfortably on a chair at one end of a corridor. Sitting down, it's easy to keep my eye still and I'm seated so that my line of view is parallel to the long walls.

The first thing to do is to notice where my eye level is. Nothing mysterious about this, just a line across the drawing to note the level of your eye. Making a decision about how far up my sheet of paper I want this to sit, I draw a horizontal line across the sheet.

As I look down the corridor I can now work out where my single vanishing point is. This will be sitting on the eye level at a point straight in front of me. All the lines in the parallel set that make up the corridor, the

■ The green line marks my eye level and the vertical red line shows how far across that line I'm looking from. Where they cross is my vanishing point and every line running away from me runs towards it.

■ Working indoors is a good way to learn the rudiments of perspective before moving outside.

rugs on the floor and the pictures on the walls, lead to this one point.

Once you realize that lines above your eye lead down to the vanishing point and those below your eye slope upwards to the same point it's like a revelation. Now I can look for all the lines that form this parallel set and start to plot these on my sheet of paper. If you're already confident with the technique of measuring described above combine this with your new knowledge of perspective to help get things in the right place. Drawing in the landscape, I'll often measure first, then look for any perspective cues that I can use to confirm my measurements.

Making a perspective drawing indoors is a great way to learn the rudiments and to gain confidence with the practicalities. As we'll see shortly, there are plenty of opportunities to apply perspective in the natural world. Single point, or square perspective applies in any situation such as this where a set of parallel edges run straight away from your eye. Things get just a little more complex when our viewpoint is cornerwise, or when there are hills or bends involved and for this we'll move outside into the landscape.

PERSPECTIVE IN THE LANDSCAPE

While single-point perspective gives us an easy way in to interpreting what we see, in the real world we are often dealing with views from angles and odd corners. The examples that follow illustrate where perspective might be seen and suggest how it may happily deal with more 'real world' painting situations.

My drawing of part of Weymouth harbour uses the same square, or single-point perspective illustrated in the indoor drawing. The only difference is that most of what I've chosen to draw is to the left of the vanishing point which sits close to the right hand edge of my paper.

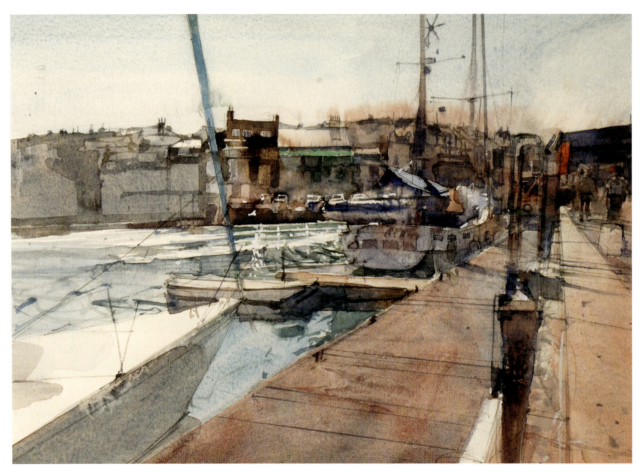

■ *Nefertiti, Weymouth Harbour*. Drawing and watercolour, 10 × 14 in (25 × 36 cm), Richard Pikesley.

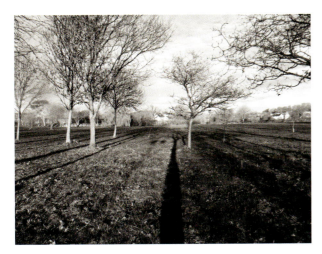

■ The shadows of the tall trees run away from me in perfect single-point perspective.

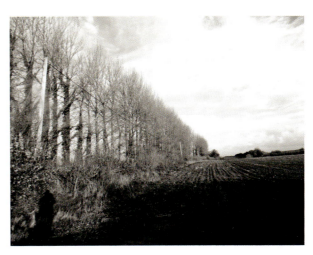

■ Square perspective again in the line of trees and the ploughed field.

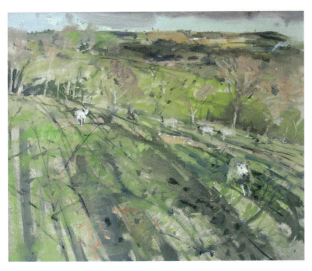

■ Looking slightly downhill in this painting, the lines of the tree shadows help to describe the shape of the hillside.

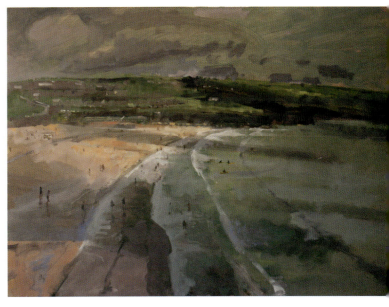

■ *Porthmeor Beach, Cloud Shadows*. Oil on canvas, 24 × 34 in (61 × 86 cm), Richard Pikesley.

This arrangement gives a sense of everything moving from left to right. The lines of the edge of the quay, on which I'm sitting, disappearing towards the vanishing point makes a strong spatial framework for all the detail of the drawing that followed.

Away from the landscape of buildings, there are still plenty of examples of perspective. It's a good exercise to simply look for these and I found two without any difficulty. Standing amongst a group of tall trees with the sun on my back, the lines of shadows run towards the horizon across a flat field, in perfect single-point

perspective. In another view a line of poplar trees and cable on the left-hand side point towards a vanishing point very close to the point where all the ploughing lines converge. Although the ground is running slightly uphill, the perspective creates a powerful feeling of space.

Look for these spatial cues wherever you paint. Once you become aware of its effects you will be able to use perspective to open up a compelling sense of space in your paintings. Although perspective that would fit a diagram isn't the sort of thing you would expect to find in a painting of the natural landscape, its effect is

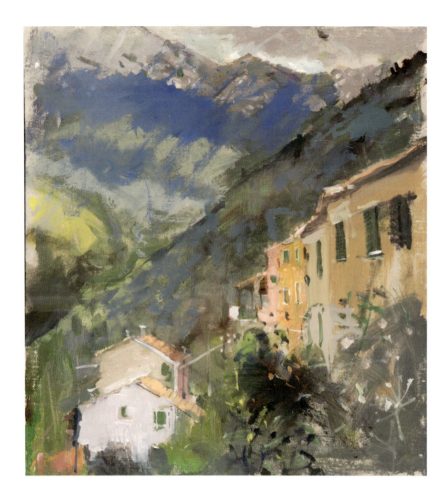

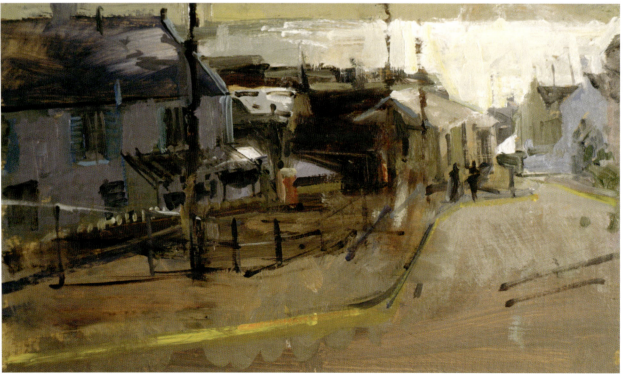

■ *Road to the Cobb, Lyme Regis*. Oil on board, 6 × 11 in (15 × 28 cm), Richard Pikesley.

Plough lines map out every curve and undulation in this field.

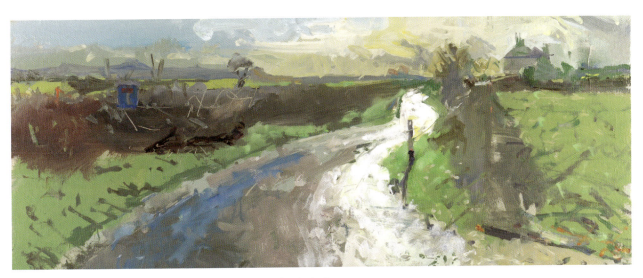

■ *In Marshwood Vale*. Oil on board, 10 × 24 in (25 × 61 cm), Richard Pikesley.

everywhere, from edges of cloud masses to shadow lines on the ground. Remember, however, that as we've already found, there are lots of things which add together to give a seamless illusion of a three-dimensional world, other than perspective alone.

So far we've just looked at the use of perspective on a flat surface with vanishing points on the eye level. But perspective will take us up and down hills as well as around corners. In the painting of houses with mountains beyond, the eye level implicit in the way the buildings have been observed places the viewer low in the picture frame with the mountains towering above

us. By moving the vanishing point below the eye level, the road goes downhill; in the little oil study of Lyme Regis our eye level is high, the same as the sea's horizon, but the vanishing points for the twisting road take us steeply downhill.

Perspective will also take us around corners. In the photograph above the curving lines of the planted crop relate to multiple vanishing points along the viewer's eye level as the lines sweep and curve across this flat field. A curving road can easily be described by drawing a sequence of short straight sections and then drawing the best line through all of these points.

DRAWING WITHIN PAINTING

It's hard to say exactly when drawing stops and painting starts. As part of the painting process, the role of drawing may be very varied. For some artists, a comprehensive linear drawing may be made on each canvas before any work with colour begins. For others, myself included, drawing alternates with broader tonal and colour marks throughout the painting's development. On smaller pieces which will be completed quickly on location, the first drawing marks will settle how the composition will sit on the board and how much I'm going to get in. These indications don't necessarily need to be very complicated; a few carefully placed dots and dashes will be all I need before I dive in with a loaded brush and start to build the image in blocks of colour. As long as I know what these early marks signify, that's enough and there's no need usually to make a fully developed drawing. With larger, more complex studio paintings I'll generally have made a careful drawing on the spot and this will be transferred to the canvas using a process known as squaring up. This takes a bit of time but will give me a more secure start

than painting freely on the larger surface and probably making mistakes of scale and proportion which will need to be corrected. As I develop the painting I'll bury these drawing marks, which may remain as no more than minor traces in the finished painting. If I start to lose my way, however, the lines can be quickly re-stated from the original drawing.

This process works very well for oil paint or other opaque media where the scaffolding of the drawing can be obliterated by layers of paint. However, watercolour demands a lighter touch and drawing marks will probably need to be made rather more faintly if they are not wanted as part of the completed image. Faced with a complicated subject in watercolour I may still use a brush right from the beginning and not use any pencil lines. A fine pointed brush with a little dilute Cerulean Blue watercolour produces a fine line which is perfectly visible, and can be easily integrated and lost in subsequent layers of colour. If I change my mind about where things are going, Cerulean Blue can be lifted off the paper easily with a little water and a sponge.

WHY DO SO MANY PAINTERS CARE ABOUT DRAWING?

The technical simplicity of drawing gives it a fantastic ability to say a great deal with very slender means. It can have the brevity of a haiku, yet can imply so very much. Setting out to make paintings from landscape it's easy to be overwhelmed by complexity as I'm bombarded by sheer visual overload. Drawing allows me to grasp what I see all of a piece and enables me to figure out how I

can take just part of what I'm seeing and make it mine. While the process of painting will require me to do one thing at a time, drawing allows me to grasp the subject whole. Above all, drawing makes me look and stops me making false assumptions about such things as scale, foreshortening, and which way lines tilt.

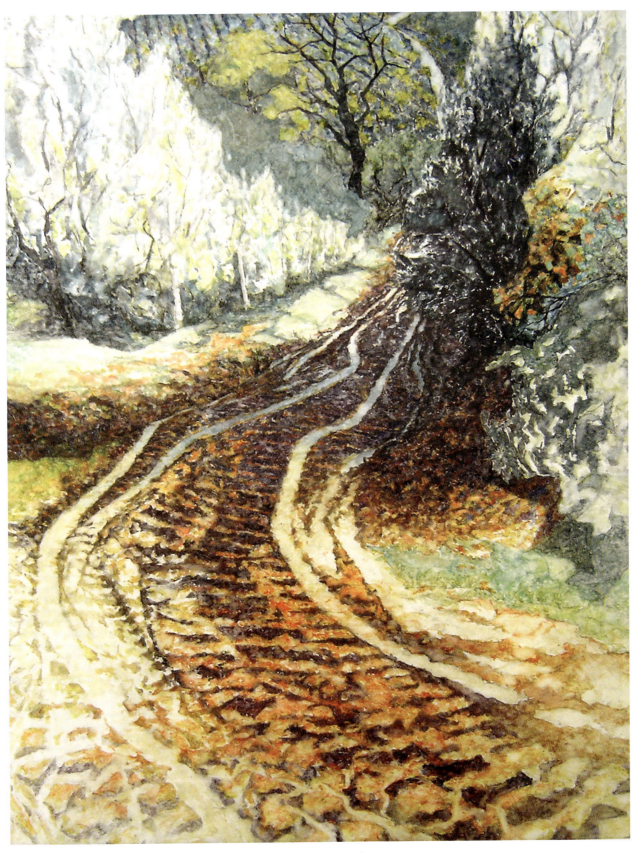

■ *Sun-bleached Track, Tuscany*. Watercolour, 54 × 40 in (137 × 102 cm), Patrick Cullen.

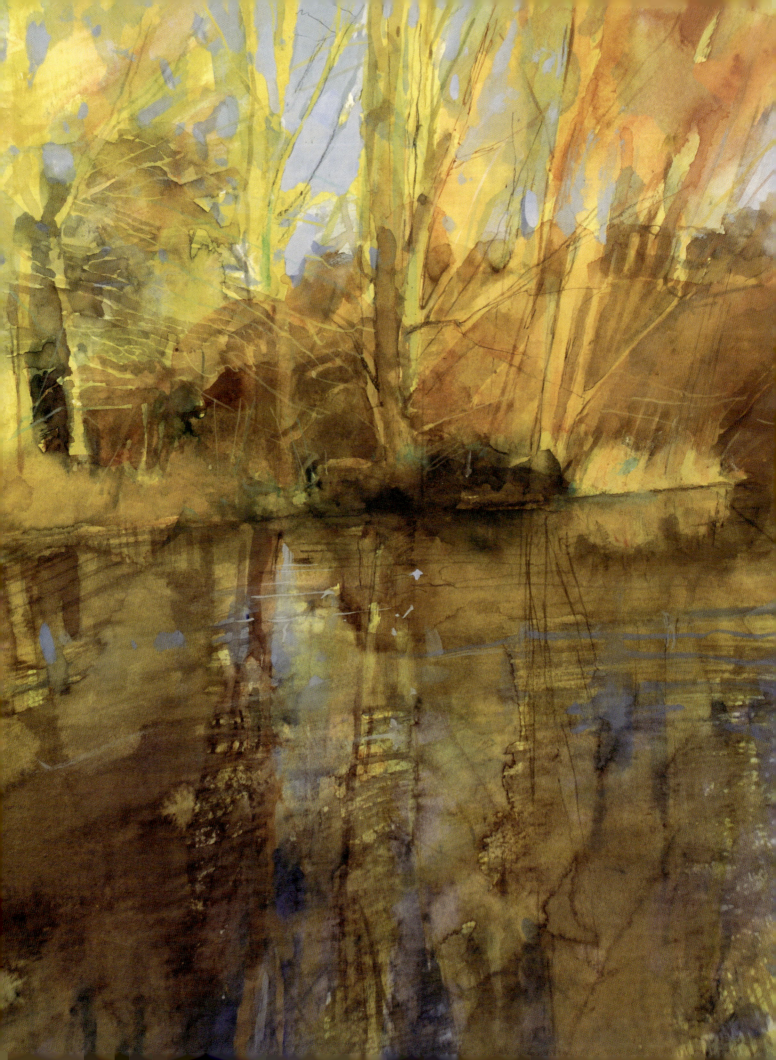

CHAPTER 6

Materials

This chapter is intended as a resource for the whole book – too important to be an appendix, but too complex to come right at the start, so here we are in the middle.

I'm sure any painter castaway on a desert island would find something to draw with, even if only a stick in the sand or a chalky pebble. The instinct to make a mark is deep within all of us. There are many things you might use to make marks from which a landscape could be constructed, but I'm mostly going to concentrate in this chapter on drawing in dry media, and painting with water-based paints and oil colours. The materials of the artist responding to landscape may include anything that will make a mark as well as the surface that receives it. This includes all the traditional artists' materials and also a host of other things which, while not necessarily being permanent enough to make a durable work of art, will provide invaluable diversity of mark-making for studies and the working process.

The pen with which I am writing this is an inexpensive item picked up at the local newsagent. It makes a mark whether it's pushed or pulled, unlike a dip-pen which only works on the pull stroke. As I write, it responds quite well to variations in pressure and makes quite an emphatic mark as I increase the pressure, lightening off to something more wispy when I lighten my hand. The ink appears to be waterproof so could be used to make a drawing washed over with watercolour, and where you would want the line to remain visible and not be smudged by layers of wash.

With an open mind and a bit of experiment many 'alternative' materials might suit our needs better than traditional artists' materials. So although the main focus of this chapter is on the more conventional artists' colours, media and surfaces, a little imagination and experiment will reveal plenty of alternatives. Remember too that painting is a tactile as well as a visual process, and how a particular type of paper or canvas reacts to your touch is important: it can be unsettling to hop about between different materials.

◼ *Stour, Sun after Rain*. Watercolour, 21 × 15 in (54 × 38 cm), Richard Pikesley.

MAKING DRAWN MARKS

PENCILS AND CHARCOAL

Go into any well stocked art materials shop and you will be faced with a bewildering variety of pencils and crayons, any of which might be an appropriate choice. As with each of these categories, I would advise you to try out as many as you like before settling on just a few. The tactile, handling quality of the way a line goes down on paper, or the touch of a brush full of oil colour on canvas, are very much part of the process and with familiarity this 'feel' becomes second nature and you are less likely to be 'thrown' by something not quite feeling or working as expected.

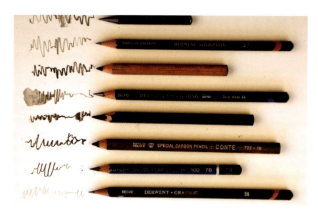

■ A variety of pencils, all a pleasure to draw with.

■ Sticks of charcoal come in all sizes and make a wide variety of marks.

■ Charcoal pencils are too crumbly to sharpen with a pencil sharpener. Instead, use a craft knife and finish with sandpaper.

■ Erasers are for drawing as well as rubbing out. When they get grubby they can be washed in water.

PASTELS

These come in a number of different forms but the most useful are probably the soft artists' pastels produced by several of the big art materials manufacturers. A stick of loosely bound pigment which easily produces a mark on slightly rough paper is held together in a paper wrapping. They have the advantage that the colour is ready mixed in each stick but you do need a lot of individual pastels to cover all of your likely needs. The colours may be mixed on the paper by hatching one colour over another which is allowed to shine through the gaps and create an effect of optical mixing. The pastels can be stored and carried in a box with separate division for each stick, or less bulkily in a plastic box partly filled with rice grains which will help to keep the pastels clean. Use on toned paper with a slightly rough surface such as Ingres paper which is available in a wide range of colours. The rough surface is needed to pull the pigment off the end of the stick so that a mark is left. Some artists also use abrasive papers (sandpaper) which can be purchased in very fine grades.

PENS

I've collected loads of pens over the years ranging from dip pens with mapping or Gillot 303 nibs to a whole variety of modern disposable pens with a wide variety of nib sizes. Art shops will also often sell pens cut from bamboo or quills and these can be fun to draw with and produce a generally softer line than a metal nib. Even used with care, all of the 'dip pen' options will occasionally leave a blot but the character of the line produced that will go fine or thick according to the weight of your hand, has great beauty and nothing is so sensitive to an artist's intent.

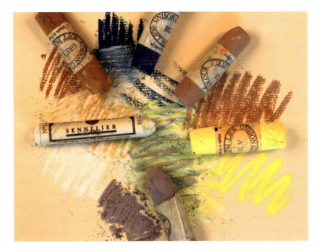

Pastels rely on the roughness of the paper to deposit a good layer of colour. They can be mixed optically by cross hatching one layer over another.

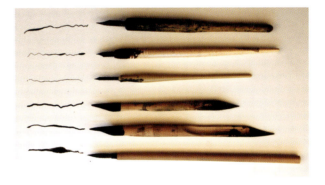

Some of my collection of pens and brushes. Each makes a line with a different character.

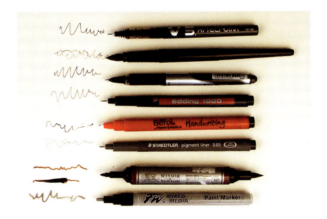

Various ink- and pigment-filled pens from art shops and stationers; very useful but may produce a rather mechanical line. The watercolour marker (second from bottom), however, is more like a brush in use and the paint marker (bottom) is supplied empty for you to fill with ink or paint of your choice.

WATER-BASED MEDIA

The first paints which most of us will have encountered in childhood would have been powder paints to be mixed with water or poster colours in jars or tubes. Inexpensively made by avoiding costly pigments and not worrying too much about permanence, they lacked subtlety but were easy to use and could be built up in layers once dry. Looking for something more permanent and predictable, designers' gouache and artists' watercolour will meet most needs.

DESIGNERS' GOUACHE

Designers' gouache offers a more durable and versatile version of the same idea as those early poster paints. Originally made for designers who needed to paint flat, unmodulated areas of bright colour, today these paints find a place in the working materials of many artists who value their unique qualities. As with watercolours, these tube colours can be squeezed out onto a palette and mixed with water, but unlike artists' watercolours, gouache paints are opaque even when thinned quite a bit so can't be used to make transparent washes. A very handy resource for the travelling artist, these would be my first choice before watercolours for their ease of

use. Unlike watercolours, these paints can be used over darker surfaces such as darker toned papers or white sheets given an initial tonal wash. This allows the artist to go straight in at the desired tonal pitch rather than spending a lot of time working down from white paper.

ARTISTS' WATERCOLOURS

I've headed this section 'Artists' watercolours' to differentiate these from gouache; however, these are also available in students' quality ranges at a lower price from all the major manufacturers. The glory of pure watercolour is its transparency. The paints are designed to produce clear washes and in its purest technique are used without white, relying instead on the white of the paper shining through layers of colour to provide tonal variety. They are, however, enormously versatile and have a luminous, weightless quality quite unlike anything else.

Confusingly for a beginner, artists' watercolours are available in two rather different forms. They are sold in tubes, generally smaller than tubes of oil paint, in a moist consistency that can be squeezed out for use on a palette. Alternatively they can be purchased in metal boxes with little rectangles of hard colour which have to be wetted before use to bring the colour to life. I use both types, largely depending on the scale of what I'm doing or the need to carry as little as possible. My tiny box of 'half pans' is a vital part of my kit, easily slipped into a pocket and perfect for making little notes in a small sketchbook. However, for anything on a larger scale I like to use tube colours and be able to squeeze out enough paint to make a big wash. For the metal box option, consider buying an empty box and filling it with pans or half pans of your own choice.

Two things about the myth of watercolour painting continue to baffle me. One is that it is seen as the quintessentially English medium. Working out of doors through a typically English February causes me to wonder about this as washes take an age to dry in the damp, cold atmosphere. The other preconception is

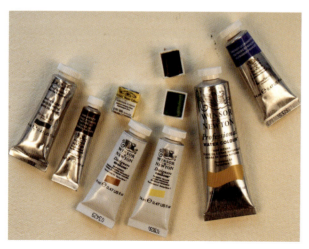

■ Watercolours in tubes and pans and gouache. Watercolours come in various sized tubes. I buy the biggest for the colours I use most as these are more economical.

about scale. Watercolour is often thought of as having an intimate quality well suited to smaller paintings. For me, a trip to India, where I had the joy of working with artists from all over the subcontinent dispelled both of these notions. Working in warm dry conditions, the drying time is quite quick (sometimes rather too fast, but this can be controlled) and all the Indian born painters on that trip were happy to work big and bold and had been well taught, certainly not considering watercolour to be a minor medium in any way inferior to oil paint.

I'm much more likely to use a limited palette with watercolour than I am with oils. Because of the luminous quality of thin layers over white paper, colours have a particular vibrancy which can be quite hard to control, so for me, fewer colours and a more tonal approach suits me well.

Brushes for watercolour and gouache

Watercolour brushes are traditionally made from sable, and in bigger sizes these can be very expensive. However, good brushes are worth the investment and most of my brushes have been in frequent use for many years. The most versatile brush is a big round brush with a fine point, capable of carrying and laying a big wash and also painting the finest lines. These days, the range of brushes available to the artist is enormous and with synthetic

brushes and those made with a mixture of natural and synthetic fibres there are many cheaper alternatives to the best Kolinsky sable. Chinese brushes are also worth a look; typically made of goat hair, some of the big-bellied pointed brushes are lovely to paint with, having been produced to draw the swelling lines and intricate detail of calligraphy. For gouache, your watercolour brushes will be ideal, but you can also use stiffer hog brushes of the type you might use for oils. If you do, use a separate set for water-based paints as the greasiness from the oils would prevent them from handling well.

Whichever brushes you use, make sure they are cleaned after use. Run them under the tap with a little bit of soap, carefully rinse out, then allow to dry before you put them away. A canvas roll is perfect for storing your brushes and an easy way to transport them safely when you're out and about painting.

ACRYLICS

On the face of it, acrylics combine the practicality of water-based media with some of the working properties of oil colours. They are available in a similar range of colour to oils and, like oils, are packaged in larger tubes. Unlike oil paints they are diluted with water and straight from the tube they will dry quickly giving a fully dry surface for overpainting if desired. A variety of special media may be mixed with the colour to alter its characteristics: impasto medium creates craggy surfaces; retarder

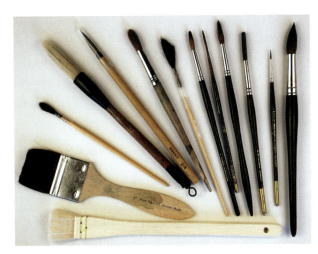

■ A few of my watercolour brushes. These range from inexpensive synthetics and oriental brushes to Kolinsky sable which will last a lifetime. The sable brush in the middle whose handle has lost its black coating has been used almost daily for more than forty years. Even though its fine point has worn away it's still a delight to use.

■ A box of assorted acrylics and the brushes I use. These are washed out immediately after use to keep them clean.

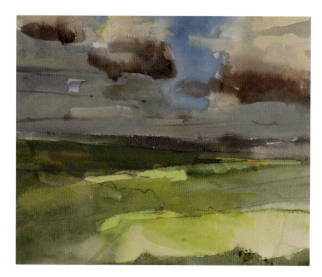

■ *Long View South, Eggardon, Winter*. Mixed media, 9 × 11 in (23 × 28 cm), Richard Pikesley. Started in pencil, this drawing was developed using both watercolours and gouache. Gouache can be a delight to use alongside the looser washes of pure watercolour and although I sacrifice some transparency I gain optical effects unachievable with pure watercolour.

slows down the drying time; and glaze media allow for painting thin washes.

So why doesn't everyone use them? For me, it comes down to what they haven't got: the complexity and beauty of oil paint. However, they can be ideal for working on location for gathering information as their versatility and fast drying time makes them such a good sketchbook medium.

Brushes for acrylic

The versatility of acrylics means they lend themselves to many different ways of handling, so the stiffer hog type brushes or their synthetic counterparts used for oil paint work well, as do synthetic type watercolour brushes. Be scrupulous about washing brushes after they've been used with acrylics; it is also probably best not to use expensive sable brushes.

MIXED MEDIA

'Mixed media' is a very loose term to describe any two or more media used in combination. The water-based paints, gouache, watercolour and acrylics can all be used together and each may also be combined with dry materials like charcoal or pastels. It's best to use materials in combination in a way that allows each to contribute its unique qualities. Thus a drawing may be made in waterproof ink and then, once dry, watercolour washes added to provide colour. The permanence of ink prevents it from smudging and the transparency of the watercolour washes allows the bones of the drawing to remain visible. Unless you are deliberately trying to exploit textural effects it's probably best to avoid using oily media like oil pastels alongside water-based paint.

I sometimes extend the use of watercolour by combining it with gouache, and find the combination of opaque colour alongside translucent washes to be particularly telling. Using two palettes, one for gouache and another for watercolour, and working wet in wet, the gouache will stay where it's put rather more than the watercolour, which tends to migrate quickly across wet paper, bleeding into washes. Also, semi-transparent washes may be created by combining the two media so that they half cover what lies beneath, building complexity and texture with each wash. Alternatively, gouache can be used to develop freely started watercolour paintings with more intricate detail, though as the watercolour is obscured by a layer of opaque gouache the painting will begin to lose its transparency.

SURFACES AND SUPPORTS FOR DRY AND WATER-BASED MEDIA

I've seen many painters give enormous thought to their choice of paints or pencils only to then try to make a painting or drawing on whatever comes to hand. The surface on which you work plays a huge role in the characteristics of your chosen medium and its importance shouldn't be underestimated. Now, that isn't to say you should always choose the most expensive paper, just the one that enables you to do just what you want without it getting in the way. Chopping and changing between different papers can be surprisingly unsettling and makes it almost impossible to predict how a piece of drawing or painting will go.

DRAWING PAPERS

These are very varied and even within the category of cartridge paper you'll find a wide range of surface textures, colours and weights. This applies as much to paper in sketchbooks as to loose sheets, so examine anything you are offered carefully.

Make sure the paper is robust enough to take a bit of punishment. It needs to have a little bit of texture to provide some grip to drag pigment off your pencil or crayon. Some pastel painters go further, working on fine abrasive papers which will accept plenty of pigment across its very evenly textured surface. The other main choice for pastel painters is Ingres paper, which comes in a wide variety of colours much better suited to the medium than the usual white or cream of cartridge paper.

If you're going to be combining wet media with dry, make sure the paper is heavy enough to take a wash without excessive buckling. Consider tinted paper if you're working with gouache. It allows you to start in the middle of the tonal range and lighten or darken to build a suggestion of space quickly.

WATERCOLOUR PAPER

Watercolour paper may be used as a support for any of the water-based media. It is very varied and its tactile quality is a very important part of picture making. Watercolour papers are manufactured using several different processes ranging from entirely handmade to mass-produced. Handmade papers are likely to be very expensive but the somewhat cheaper mould-made papers can be very good indeed and the manufacturing process ensures a greater consistency. These papers often have just two deckle edges, indicating that they've been made on a continuous roll. There are broadly three types of surface depending on how the paper has been finished, and whose choice will affect the way you paint.

◼ A variety of watercolour papers from hot pressed to very rough, including some coloured sheets.

Rough

These papers have the natural surface of a handmade paper that is just dried with no further pressing. Mould-made papers take their surface characteristics from the felt used in their manufacture. These papers have a very assertive surface which is at its best when used for quite large paintings.

Not (or cold pressed)

These papers have a less extreme surface than the rough sheets described above, but still have a noticeable surface texture. These are the papers that most painters use most of the time. Big washes can be laid easily and a dryer brush pulled across the surface produces a more broken effect. Very versatile.

Hot pressed

Passed between heated steel rollers as part of the finishing process, the surface of HP paper is hard and smooth. I like these papers and use them for smaller scale watercolours and in my sketchbooks. I enjoy the fact that there's no surface texture to get in the way visually. I buy the heaviest weight I can find and cut it down into smaller sheets, where it is stiff enough not to need stretching.

STRETCHING PAPER

We stretch paper on drawing boards to prevent it from buckling when we paint. This applies especially to thinner papers; a watercolour painting made on such papers may be impossible to get to lie flat enough to frame successfully. The paper is wetted and taped down onto a drawing board. On drying, the paper tries to contract and pulls very tight on the board, a bit like a drumskin. Completing the painting with the paper securely taped down, it is allowed to dry fully before being cut off the board. A sheet of beautifully stretched paper, hard and flat on a drawing board, is a wonderful thing. Having said that, I stretch paper far less often than I used to. The desire to carry less when I'm working out in the landscape pushes me to carry a number of loose sheets and just one board. I've also found that the working characteristics of my favourite papers are different if I choose the same paper but in a lighter weight.

There are, however, occasions when I do need to stretch a sheet of paper to ensure that a large sheet stays entirely flat; the photographic sequence shows how this is done.

OILS

As with watercolours, there are students' quality colours available as well as the artists' range from each of the big manufacturers. The main difference between the two is again around the use of more expensive pigments rather than substitutes and the amount of filler used in the colour to bulk up the cheaper colours. For the beginner, the students' colours can be easier to work with as they have more consistent handling characteristics than the more expensive artists' range. However, one of the great beauties of fine quality oil paints is that each pigment is different in many other respects than just its colour. They vary in intensity, in covering power and how transparent or opaque they appear, and building a working palette involves balancing the properties and capabilities of a number of different colours.

ARTISTS' OIL COLOURS

Artists' oil colours are simply made from mineral pigment and oils with very few other additions. They display the unique characteristics of each of these pigment sources and it takes a little time to learn fully how each will behave. They are available in standard size tubes of about 37 ml as well as in bigger 200 ml tubes and tins for whites and some colours. The price of each tube will depend on the pigment, ranging from cheaper earth colours right up to those derived from precious gemstones. Oil colour in 200 ml tubes is significantly less expensive than the smaller ones, so I have big tubes to use in the studio and the smaller ones in my travelling kit. My standard palette of colours is listed below. Where different manufacturers apply different names to the same pigment I've given alternative versions.

Stretching paper

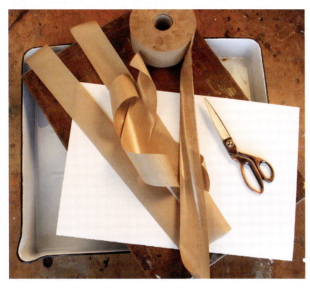

Step 1. The paper should be trimmed to about two inches less than the dimensions of the board, giving a margin all round of one inch. If you are purchasing or making drawing boards, plan their dimensions to accommodate quarter or half sheets as well as whole ones. My favourite paper comes in sheets measuring 56 × 76 cm.

Step 2. The paper to be stretched should be soaked in cold water in a large sink or tray. If the paper is too big to lay flat in the tray, ensure sufficient depth so that the paper isn't tightly folded. If you are stretching several sheets in one session, make sure that you place the sheets in the water one at a time and that air trapped between the sheets doesn't prevent the paper becoming properly wet. Removing a sheet from the water, blot it lightly and then lay it down on the board.

Step 3. Quickly wipe the water away around the edges and use your hands to expel any pockets of air trapped under the sheet. Using pre-soaked gumstrip paper, tape the paper to the board, with about half the width of the gumstrip on the paper and half on the board.

Step 4. Leave it lying flat until fully dry when it should be stretched tight. Remember to leave the paper taped to the board until you've finished the painting and it is fully dry. It can then be cut from the board with a craft knife.

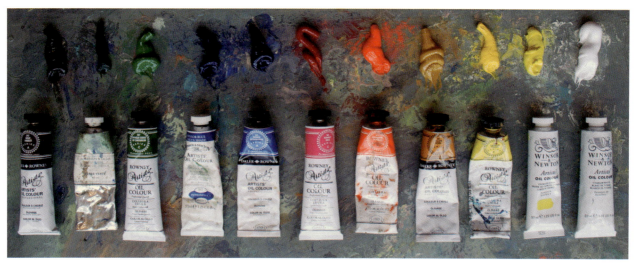

■ Oils squeezed out onto my studio palette ready for a day's work. I use the same colours, laid out in the same order every time.

- Titanium White: opaque, cool white and safer than its lead-based alternatives.
- Cadmium Lemon: a cool, slightly greenish pale yellow which can't be imitated with other pigments. Lemon Yellow is a good substitute if you're looking for something cheaper; a similar colour but it has nowhere near the same power.
- Cadmium Yellow: available in many variants, pale or deep. I use the basic one, a good powerful, warmish mid-yellow.
- Yellow Ochre: a yellow earth; rather variable between manufacturers so find one you like.
- Cadmium Scarlet: expensive, but I think a much better hot red than either Cadmium Red or Vermilion.
- Quinacridone Red (Rowney Rose): cool, transparent and rather weak, but a real cool red and the perfect foil to Cadmium Scarlet. Infinitely better than that thug Alizarin Crimson.
- French Ultramarine (not green shade): dark purply mid-blue, which mixes well with Raw Umber to create a range of darks.
- Phthalocyanine Blue (Winsor Blue, Green Shade): while Ultramarine gives you the purple end of the blue range, Winsor Blue takes care of the green end. These two blues have completely different characters and will create different ranges when mixed with anything else.

- Opaque Oxide of Chromium: an odd one, this, and I think not much used. It's a cool, opaque, mid-toned green with massive opacity and covering power.
- Terre Verte: transparent and warm; quite a weak colour but for me indispensable.
- Raw Umber: a dark, rather transparent, greyish brown. Gives me access to deep tones without resorting to black.

There are additionally, occasional 'guest' colours added. These might include two of the Cobalts, Green and Blue, and Cadmium Green. Now, that's quite a lot of colours. We learnt in Chapter 4 that there are no optically pure pigments that we can use and that a wider range is necessary to balance the properties of a number of pigments. My aim in building this palette was to give me options to go warmer or cooler, and to be able to create different 'families' of colour. As an example of this, try mixing a little French Ultramarine with white and alongside place a mix of Winsor Blue with White. The colours are obviously different and mixing each with other colours will quickly build colour worlds that are quite distinct.

It comes as a surprise to some painters when they notice the colours I choose not to use. Viridian Green and Alizarin Crimson are both popular but they're real thugs and will stain every colour in which they are mixed with a very prominent colour cast. They are however,

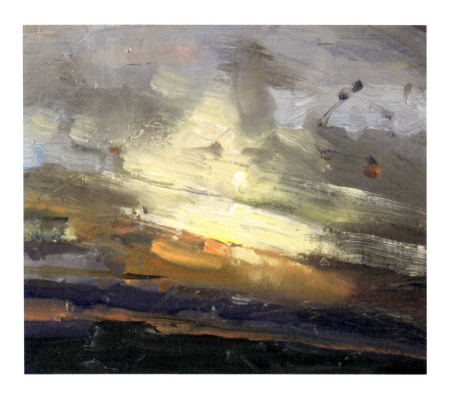

Last Light, Exmoor. Oil on board (detail), Richard Pikesley. Nothing else has quite the luscious quality of artists' oil colour.

capable of creating a very beautiful series of greys when mixed with each other, a virtue which still fails to see them appear on my palette.

I've been working with these colours for many years, and since they are always laid out in the same order on my palette I can work rather intuitively, especially at the end of the day when I can continue to work in very low light in spite of not being able to properly distinguish differences that would be clear in daylight.

Having said all of this about my extended palette, you may be surprised to find me extolling the virtues of a truly limited palette. Certainly a great antidote at times when too much choice is causing a bit of a muddle, working with the bare minimum can be a revelation. What it can't do is to duplicate everything you can see in paint, but the range of colour achievable is quite extraordinary. A high-key, high-chroma option would be something like Titanium White, Cobalt Blue, Cadmium Red, Cadmium Lemon. Going the other way and quietening everything down might take me to White, Raw Sienna, Indian Red and Ultramarine.

SURFACES FOR OIL PAINTING

Oil paint was traditionally used mainly on stretched canvas, and while this remains a good option there are a few other choices to consider.

Stretched canvas

Primed canvases may be bought from artists' suppliers in a range of sizes. The more expensive ones will generally be primed linen on wooden stretchers with wedges in the corners. These wedges can be tapped in to restore tension if the canvas becomes slack. Cheap canvases made of cotton duck on rigid 'stretchers' are also readily available but as these have no way of being re-tightened they should generally be avoided.

As an alternative to buying ready-made canvases, you could buy a roll of canvas and a stock of stretchers. This will allow you much more flexibility in the range of sizes and proportions of your paintings. Store your roll of canvas in a dry place or make sure it is properly dry before you attach it to a stretcher. I have a wooden box with a light bulb in it which does the job nicely. Canvas increases in size slightly as it dries and by fixing the canvas as dry as possible it minimizes the risk of it going baggy under the drying effect of gallery lights.

Step-by-Step

Making a stretched canvas

Step 1. To make a stretched canvas, you will need:
- Two pairs of stretcher bars
- Eight wedges
- Piece of primed linen canvas, or primed cotton duck about 4 inches larger each way than the assembled stretcher
- Wooden mallet
- Small hammer
- Canvas pliers
- Staple gun and staples
- Tape measure

Step 2. Join stretchers to make a complete frame. Make sure all four pieces are the same way up. Knock the four pieces together using a wooden mallet until the joints are completely closed.

Step 3. Measure the two diagonals; these should be exactly the same if your corners are all right angles. If not, gently tap a corner, re-measuring until everything's square.

Step 4. Lay the piece of canvas face down on a table or floor and place the bevelled side of the stretcher face down on top of it ensuring that the margin of canvas is equal on all four sides. Fire a staple into the centre of one side through the canvas and the narrow outer edge of the stretcher bar. Turn the canvas, and pulling with the canvas pliers to give moderate tension, fire a staple into the centre of the opposite side.

Step 5. Repeat the process on the remaining two sides. Returning to the first side, place two more staples either side of the first one. These should be evenly placed, about 1.5 inches apart. By slightly angling the canvas pliers, create a bit of tension between the staples. Don't overdo the pressure on the pliers as you've not yet placed more staples on the opposite side.

Turn the canvas to work on the opposite side, repeating previous step. This time you can lean a bit harder on the pliers as now the canvas is held by five staples on the opposite side. Repeat the two steps above for the remaining two sides, continuing to exert some sideways pressure as well as across the frame.

Continue to work around the canvas, completing the two pairs of opposite sides. Work outwards from the five staples already placed, towards the corners adding perhaps six staples each side before turning to deal with the opposite side.

Step 6. Depending on the size of the canvas, you will soon have the canvas fixed to the stretcher with a nice even tension. Now lay the canvas face down, carefully folding the excess cloth in the four corners, securing each to the back of the stretcher with a staple or two.

Step 7. Place wedges in the slots in the inside corners and tap just enough with a hammer to stop them falling out. If the canvas becomes at all baggy at any time, tap the wedges in a little further to restore tension.

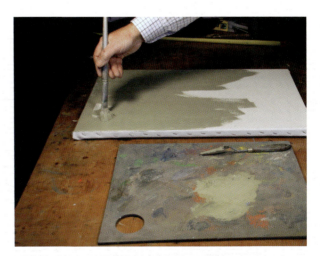

Step 8. Prepare enough oil paint, slightly thinned with turpentine, to give your white canvas a toned ground. This should be left to dry completely before use.

Boards for oil paint

There are plenty of commercially available boards made in lots of sizes. Some can be quite good but others less so. I have known these to bubble and delaminate under their top surface when used in a hot climate, and there's a general fault that many tend to be a bit too slick. I make up my own boards in two different ways.

Acrylic gesso on MDF

The simplest boards are simply thin sheets of medium density fibreboard (MDF) cut to size and painted with about three coats of acrylic gesso. I use these boards for my smallest size and enjoy the fact that there's no grainy surface to add any visual distraction to these tiny paintings, just the brushy texture of the ground that integrates well with the brushstrokes of the painting. Some DIY chains and specialist framing materials suppliers offer a cutting surface for MDF; if you cut it yourself you must take care as the dust can be hazardous. A dust mask and dust extraction should always be used.

Muslin for more tooth

For slightly larger boards, from about 8 × 10 in, thicker MDF (4–6 mm) is cut to size and covered with muslin, glued on with a warm solution of rabbit-skin glue. Once dry, I give two or three coats of Winsor and Newton oil-based primer, allowing them to dry according to the manufacturer's recommendations between coats and after the final coat. More coats will fill up more of the muslin texture and may give an overly slippery surface. These are a little time consuming and rather messy to produce, but for me they're worth the effort and I'll make a lot during the winter when the weather and light may be too bad to work outside. I think that of all the various components of picture making, for me the tactile quality of the support is the most influential, and these boards when correctly made are superb.

■ Muslin, glued down onto board and primed with oil primer, makes an excellent painting surface.

PAPER FOR OIL PAINT

Oil sketching paper, ready for use, may be bought in loose sheets or pads. It is inexpensive and also has the advantage that it can be easily cut to size; very convenient for the travelling artist, but should be framed under glass. Other robust papers can be prepared for use with oil paint by giving them a coat of acrylic primer, and heavy watercolour papers prepared in this way make a good surface for oil paint.

Different surfaces compared

Surface	Plus points	Minus points
Stretched canvas	Nothing quite matches the tactile quality of the spring of a properly stretched canvas.	When purchased from an art supplier, these are generally available in a limited range of shapes. Stretcher bars are only available in 2-inch steps. Needs some effort to produce your own.
Primed board	Inexpensive and quick to prepare. Any shape or size. In smaller sizes, light and portable.	Surface can be a bit too 'slick' and so lacks the tactile quality of other options.
Primed board with muslin	The muslin gives the surface a bit more 'grip' allowing an easier build-up of brush strokes.	More effort to prepare than simple primed boards.
Oil sketching paper	Available as large sheets or in pads, this shouldn't be underestimated. Inexpensive and though the various brands vary their working qualities are generally good.	Generally needs to be framed under glass for support and protection..
Other paper	Watercolour paper or drawing paper can be used if first prepared with a coat or two of acrylic primer. Rough grades of watercolour paper, suitably prepared, give a more strongly textured surface if this is preferred.	A little forward planning is required. Needs framing under glass as above.

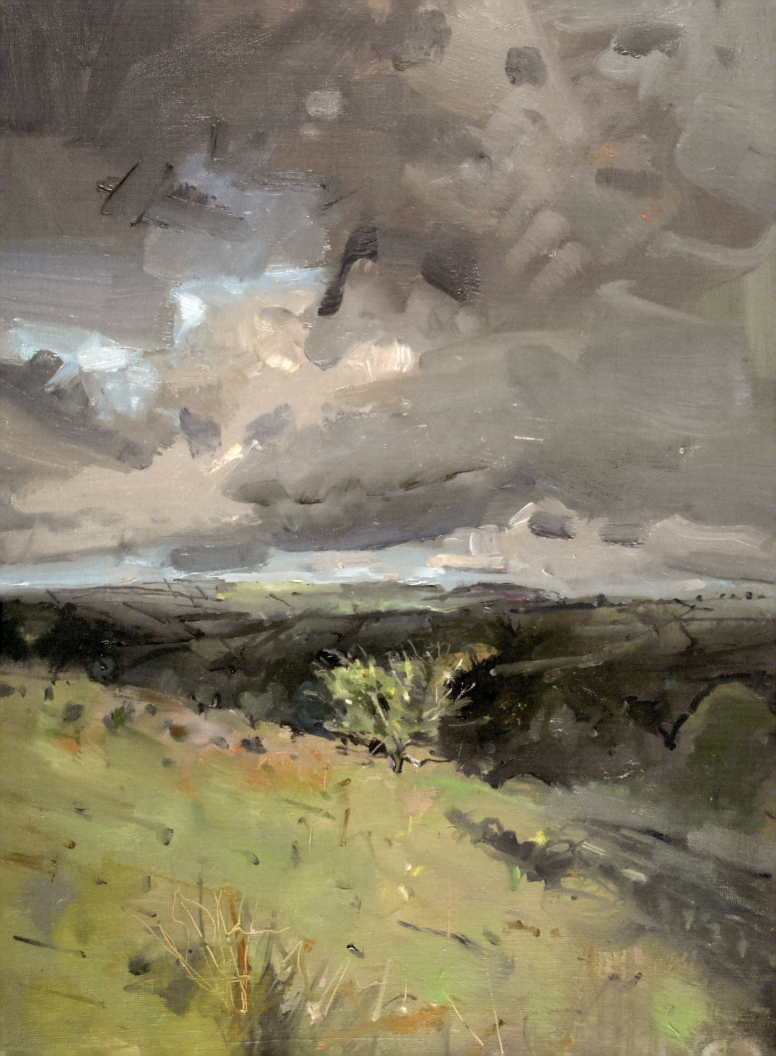

Putting it All Together

Painting makes us selective. We have no choice, we can't be in the business of creating a duplicate world. The most convincing piece of photo-realism is still an abstraction of sorts, and how to present a three-dimensional world on a flat surface has been a preoccupation of artists for hundreds of years. As landscape painters faced with a very real and complex world we have to decide how to represent what we see and also what we feel, and this is where selection starts. As a young painter I didn't really believe in composition. I thought that I could take any slice of nature and by examining it intensely enough I could make a painting. I now know that the basic framework which an understanding of compositional devices gives, underlies pretty much all good painting. One of the real joys of painting from nature is the conspiratorial relationship between viewer and artist, where both know that the canvas is a flat surface but choose to suspend their disbelief and also understand the painting as a depiction of part of the real world. The simultaneous reading of the picture surface as at once solid, flat and material and at the same time no more than an open window is a particular thrill of landscape painting.

If we accept that selection has to play a part in how we paint, then how are we to begin to make these choices? Well, to some extent, these decisions are informed by our choice of medium. If I pick up a pen, it's likely that the drawing I produce with it will be linear rather than tonal, for example. But our selection will also be driven by the aspects of the subject that we find striking.

■ *Exmoor – Above Barle Valley*. Oil on board, 20 × 16 in (51 × 41 cm), Richard Pikesley.

COMPOSITION THROUGH SELECTIVE OBSERVATION

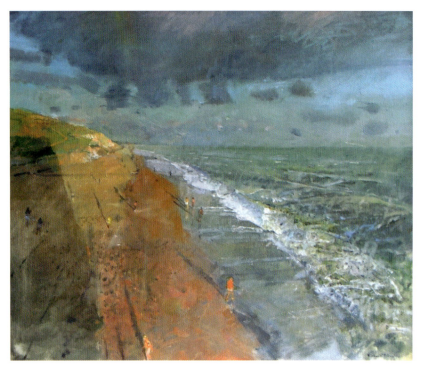

◼ If I were to make a linear diagram of this composition it would emphasize the edges which run away from my viewpoint in linear perspective. But the thing that struck me about this subject when I first encountered it was the division into dark and light masses brought about by the cliff's shadow just before sunset.

Learning composition through looking at two-dimensional diagrams only ever tells part of the story. When a tracing or a simplified line drawing is made from a painting it's often tracing lines which are either not visible in the painting or which map out boundary lines between closely related masses of tone. When, for example, thinking about creating a feeling of stability in an image, an underlying structure of a broad-based triangle may seem to do this, but following this formula too rigidly will inevitably lead to rather dull compositions. It's perhaps more useful to learn to control instability in a design and channel the energy implicit in your drawing. As a painter, you have the ability to lead the viewer's eye around your landscape, and good composition is about doing this with both energy and repose. Paintings are generally created with very few drawn outlines which would correspond to any sort of compositional diagram, so let's think about

what the eye will actually read as design elements. There will be diagrams in the description that follows, but please take these as just one part of a bigger story, which I will try to illustrate with real paintings.

BOUNDARIES BETWEEN CONTRASTING TONAL MASSES

Far more telling than mere edges between things, boundaries between light and dark have real energy in a painting and may be the most important compositional drivers. When looking at an unfamiliar painting for the first time, the starting point for my eye's journey around the compositional space is often the point at which light meets dark, the strongest tonal contrast within the painting.

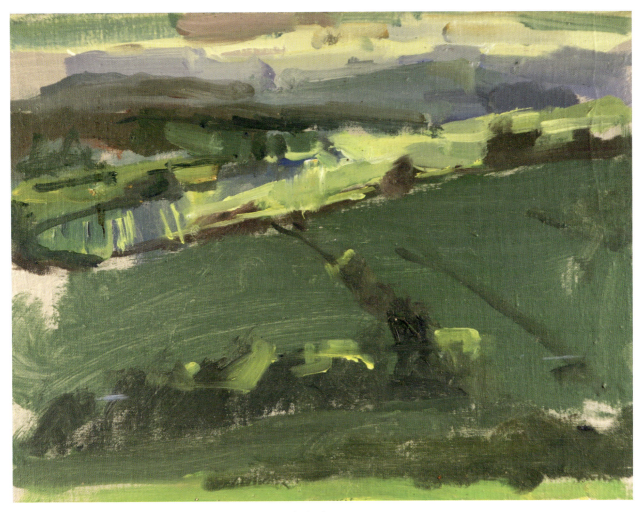

■ *Last Sun, Eggardon*. Oil on board, 9 × 12 in (22 × 30 cm), Richard Pikesley.

The drawing and painting shown here were made in a Mediterranean sea port. The thing that attracted me was the strong arrangement of light and dark shapes that would spill a geometry across the picture plane. The starting point was the quickest note of this tonal pattern, which helped me to work out how the subject would best sit within the boundary of the picture's edge, followed by a small oil study to grab the light before the strongest effect passed, then a more detailed measured drawing, in itself half a day's careful work. The pattern of interlocking near rectangles which make up the image are one strand of why I think this subject 'works'. The other is the counterpoint between this strong, but flat, pattern and the depth provided by the linear drawing. There's an inherent instability in the toppling stack of light and dark blocks, which make a strong flat pattern, but this is countered by the sense of a flat receding foreground plane and lots of grid-like horizontals and verticals. In a musical analogy, there's a sort of counterpoint between the tonal pattern of such a subject and the contour lines that run around the objects from which it's made.

PLACEMENT WITHIN THE PICTURE PLANE

The way that you place the composition within the constraints of the picture plane will have a strong influence on the success or otherwise of your painting. On the whole, it's best to keep things simple and avoid trying to have too many visual incidents fighting for the viewer's attention. This starts with where you choose to imagine

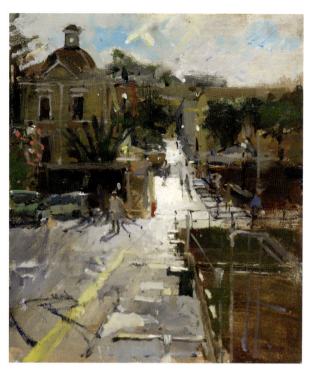

■ *Santi Silverio e Domitilla, Morning Light*. Oil on board, 10 × 9 in (26 × 22 cm), Richard Pikesley. A quickly painted oil study to grab this view while the light was exactly where I wanted it.

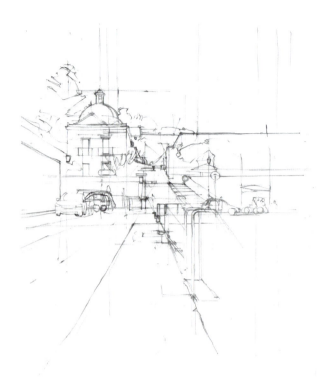

■ A drawing in the same location mapping out all the edges by measuring and perspective. The drawing isn't dependent on the momentary light effect and I could take my time.

your frame. Our view of the world has no hard edges and yet as painters we impose limits to what we choose to include. I've mentioned elsewhere the usefulness of viewfinders and one with one adjustable edge can be a great way of settling how a painting might be extracted from the landscape around you. I illustrate this point with a wide-angle landscape photograph chosen because it offers a number of different compositional options based on framing the view in a variety of ways. We'll see that it's often as much about what you choose not to include rather than trying to get everything in.

Selection is key; in the first sequence of a moorland landscape the first image has many incidents which are themselves visually interesting. There are changing textures as your eye travels up toward the horizon, and a band of shadow through the middle distance. The black cows on the left draw your attention, as do the prominent dark trees close to the rocky tor. I feel there's too much going on here to make a successful painting, as inevitably the various elements will be fighting for attention.

In the next photograph, I've cropped it to a letterbox shape eliminating both the foreground and all of the sky. Two dominant elements remain: the cows at lower left and the dark tree close to the right-hand edge. This creates an effect where your eye is inclined to hop between the two edges; with both accents about equally weighted, this arrangement – though better than the first – is still not ideal.

The third photograph shows a squarer crop, reinstating foreground and sky. This strikes me as much better and I'm immediately struck by the repetition of similar shapes in the foreground tussocks of gorse making a sort of rhyme with the dark tree and the patch of woodland just visible in the more distant farmland.

The final image in this sequence returns to the 'letterbox' shape but on a rather wider angle of view. Most of the elements from the first image are here again but because the dark tree has moved back towards the centre of the frame, it's not fighting with the cows for your attention. There is also a pattern of slight diagonal lines within the design which seems to me quite different in character from the more grid-like pattern of the squarer image in the previous crop.

DON'T FORGET THE PEOPLE

Walk around some exhibitions of landscape painting and you could be forgiven for thinking that the artist was working in a world where all the people had disappeared. The chances are that wherever you are painting, unless it's somewhere very remote, people, cows, dogs, cars and many other movable items are going to cross your field of view. I think these get left out for two different reasons: one is that there's a nervousness about tackling

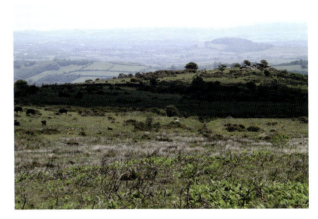

■ A wide-angle view with no particular focus.

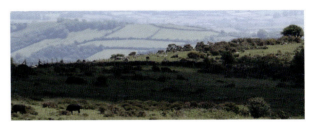

■ Focal points close to right and left edges may be rather unsettling for the eye.

■ A stronger sense of space with more foreground.

■ Letterbox format narrowing down the view.

Placing the horizon

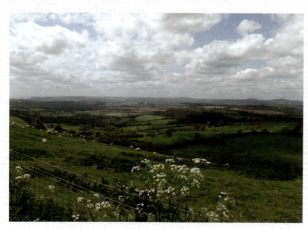

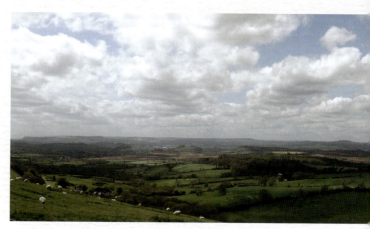

■ This sequence is all about the horizon and where it might be placed. This first photograph, showing the full, wide-angle, frame has a horizon line above the centre. The feeling of the image is one of a large space and a distant view, but perhaps too broad a prospect to make a painting as it lacks a specific focus.

■ Cropping out the foreground changes the balance within the composition but the wide view is making everything feel rather middle distance and remote. I have a feeling that moving the horizon to create a less equal balance between land and sky would give the composition more focus.

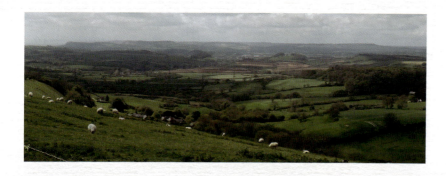

■ The next image telescopes in a little and places the horizon high in the frame. There's a sort of symmetry about the horizon line here with sea cliffs on the far left and the edge of a distinctive hill on the far right, combining to provide a sort of frame. The land falls away from the viewer crossing a broad vale before rising to distant hills. The high horizon line helps to contain the landscape and helps to draw the viewer in.

■ The final image in the sequence draws us in even closer. Abandoning the horizon line altogether there's more of a focus on the vertiginous falling away of the foreground and the sheep and the cloud shadows give a sense of an unseen but moving sky. Instead of a three-way division of foreground, middle distance and sky, we now have just two big interlocking slabs.

■ It's all about the people. Rather than drawing this street scene in Italy and then putting in all the figures, their shapes as they move in and out of shadow became the starting point for this little watercolour study.

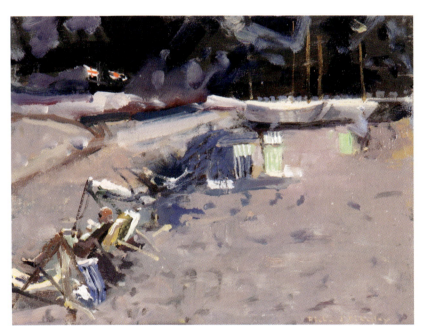

■ *Deckchairs, Beer Beach*. Oil on board, 10 × 12 in (25 × 30 cm), Richard Pikesley. The simplest of compositions, a dark slab and a light one, enlivened by the diagonal line of deckchairs and a lone figure looking out of the frame.

the challenge of including them and getting the drawing and scale right; the other is that their appearance can be rather fleeting and there's not enough time. While I have sympathy for both of these perceptions, I'm going to suggest that it's well worth tackling these difficulties head on. The inclusion of figures in your landscape can bring the subject alive, as well as giving us lots of clues about space and perspective within the painting.

However, they shouldn't be an afterthought, as this will look obviously contrived. Rather, get into the habit of dealing with the people you are painting just like any

other part of the composition. Often, if I'm painting somewhere crowded, I'll paint in figures right from the start. These might get painted out as things develop, and I may get the top half of one person combining with someone else's legs, as people flit through my view, but this won't worry me. In a little painting, which is all about immediacy of response, areas that are incomplete aren't a problem and the painting will gain enormously the sense of being there.

Just as we don't usually see anything whole and complete, with a nice neat line around it, so it is with

people. Our view is probably fragmented or interrupted in some way. To get to grips with this way of working, try making notes in a sketchbook, concentrating on relating figures to their surroundings. Very often, people will be seen in groups with lots of overlapping bringing several figures together in a single connected shape. It's a good exercise to make drawings of these little clusters as they connect and then break up. You'll have to work very fast, but it will sharpen your eye.

STRONGLY ACCENTED COLOUR

In a painting where the colour palette is fairly quiet, tiny notes of more punchy colour will draw the viewer's eye. In the little *Before Dawn, Adriatic*, the basic tonality runs from grey to yellow/grey, but it's the two little orange dashes showing where the rising sun is breaking through the cloud that catch your eye. The little 'letter-box' painting of Weymouth harbour is another example. Late on a summer day, the warmth of the evening light lit up buildings across the water whilst the foreground and to the right fell into shadow. A composition which would have been completely unbalanced in a flat, even light suddenly becomes possible. Working across the colour wheel and thinking about complementary colour, a painting predominantly in greens and grey-greens can be ignited with tiny touches of reds and pinks.

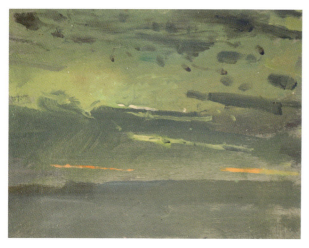

■ *Before Dawn, Adriatic*. Oil on board, 6 × 8 in (15 × 20 cm), Richard Pikesley. It's all relative. In this very quietly painted study, the brighter notes of colour in the sky pull your eye.

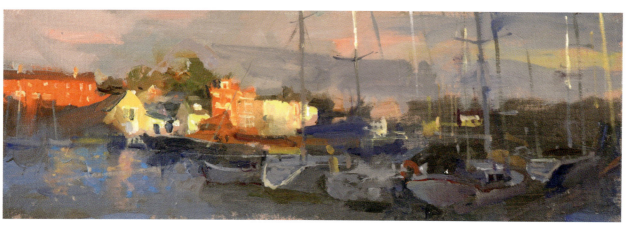

■ *Life Boat and Visiting Yachts, Weymouth*. Oil on board, 6 × 18 in (15 × 46 cm), Richard Pikesley.

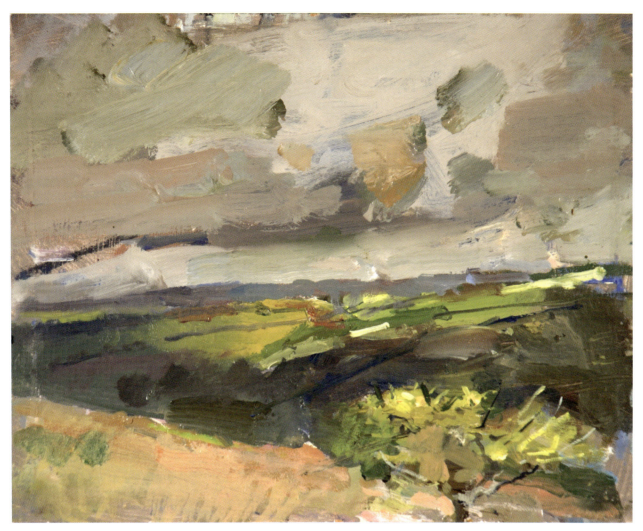

■ *Above Old Ashways, Exmoor.* Oil on board, 8 × 10 in (20 × 25 cm), Richard Pikesley. In this little oil study every touch of the brush is visible and these marks drive my eye around the composition.

EDGES AND MARKS LEFT BY THE BRUSH

Brushstrokes and paint handling will draw attention to themselves; when carefully placed, a painterly accent helps to control the path taken by the viewer's eye. Equally, these can be a distraction if allowed to become too busy in an area which would be better left rather quiet. Many painters think hard about having a beautiful sensitive touch and the appearance of delicious brushwork can be mesmerizing, but the ability to paint simple large areas of colour in a quiet and untroubled way shouldn't be underestimated. Good painting is often about putting the stuff down simply and directly. Beware of a way of painting where the initial drawing is simply filled in with patches of colour. The drawing, very probably with a few mistakes, is relied on too much and inhibits the painting from developing. Often, the tell-tale mark of good draughtsmanship in paint is the way that edges and boundaries emerge from patches of buttery paint that push against each other as the artist makes little ongoing adjustments.

DRIVING THE VIEWER'S EYE

A viewer coming across your work in a gallery will see it without your knowledge of how the painting was conceived and developed; they will see it as a whole in a way which can be difficult for the artist who knows all the twists and turns of its creation. So as a painter, you need to think about what will hold the viewer's attention, and allow their eye to make a journey around the painting. It's very easy to slip into a state where you see your own painting as a collection of technical challenges and lose sight of the 'bigger picture'. Learning to see your own work whole is an important step. I've said elsewhere in this book that this 'whole view' is often easiest right at the start of the painting process and may not return until the very end. Painters use a variety of tricks to help them see their own work afresh; covering it so it's not seen for a week or two can help, or placing it so that its reflection is seen in a mirror. In the first moments of seeing it again, any difficulties can be quickly spotted and often resolved quite simply.

TONAL CONTRAST

When you are in a gallery and look at an unfamiliar painting for the first time, ask yourself where your eye settles to begin its journey around the composition. The chances are that it will settle first on a point where there is a significant step between light and dark.

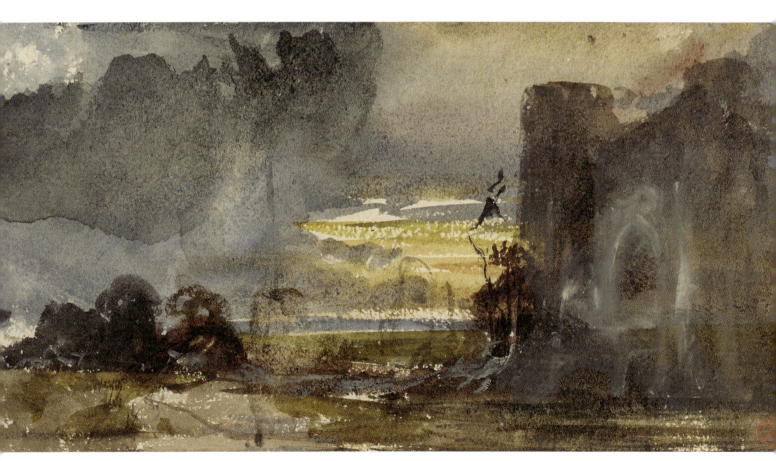

■ Paul Huet (France 1803–1869), *Romantic Landscape with Castle*. Watercolour, 5 × 10 in (13 × 26 cm) Los Angeles County Museum of Art (www.lacma.org). My eye goes straight to the point where the lightest and darkest tones meet, giving a strong contrast.

DIRECTIONAL CUES

In Chapter 10 you'll find a description of a day spent painting on the Somerset Levels, a landscape of flat marshy land and big sky. Drawing a subject with a grid-like structure of low horizon and vertical trees I was aware that although this could be a landscape of calm grandeur, what made it come alive for me was the strongly diagonal thrust of a beautifully structured sky, and the rhyme that this made with the slightest suggestion of perspective marked out in the flat grass of the foreground. Within these two areas, although one is light and the other much darker, there are directional cues which at one moment make flat triangles on the picture plane but also dive deep back into the far distance.

MOVEMENT ACROSS THE PICTURE PLANE

Rhythmic repetition can be a very powerful compositional device. In my painting of jackdaws flying above a snowy landscape the receding hedgerows create a horizontal web across which the foreground trees with their clusters of jackdaw nests provide yet another rhythm. Grid-like patterns such as this are commonly found in landscape subjects, at their simplest in the verticals of tree trunks and the flatness of the horizon but multiplied many times in a landscape of farmland broken up by hedgerows, for example.

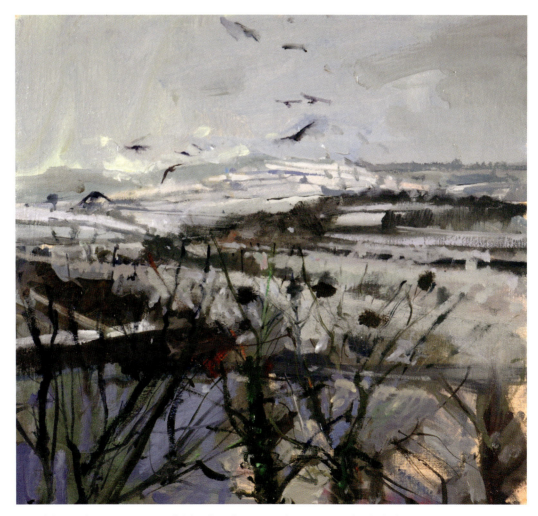

■ *Jackdaws in the Snow, Bennett's Hill*. Oil on board, 15 × 16 in (38 × 40 cm), Richard Pikesley.

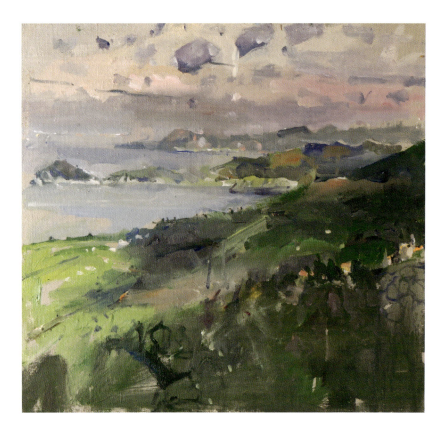

■ *Long View East, Marciana*. Oil on board, 11 × 12 in (28 × 30 cm), Richard Pikesley. Reduced to a linear diagram, this composition would read very differently. The edges of the two diagonal ridges and the islands and promontories beyond would be recorded but the pattern of shadows and the visual rhyme between the islands and clouds, which were my starting point, would be missed.

DIRECTIONS IN THREE DIMENSIONS

Whereas the previous painting relies on a rhythm across the picture plane, *Long View East, Marciana* uses lines that run more obliquely away from my viewpoint. Making this painting, on the Italian island of Elba, I was struck by the way the pattern of cloud shadows on the successive ridges of the landscape emphasized movement back into the picture plane through a series of diagonals. The pattern continues to the horizon through the shapes of the islands and promontories in the distance.

SUBJECT MATTER

We clearly don't all bring the same preconceptions when looking at a painting. For someone who is fond of cats, when they look at a painting with a cat in it, even if quietly painted and somewhere compositionally insignificant, their eye will go to the cat first. A painting of flowers which places the blooms front and centre and in the strongest light may be far less effective than one which creates a tension between a focus created by the way the light falls and the flowers placed away from the limelight. Within a landscape subject there may be one aspect that gets your creative juices flowing and it is tempting to get a bit shouty when trying to communicate this through your painting of the subject. On the whole though, your audience will be more perceptive than you expect and you can probably turn the volume down quite a bit and still get your point across.

So, I hope it's now evident that there's a lot more to composition than flat pattern. All of the factors described above, and probably lots of others I haven't thought of, play their part. The chances are that in any painting several of these will be present, exerting their own push and pull on the observer's eye. However, these aren't things to worry about or get bogged down with; just give yourself time to develop a sensitivity to all of these 'motors' and have fun driving them. If you paint and draw enough your intuition will steer you through most decisions. And breaking the rules and making it work is always quite liberating.

MORE ON TONAL PITCH

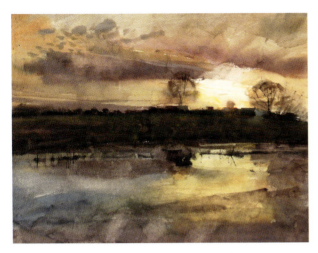

Stour, After the Swans, Winter Afternoon. Watercolour, 12.5 × 17 in (31 × 44 cm), Richard Pikesley. Painted as light levels dropped at the end of the day, my main interest is in the structured sky and its reflection in the river. To capture as many tonal steps as possible in these areas, the bottom end of the tonal range is compressed and simplified.

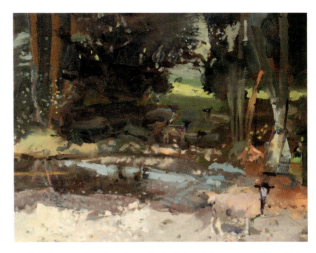

Side Stream, River Axe above Forde Abbey. Oil on canvas, 16 × 20 in (41 × 51 cm), Richard Pikesley. To get the feeling of bright sun and deep shadow, I've squeezed the tones in the dark area, just allowing myself enough variety for the sheep under the trees to be visible.

Back in Chapter 2 we took to the hills and worked in tone. I now want to look further at how in practical painting terms, tonal judgement affects the way we build paintings and respond to the world of light and dark around us. An appreciation of tone is fundamental to being a good painter, and understanding how it works will give you a firm platform on which so much else will be built.

To recap, tone is the degree of light or darkness. It is closely linked to how we build colour but can best be considered now in its simplest form.

Imagine a black and white world. Once we turn the colour off we are left with tone, but it's important to understand that what's important and recordable is a set of tonal relationships. At its simplest it might just be three steps: black, mid-grey, white. If I now squeeze these three big steps down to three little ones it might be reduced to three pale tones with small gaps, or three dark ones. As a painter you have the choice of pitch at which the tonal level may be set.

Dealing with the extremities of light is one of the biggest challenges for any landscape painter but also an opportunity for creative individuality. Imagine for a moment that you can see a hundred little tonal steps from

brightest light to deepest shadow in a landscape view. Now there are probably many more, but as painters we have to compress that extreme range down into about ten or so steps.

The way around this is to bunch tones in one part of the black to white range, to open up a bit of room where you really need it. A landscape in which the painter might have a clear choice about tonal pitch would be a darkish landscape under a strongly structured sky. Although when we look upwards towards the clouds there appears to be quite a big range of tone, the difference between the lightest and darkest points within the sky may be rather slight. Taken as a whole, the sky may be lighter than any other part of the subject. To paint the sky with its full range of tone to fully describe its structure and yet keep within the top end of the tonal range will inevitably reduce the selection of tones available for the land part of the subjects down to a rather limited range. A camera faced with this situation will do something similar and adjusting the exposure will produce at one extreme a completely white sky and a lot of tonal detail in the land or conversely a sky with all its structure visible over a landscape which is reduced to close to black.

Tonal compression

Using three photographs taken with different exposures gives a fair indication of how we might choose to see things when painting this subject on the spot.

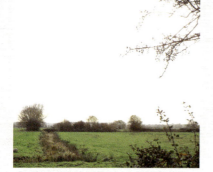

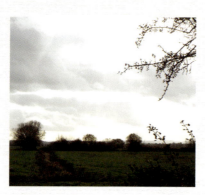

■ Three photographs of the same landscape using different exposures show tonal compression at work. In this first image all the tones in the sky have been reduced to white and I have a full range of tone in the land.

■ This image keeps most of the tonal steps in the land element and gives me some structure in the sky.

■ When I opt for more tonal steps in the sky, the land element is squeezed to a single dark slab.

Our eyes read this scene differently as they adjust to the brightness of every point on a sort of tour around the subject. As painters, this can give us lots of information simultaneously about different parts of the scene, but this information overload can be treacherous. Letting your eye linger at one point will give it time to accommodate and it's easy to be fooled into losing the sense of tonal punchiness which was so attractive about the subject in the first place! I've learnt to relax my gaze and to try to let my eyes go into 'wide-angle' mode when I'm trying to work out the tonal sequence throughout a subject. I can quickly decide the sequence of the broad areas of tone from lightest to darkest and this can either be kept as a sort of mental diagram, be drawn simply as a tonal sketch in a notebook, or used to block the subject in on the painting itself with a few big tonal areas. This can then be worked into to develop the smaller steps, knowing that I've got the broad context right.

There are a couple of aids to help you work out the tonal sequence. One is to almost shut your eyes and look at the world through the smallest gap you can leave between your eyelashes. This will cut out most of your colour vision as the light level in your eye drops. The cones in your eye that see colour stop working in low light, which is why our night vision is more mono-chromatic. With just the rods left we see in tone. Using a simple 'Claude glass' will also help; its black surface makes a very inefficient mirror, which slightly exaggerates tonal steps and supresses colour. There's more on this in Chapter 8.

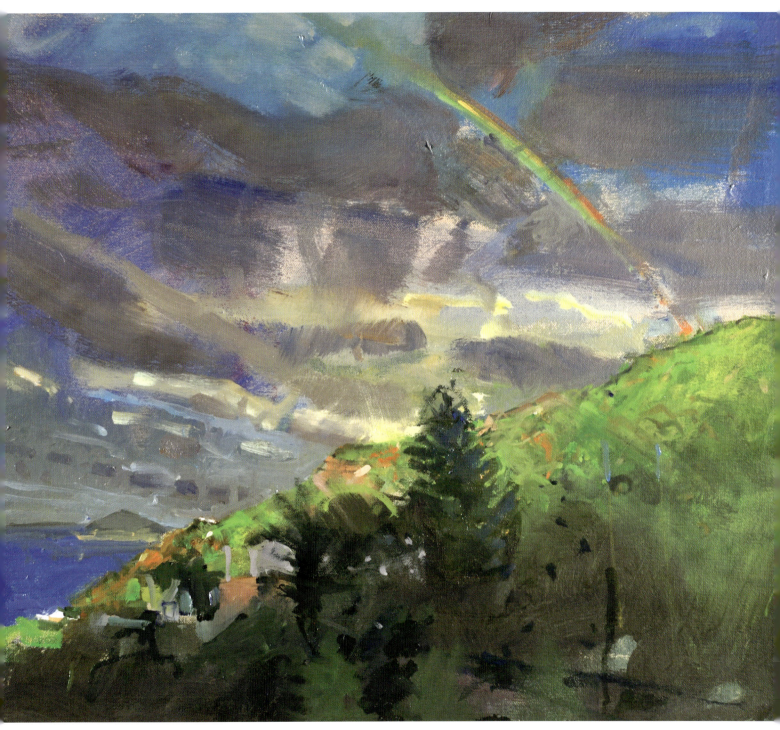

■ *Sea, Sky and Rainbow, Elba*. Oil on canvas, 16 × 18 in (41 × 46 cm), Richard Pikesley.

En Plein Air

As much as possible I work outside in front of my chosen subject. If this step takes a little bit of nerve it is well worth it, for although painting directly from the landscape brings with it a few constraints, it offers a whole world of possibilities. As well as producing finished works, the mass of accumulated studies, no matter how slight, will be an invaluable resource on those days when I'm forced to stay indoors. Working around a particular location and returning frequently allows me to get to know my subject and 'tune in' to its visual possibilities.

Generally, it's the anticipated intrusion of passers-by that worries those tackling this challenge for the first time. On the whole, however, people will leave you alone to concentrate and perhaps only engage you in conversation as you pack away at the end of a session. A little thought about where to set up helps, too. I've found when working in a very crowded Venice that moving just a few feet from the flow of humanity means that I'm left completely alone.

Painting out of doors in front of the subject is a comparatively recent invention, with its roots in English and French painting of the mid-nineteenth century. As paints became more portable, with colour in tubes or pans, it became a practical option to paint outside rather than working in the studio from drawings made on location. Just being there offers so much more, from the conversations to sounds and smells; these all stick in the memory and will feed you later when you're working in the studio.

Perhaps the most valuable gift that painting in the open air offers is a big limitation on time. Often the lack of thinking time when faced with transient lighting effects or movement makes the artist simplify and be decisive. The energy this provides can seem quite impossible to achieve in the studio when a whole day of indecision and dithering can sap the energy from a painting.

■ *Setting up the Street Stall, Lafayette and Canal Street, New York*. Oil, 16 × 12 in (41 × 30 cm), Peter Brown.

PRACTICAL CONSIDERATIONS

Many of these considerations seem to be about selecting and carrying the kit. What I carry will depend on my chosen medium and can range from a tiny drawing book and pencil in a pocket right up to oil paints and quite large canvases. So before I say too much about the kit, let's think about how a typical day might go. First thoughts are about whether I'll be working all day on one piece or moving with the changing light and producing a number of pieces. The only time I'm likely to spend a whole day on one piece is if I'm making a drawing – looking exclusively at structure and not concerning myself with effects of light. However, on most occasions when I work on location I'm probably concentrating on the way the light moves through the day. On a dull day I might get away with working for two hours on one piece but in sunlight it will be less. This means that to work through a typical day I'll need enough materials to tackle at least half a dozen paintings.

Assuming I'm heading out with the intention of painting through the day, what do I carry?

OIL PAINTS

As we've discussed already, my kit of oil paints is always much the same so that I'm using colours, brushes and surfaces that I know well. I have three different set-ups depending on how big I'm working and how static or mobile I'm likely to be through the day.

BOX EASEL

Sometimes called a French easel, this is the heaviest option and therefore a good choice if I'm likely to be fairly static. Plenty of room for tubes of oil paint and other necessities, and the palette is big enough to load with colour and leave enough space for mixing colour and producing puddles of related tones. Its weight gives it stability and it's less likely than a lighter alternative to be blown over. Stability of this or the smaller half-box easel may be improved with a little ingenuity as we'll see

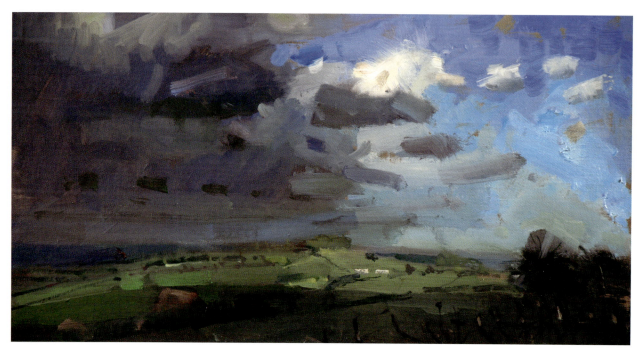

■ *Towards Halstock, Dodging Showers*. Oil on board, 8 × 15 in (20 × 38 cm), Richard Pikesley.

■ Box easel on the right, half-box on the left. I tend to use the half-box most. It's a bit lighter and will support quite a big canvas, if needed.

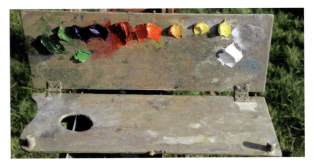

■ This older easel has a folding palette which uses cranked hinges. This means the easel can be packed away to move quickly without having to clean and reset the palette – a huge time saver.

■ The palette in the previous illustration folded up and secured with the oil paint quite safe.

later. Use an easel when you need a standing position in order to have an unobstructed view. If you wish, you can work sitting down by adjusting the legs.

HALF-BOX EASEL

Somewhat less accommodating than its big brother, there's still room inside for all my paints and brushes. Much lighter, I can easily carry mine on my back using its rucksack like straps. My example is quite old and the quality of all the fittings is very good. Especially useful are the cranked hinges on the palette, enabling a loaded palette to be folded up without disturbing the paint. Some of the current models have a palette which folds flat, much less useful when you're on the move as it has to be scraped clean before you can pack up. Either type of box easel will accommodate a canvas up to 32 inches (81 cm) tall.

POCHADE BOX

Wonderfully portable this is the simplest and lightest option if you don't mind working on your lap sitting down. Essentially a simple lidded box with compartments for paints and brushes, a palette and support for your painting inside the lid. A sliding device inside my box allows boards of different widths to be slotted in and a folding end allows for boards to be overheight. Whilst it's not suitable for canvases it's a very versatile set-up. For me its only disadvantages are that you can't easily step back to look at your work, and sitting down may not always give you the view you want. A good choice if you want to work unobtrusively in a busy place without the spread of an easel's legs to trip up passers-by.

There are now various hybrid options by several manufacturers that can give the combined advantages of easel and pochade. These generally offer a lightweight box which attaches to a photographic type tripod. Their versatility makes them appealing, but for me they lack the ruggedness and carrying capacity of the previous options.

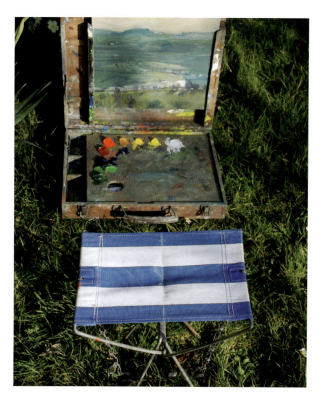

■ My pochade box, another lucky street market find. Its folding flap on the lid allows over-height boards to be used while the sliding strut on the left will adjust to accommodate different widths.

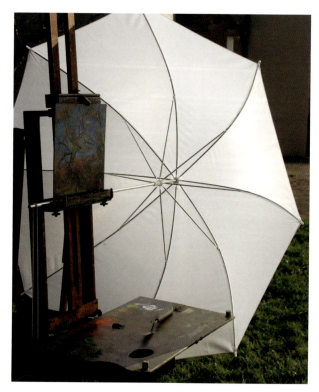

■ A parasol simply tied onto the side of the easel shields both the painting and the palette from direct sun and makes it much easier to establish the tonal range of the painting.

UMBRELLA, PARASOL

Some sort of protection from the rain can be very welcome. Raindrops will quickly disfigure a watercolour and on oil paint will make the surface of your palette and painting unworkable. Working out of the back of a car or van is one possibility but often you'll be painting some way from where you've parked. Plastic sheets to cover your work quickly can be easily stuffed into a pocket or bag and I've often worked under a large fishing umbrella which has a cranked shaft so that it can be turned to keep you out of the wind and rain. Working in bright sunlight too brings its own difficulties and it can sometimes be hard to know whether it's best to have the sun full on your painting or turn it into the shade. Working in very bright sunlight can make you think that your painting is lighter than it really is and work done in these conditions can look very dark when taken indoors. Many easels can be made to accept a white parasol which can be positioned to allow you to work in a softer, more filtered light, allowing more accurate tonal judgement.

FOLDING STOOL

This is pretty much essential if you're working with a pochade box, but optional with an easel. Mine is a type sold as a fishing stool; its metal frame folds completely flat and weighs very little. Avoid folding chairs with arms, as they get in the way.

PIECE OF STRING

Lightweight easels can blow over in windy weather and keeping them stable enough to work on may be a nuisance. Hanging something heavy under the box with a bit of string keeps everything steady. If I can't find a handy rock or brick I use my painting bag.

A piece of string and a found rock hung below the easel makes it stable and steady in quite a high wind.

SHOULDER BAG

Mine carries my lunch and a flask, bottles of solvent or medium which won't fit in the pochade box or box easel, a roll of kitchen towel, boards to paint on and a plastic bag for dirty towels, etc.

I've emphasized the weight and portability as this needs to be a very mobile way of working – in a full day I might well move five or six times as new possibilities catch my attention, so I want it as simple as possible to 'up sticks' and move.

OTHER NECESSITIES

My painting bag always includes a few other things that I prefer not to be without. I'll usually have a couple of viewfinders in different proportions, and a plumb line is very handy to check for how things line up vertically. I also have a sort of simple Claude glass. These were used

Acrylic sheet, painted with black paint protected with drafting tape makes a useful tool for helping with tonal judgements in bright light.

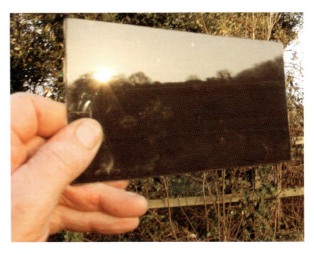

This inefficient mirror simplifies what I see reflected in very bright light.

by landscape painters during the Romantic period and were originally a darkened curved mirror, slightly convex to compress the reflected view and used to consider the chosen vista. My version is just a bit of Perspex (Plexiglass) painted with black acrylic on its back surface and protected with a layer of drafting tape. Two things about this little tool are useful: a reversed reflected view is a good way of seeing a subject afresh as your eye tires; and its darkened surface makes it possible to read the sequence of tones in a bright sky.

WHAT TO WORK ON

I use little boards in a variety of different sizes and proportions. They provide a firm surface that accepts paint well and in small sizes are more practical than stretched canvas. Using a method that I'll describe shortly they can be carried home wet at the end of the day without mishap. Painting boards are commercially available but I prefer the flexibility and consistency of the ones I make for myself. I use two basic types: for the smallest boards I have MDF cut to a variety of standard shapes from near square to a 'letterbox' proportion. These are given three coats of good quality acrylic gesso primer. They can be left slightly textured from the brush to give the surface some grip. Slightly bigger boards seem to benefit from a bit more texture and a surface that will hold a brush stroke without too much sliding. I describe how I make muslin textured boards in Chapter 6. Whichever type of board I use, once the primer is properly dry they are given an imprimatura layer, simply a thinnish wash of oil paint diluted with turpentine and containing a bit of Titanium White to give opacity. I use a variety of colours but mostly from a warmish terracotta palette. This step is vital and shouldn't be left out.

WHY AN IMPRIMATURA?

The imprimatura has several functions but the most important is lowering the tone of the surface on which you will work. When painting straight onto a white ground without this preparation, any mark will be seen as darker than the ground and this will result in pale chalky paintings as you try to adapt to an artificially high key; the process of building a sense of space also takes much longer to achieve.

Finally, it serves an important colour function, as even in the completed painting there are likely to be small gaps in the continuity of the paint layers and little flecks and dashes of this underlying colour will show through. In a landscape whose dominant colour is green, these little notes of pinks and reds, the complementary of green, will enliven the colour and help the greens to sing.

HOW TO CARRY WET PAINTINGS

At the end of a painting day I may well have quite a few little painted boards to carry home and this can be a problem. I get around this difficulty by gluing matchsticks on the back of each board close to the edge. The boards may then be stacked, the matchsticks only bruising the very edge of the painting where it will probably be covered by the frame rebate or can be easily retouched. Keep a spare, unpainted board to act as a lid for each stack and secure them with strong rubber bands. Most box easels will allow two wet canvases to be carried, though these must be the same height. These can be placed face to face, leaving a small gap so they are protected when you carry them home.

ALTERNATIVE SURFACES

I've started exploring a few other surfaces as supports for oil painting and found that these can offer a degree of flexibility that the more usual supports of canvas and board may lack. I stretch my own canvases using linen canvas from a 2.1 metre wide roll. No matter how carefully I plan my cutting there are often offcuts which are too small to attach to standard sized stretchers. Over the years I've accumulated quite a boxful of these offcuts. The advantage that these offer is that they can be attached to a drawing board using bulldog clips and I may do two or three studies on one piece, or start in the middle and see where it goes without having to worry about fitting my composition into the proportions of a board. Once dry, the painted canvas is easily cut with scissors or a craft knife and the finished painting can be glued down onto board before framing. Thinner canvas or cotton duck might buckle a little after painting as the surface tightens but the thicker primed linen I use works very well.

Oil sketching paper may be purchased ready primed and can be further enhanced with a thin colour wash allowed to dry before use. Any other paper may be used for oil painting as long as it's sufficiently robust and given

■ Matchsticks glued on to the backs of boards allow them to be stacked and carried wet without damage.

■ The small gaps prevent any damage to painted surfaces.

■ Rubber bands keep the whole stack of wet paintings safe. The top board is dry.

■ Box easels allow one or two wet canvases to be carried.

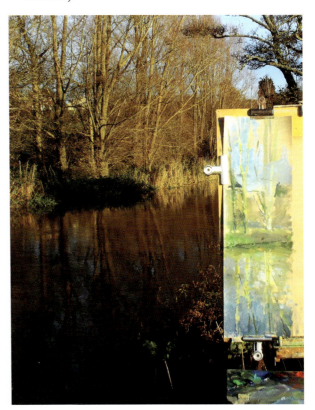

■ I'm struck by the colour of the bare tree trunks on the opposite bank as they're reflected in the water. I want to explore a tall, skinny shape and none of my panels is quite the right proportion, so a piece of the canvas, clipped onto my drawing board, gives me the shape I want. It can be further trimmed when dry and glued onto board, for framing if required.

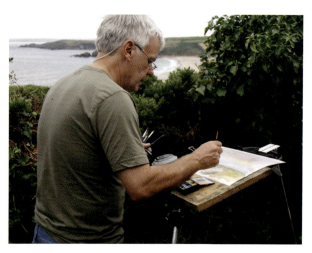

■ The legs on this aluminium easel will spread very wide for maximum stability and it will hold quite a large drawing board, without too many wobbles.

WATER-BASED PAINTS

On days when I've made the decision to focus on water-colour, the oils are left at home and I'll take a different set of kit. I prefer to use tube watercolours rather than pans as I can use them a bit more generously. I have a plastic palette with a clip-on lid which makes them very portable. A few tubes of gouache add to the flexibility without much extra weight. Once again, everything has to be easy to carry and simple to pack away so that I can move from place to place. Carrying enough water for a day's work can add quite a bit to the weight so if possible, replenish your water supply when the opportunity arises and cut down on the amount that needs to be carried.

a couple of coats of acrylic gesso. Heavier watercolour paper prepared in this way can make a very nice surface. Work on paper needs to be framed under glass.

Alongside the oil painting gear I'll also carry a small sketchbook of cartridge paper, a pencil or two and a sharpener.

LIGHTWEIGHT EASEL

Made of aluminium alloy, this easel has telescopic legs and can be adjusted to allow the painting to be nearly horizontal or nearly vertical depending on need. It doesn't weigh much but will support a large drawing board if I want to work big. It folds down flat and is small enough to carry easily when I'm ready to move. A little shelf which clips onto the legs will house my waterpots and brushes and pencils.

A drawing board with a few sheets of paper, cut to size, bulldog clips to attach it to the board, my brush roll, and watercolours in a tray or tubes along with a couple of plastic palettes complete the outfit.

En plein air – working with oil paint

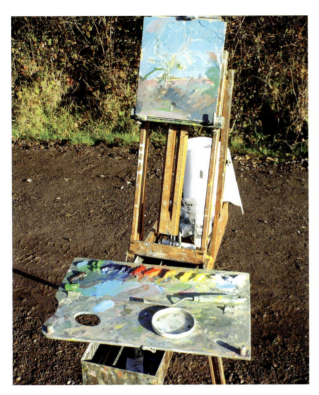

■ Everything I need. Using the half-box easel I can support a canvas, or board, at a comfortable working height.

It's a bright, cold morning, so with my bag loaded and my half-box easel I'm heading out to paint in an area of ancient woodland which lies below one of our great Wessex hillforts. I've packed enough of everything to allow me a long day's painting; a variety of shapes and sizes of board will give me plenty of options for composition. As usual, there's a little drawing book and a pencil tucked into my bag so that I can make a note as a reminder of additional subjects I may come back to. I haven't painted here for a while and will use today to explore its possibilities once again. Parking just off the road, I head down a track with trees either side. I notice that the winter sun, low in the sky, is giving strong colour to the trees on my right and remember there's a point further on where the trees open out to give me a good viewpoint in that direction. Just where the track leaves this clearing down a curving slope my attention is caught by a big old oak tree, its trunk lichen-covered and shining green in the winter light. The upper part of the

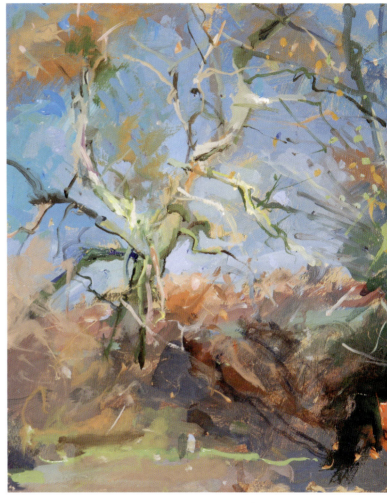

■ With the sun on my back this winter oak tree against a blue sky made a lively subject.

tree stands against the clear blue sky and I know this is where I want to start. This moment of recognition is very important to me and I'm usually very aware of having to paint a particular view.

Choosing a near-square board to start with, I set up my easel and within a couple of minutes I'm painting. I'd squeezed out paint onto my palette earlier this morning before I left the studio, as it can be frustrating taking time to do this on location when the light may be perfect for such a brief spell. The board I've picked is one of the smaller ones, simply primed with acrylic gesso and then covered in a warm brown wash of oil colour which has been allowed to dry over several days. I make a start with

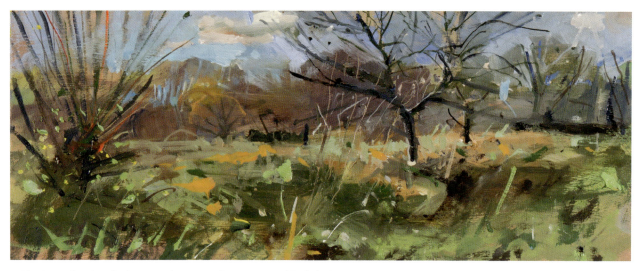

■ Turning to face into the hazy sun the screen of trees was simplified a little.

some drawing marks made with touches of the brush, to establish the scale and how the image will sit on the board. Then I go straight for the thing that excites me most and lay two brushstrokes side by side where the luminous green trunk stands against the pale sky. With the toned ground, these initial marks read straight away, and as the tone of the ground is roughly the same as my palette I have the same context as I mix colour as on the developing painting. Starting with these two brushmarks I begin to work outwards, establishing a cluster of related tones describing the heart of the tree and the sky beyond. As I work, I'm spending more time with my eye on the subject than looking at the painting, and with glances down to the palette the process becomes a sort of three-way conversation between the subject, the puddles of colour mixed side by side on the palette, and my fledgling painting. I know I won't get long on this one: the angle of the sunlight is rising in the sky and light will soon reach further into the shadows around the base of the tree, weakening the effect. I get about half an hour before the changes become too much and I put my brushes down, pour a coffee from my flask and look around. I'd picked this spot because of that particular view of one tree but as I look over my shoulder I become aware of other possibilities from the same position. My first little painting was made with the sun behind me. Looking 'down sun', the tree is lit at its strongest, throwing shadows behind it. The view the other way is the opposite: looking into

the sun the screen of saplings is dark against the bright sky and looking into the light has the effect of simplifying the tonal pattern, creating broad masses of light and dark. The view in this direction is across the clearing and as well as the clusters of saplings growing up in the open space there are just one or two rather more mature trees making good shapes and I pick a view that includes two of these within a 'letterbox' format. I have in my bag some boards that are just the right proportion, at 5 × 12 inches. With luck I'll have a little longer on this one, as looking broadly into the light it's not going to change quite so quickly.

RAPIDLY CHANGING LIGHT

Working far from home there's an added urgency in grabbing any possible subject and making as complete a record of it as possible. This urgency is intensified when the light is changing fast. While teaching in Southern Italy recently one such situation occurred in the old town of Polignano on our first evening when a few of us walked up into the crowded town square as it began to get dark. In the piazza an opera singer gave a recital in the open air. I didn't have my usual drawing book in my pocket, but the scene remained with me until later in the week when an opportunity arose for an informal demonstration as we walked into the town after dinner. I looked around

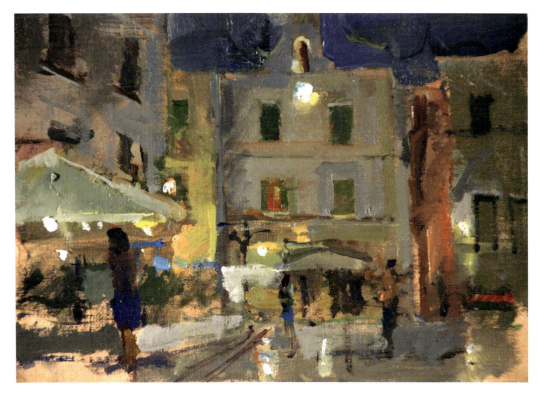

La Passeggiata, study. Oil on board, 7 × 10 in (18 × 25 cm), Richard Pikesley.

for the best view of the square and quickly set up to paint without giving too much thought to where my audience could watch from. Preoccupied with setting up as quickly as possible, I gave a running commentary as I furiously painted until, looking round as I finished, I found my audience sitting and standing in whatever space they could, on or between a group of restaurant dustbins!

The lights from the bars and houses began to tell as the daylight faded and the feeling of a warm summer evening began to emerge in the changing balance of natural and artificial light. It was going to be a process of constant revision right from the start and this urgency drives away any sort of blank canvas stage fright – I know I've just got to go for it. This is the sort of situation where I know I have to do everything at once; quickly mixing puddles of colour on the palette, marks started to go down working out enough drawing to see how the subject would fit on the little 7 × 10 inch board and placing broad blocks of colour. Finish was never going to be an issue here; what I wanted was a record of how the square looked in a particular five or ten minutes as the light changed. A white building with a little bell tower

was right in front of me and, as I started to paint, its walls were decidedly darker than the sky beyond. Within just a few minutes this tonality had reversed with the darkening sky, but the walls themselves were now far from white, as the electric lights were now giving me the lightest tones.

As usual, the board on which I was working was one with a layer of primed muslin to give me a bit of tooth and hold the image, and a wash of an umber and white mix to give me a mid-toned ground. Both of these factors helped me now, as with a brush in one hand and a rag in the other I could wipe paint off the board, leaving enough of the drawing showing in the little pits of the muslin texture and quickly restate. The mid-tone of the ground meant that my lights would tell right from the start and save a lot of labour working out the tonal structure on a white surface.

Knowing that my colour vision would be changing as daylight slipped away, I didn't want to work on for too long even though there was enough electric light to see what I was doing. Typically, electric light has a strongly yellow colour cast compared with the intense blue-white

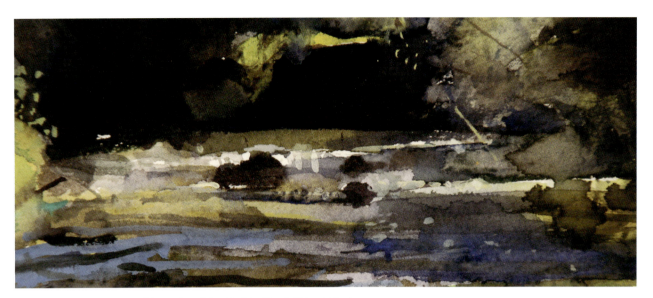

■ *Boulder Country, River Dart*. Watercolour, 2.5 × 6 in (7 × 15 cm), Richard Pikesley.

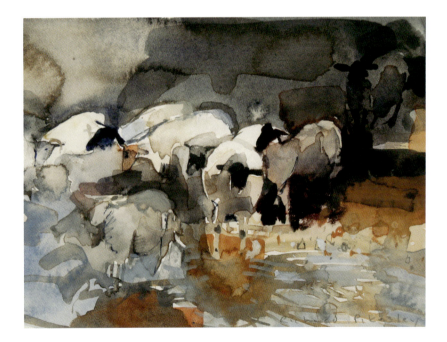

■ *Crossing the Brook, Winsham*. Watercolour, 4.5 × 6 in (11 × 15 cm), Richard Pikesley.

of day and I've been disappointed in the past when viewing the previous evening's work and a previously unnoticed colour cast had made nonsense of what had looked fine under artificial light. Working in southern Europe, or in India, the abruptness of nightfall changes the world from day into night very quickly. When at home in England, however, there is not quite the same urgency and the afterglow on a summer's evening can give me nearly an hour of usable light beyond sunset.

PLEIN AIR IN WATERCOLOUR

On most occasions when I'm working on the spot with oil paint I'll also have my little watercolour kit tucked into a pocket so that I can make some additional notes. However, sometimes I'll decide before I go out that it will be a watercolour day. The oil paints are left in the studio and I can carry my alternative kit. If I know I can work sitting on the ground or on my folding stool I won't bother with an easel. An A1 sheet of paper stretched onto

■ Working on a full sheet of watercolour paper I can explore different facets of the same view on a single sheet.

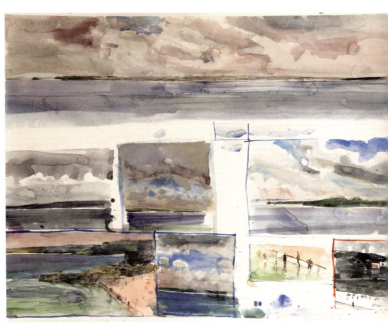

■ *One Sheet of Paper, St. Ives Head*. Watercolour, 22 × 30 in (56 × 76 cm), Richard Pikesley.

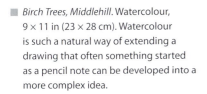

■ *Birch Trees, Middlehill*. Watercolour, 9 × 11 in (23 × 28 cm). Watercolour is such a natural way of extending a drawing that often something started as a pencil note can be developed into a more complex idea.

a big drawing board gives me plenty of room to make lots of notes, either for future reference or cut up for framing later. This set-up allows me to hop from one study to another as the paper dries enough for further touches and gives me room to make further notes of anything that catches my eye.

NEW EVERY DAY

I think the most exciting aspect of working on the spot is that even if I'm working around a familiar location, the weather and the light as well as encounters with people or animals make every day a new challenge and I never know quite what I'll come home with. This is why I paint from what I see. The subjects that appear when I'm painting on the spot have a variety and beauty that my imagination alone would never be able to conjure up, and my main role becomes one of selection from all the many visual possibilities. I often get caught out by the weather and have many rain-spattered watercolours to prove it, but with a little thought and good luck, rainy or difficult weather days can be particularly rewarding. There are often dramatic skies just after a big weather system goes through and if you don't mind dodging the showers there are rewards to be had. Peter Brown, whose New York painting begins this chapter is known for his paintings of towns and cities, often in the worst of weathers but always a visual delight. His painting of the wet New York streets was made on the spot using the scaffolding on a building to get some shelter from the pouring rain.

THE ART OF THE POSSIBLE

Don't expect to be able to make paintings on the spot where all the loose ends are tied up neatly and with a high degree of finish. For me, it is the fragmentary nature of these encounters which can be such a joy and the sense of the artist's visual faculties working at full stretch gives a unique character to the best work. Much as we might try, the painting can't quite be made in one moment and there are often tell-tale indications that the artist is working flat out to catch the visual sensation on the fly.

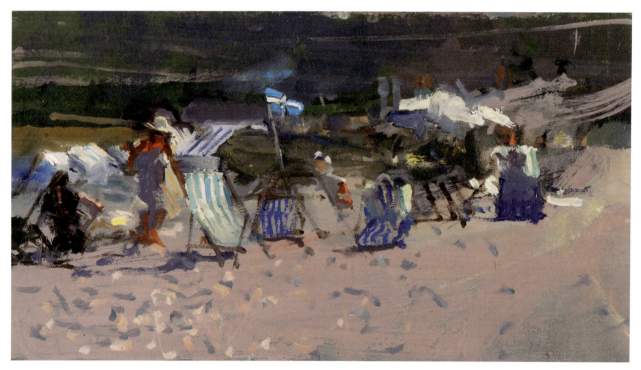

■ *Into the Light, Beer Beach*. Oil on board, 5 × 10 in (13 × 25 cm), Richard Pikesley. With the wind blowing and people on the move this is a painting of fragments, but it says what I wanted about the light.

Weather and light

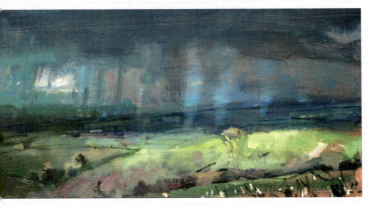

■ *Above Corscombe, Rain Coming*. Oil on board, 8 × 17 in (20 × 43 cm), Richard Pikesley. Rain in the distance roaring up the valley while I paint in bright sun. Ten minutes later I had a soaking.

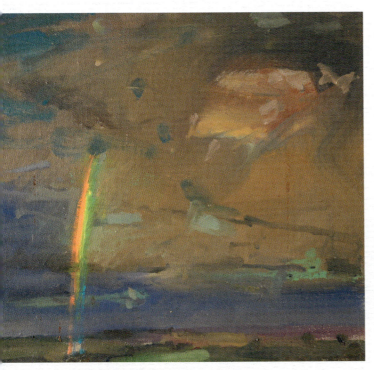

■ *Dodging the Rain, Eggardon*. Oil on board, 8 × 9 in (20 × 22 cm), Richard Pikesley. Just this little bit of rainbow appeared on a day of sun and squally showers.

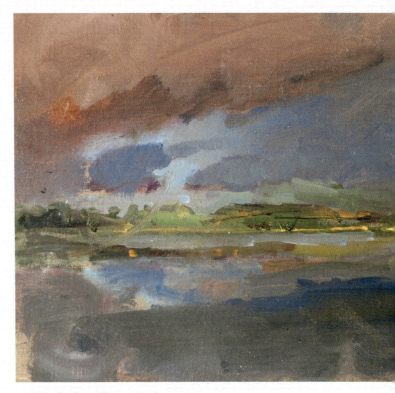

■ *Axe Evening, Upstream*. Oil on board, 8 × 9 in (20 × 22 cm). Weather doesn't have to be dramatic. With the water of the river estuary like glass in the still air, the reflection of the cloud in the river was the starting point for this study.

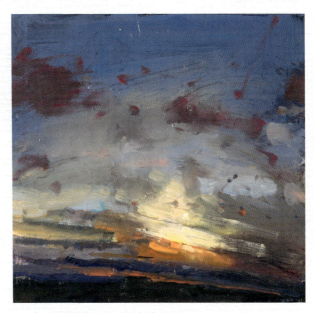

■ *Last Light, Exmoor*. Oil on board, 12 × 13 in (30 × 33 cm), Richard Pikesley.

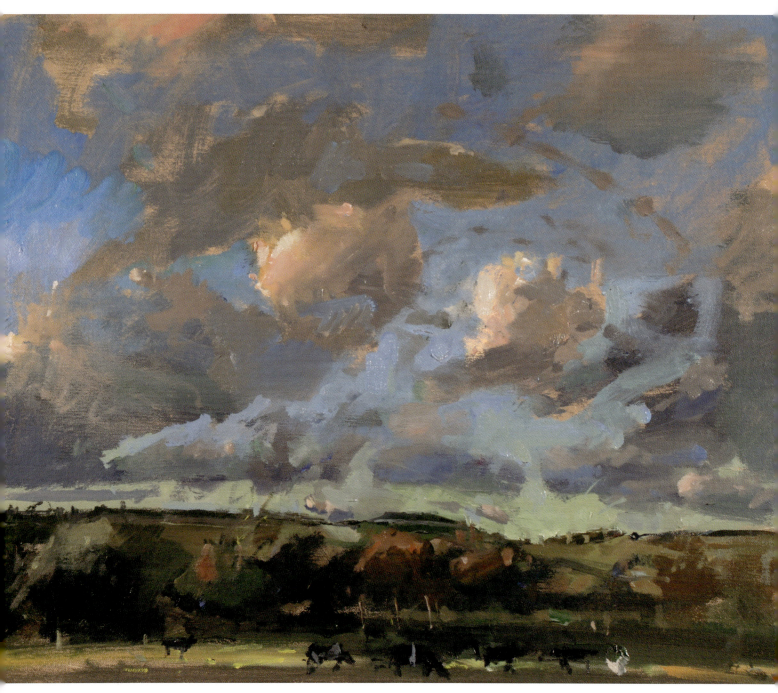

■ *Cows at Burton*. Oil on canvas, 16 × 20 in (41 × 51 cm), Richard Pikesley. A thinly painted start on one evening was completed a week later once the underpainting was dry. Having two bites at this made it possible for me to complete this slightly larger composition.

Painting *en plein air* doesn't necessarily mean that the work must be completed in one session. For me, I often do work small and fast, aiming to complete what I'm going to say about a subject in one session. However, if I'm working at a location where I'll be able to return for a second or third day, I'll feel free to work a little bit bigger. Sometimes, going back for a second bite at a subject, everything will have changed; remember, it's only paint and you can modify what you did last time really quickly and the work already invested will have settled the drawing and composition.

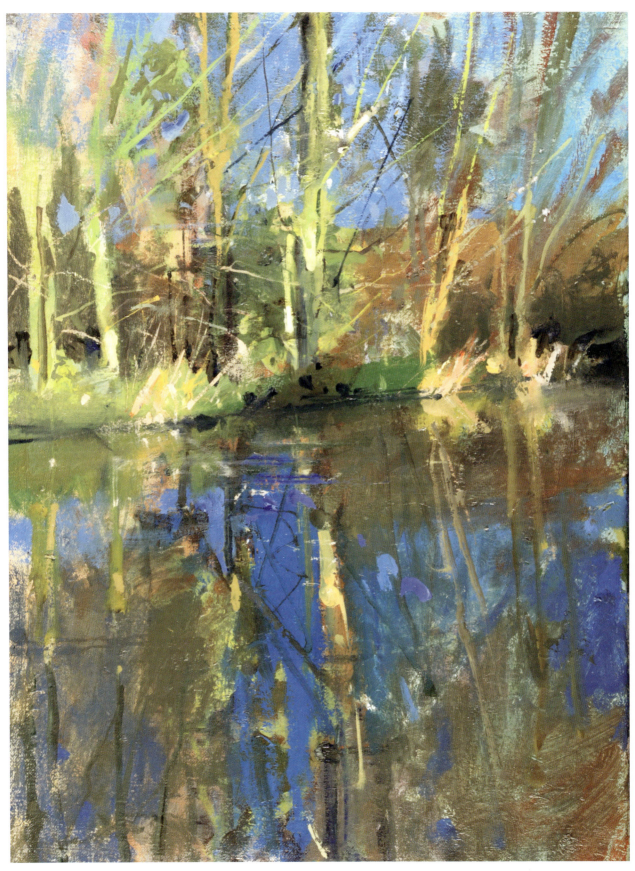

■ *Blue and Gold, Winter Trees and River*. Oil on canvas, 18 × 12 in (46 × 30 cm), Richard Pikesley.

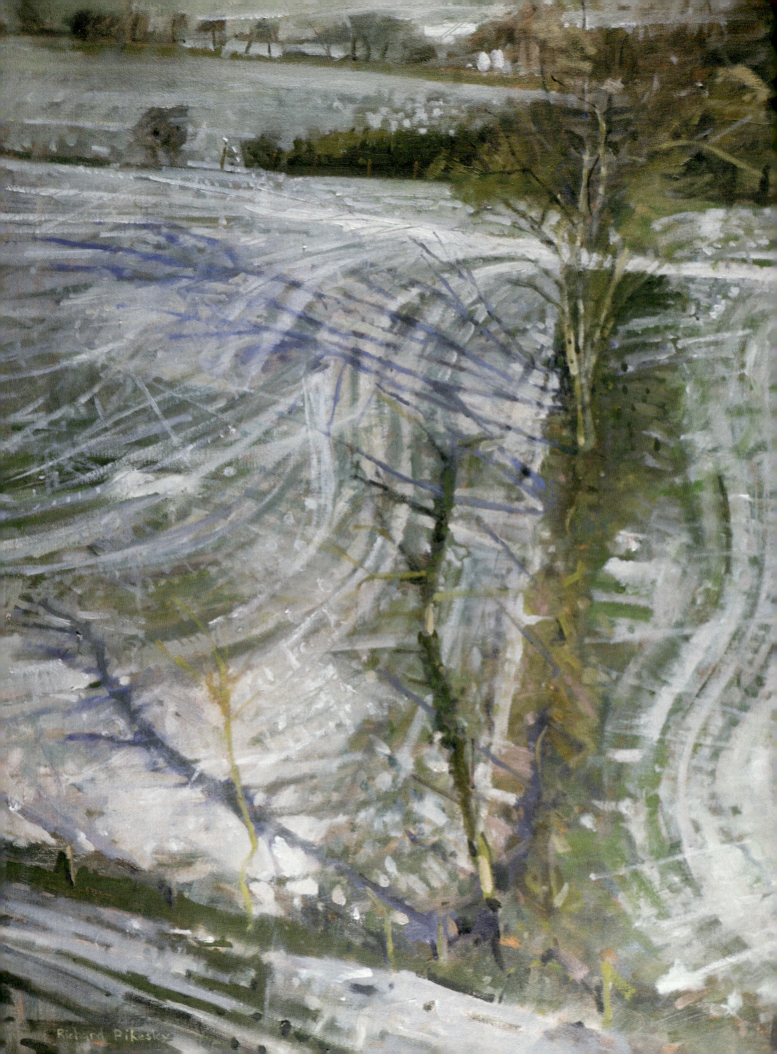

Richard Pikesley

Big or Small?

f I've learned one thing over my time as an artist it's this: a big painting isn't just a big little painting, they're altogether different creatures. To a large extent, little paintings derive their energy from the relationship of individual marks to the scale of the work. A little oil study or a small watercolour will have a finite number of brushstrokes or touches, and the scale of these has a natural relationship with the modest size and edges of the surface on which we work. None of this is true with a big painting unless you routinely use huge brushes and make big gestural marks. This can make it more natural for a small painting to have 'good bones' while its larger cousin has to fight harder to avoid looking fussy and flabby.

Only a few of my own paintings are painted big straight away and over the years I think I've developed an instinct for knowing which subjects can be pushed a bit bigger. Often the bones of the composition might suggest a larger scale but the way it's recreated may look quite different from its smaller ancestor, and is now re-made in a fresh and new way. But big paintings can have a power and presence, and bring a sense of continuing the human scale through the picture frame rather than entering a miniature world. To choose a well-known example, Claude Monet's vast paintings of waterlilies seem to invite us to step through the frame when standing close; such paintings can completely fill our vision. So what do we have to consider when deciding whether to work big or small?

Sundial Trees. Oil on canvas, 30 × 24 in (76 × 61 cm), Richard Pikesley.

STUDIO PAINTING OR ON THE SPOT?

The pattern I work to is that I make a lot of small paintings on location, directly from my chosen subject. Some of these will give me a nudge to work the subject up to a bigger scale and this usually involves painting away from the subject in the studio. Painters who work this way generally say they get an instinct for which of the little subjects might work well on a larger scale. But there are no hard and fast rules; Peter Brown for instance, examples of whose work are illustrated in this book, will work on a large scale directly from the subject.

TIME

We've already considered this in the chapter on *plein air* painting. If you're working direct from your landscape subject, the moving sun will dictate how long you can work on one piece. Of course, when you look at Impressionist landscapes, many of these are quite big and some of the artists, Monet in particular, would return to a subject at the same time over many days while the weather held, working for perhaps an hour before moving on.

My bigger paintings tend to be the ones done in the studio, in my case often working from studies and smaller paintings made on location. The studio painting proceeds at a different pace and there are many ways of working. One might, for example, work everything out on a small scale study and square it up to enlarge it onto a larger canvas. Alternatively, others like to keep it fresh by allowing for changes of direction to happen during the painting process. The exceptions are larger paintings of subjects that I can get back to over several visits with a reasonable expectation that I'll be seeing the same thing each time. A few days of steady weather and carefully timed sessions can make this a possibility and knowing that I don't have to get everything down in one go means I can plan the work over several days. The French Impressionists developed the technique of working on several larger pictures within one day, returning at the same times the following day to work on each painting until either the weather broke or the paint surface became too sticky to work on. By stripping off some of the paint at the end of each session either by gently scraping with a palette knife or by 'Tonking' – laying a sheet of absorbent paper over the surface and

■ A small oil study, typical of many that I make when painting on location. Paintings of this size retain a close relationship between the marks left by the brush and the scale of the work.

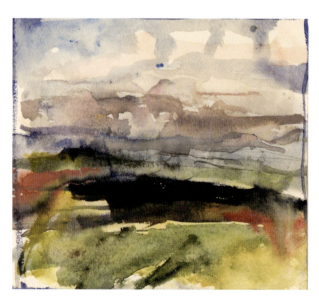

■ Although this tiny watercolour study has little detail, it records for me a sense of being there and of weather and atmosphere and will be a great memory aid later.

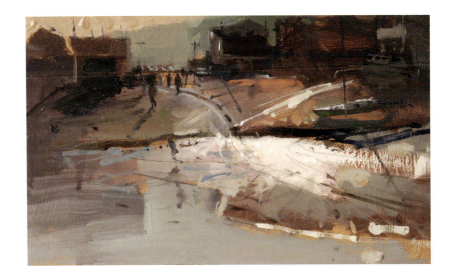

■ *Shining Sand, Evening*. Oil on board, 7 × 12 in (18 × 30 cm), Richard Pikesley. A near-monochrome oil study of evening light.

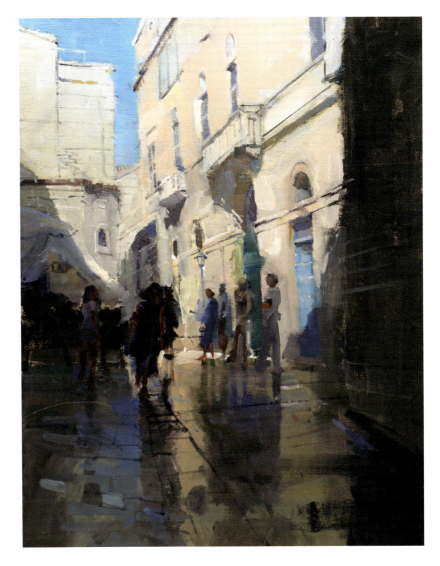

■ *Into the Old Town, Polignano*. Oil on canvas, 20 × 16 in (51 × 41 cm), Richard Pikesley. I made the studies for this painting standing in a gateway as people streamed past me. This was typical of many situations where there's no room to set up an easel.

pulling it away sharply – the thicker passages of paint are removed but enough is left to underlay tomorrow's work and to dry more quickly than a thicker impasto.

MEDIUM

There's a relationship of sorts between chosen medium and scale. A pen and ink drawing is probably going to be quite small. If you choose, watercolour allows you to work bigger and large wash brushes will carry a lot of paint and cover the paper quickly. Drawings in charcoal and other dry media like pastel can be worked quite big, even with limited time in a session; their broader nature allows them to be pushed about and developed quite rapidly.

PORTABILITY

If you've got to carry lots of gear, scale may be an issue. So it's worth thinking about what you have to take and what may be left in the studio. Large boards prepared for oil painting are likely to be heavier than canvases so for working outside I general prepare canvases for sizes above about 18 inches square (45 cm). With a little ingenuity it is fairly easy to make or adapt a trolley for carrying some of your kit.

PERSONAL CHOICE AND PERSONALITY

When it comes to working quickly you have to be comfortable with your choice. What may be the perfect small scale for one painter will feel cramped and awkward to another and may inhibit the flow of the work and the amount that can be achieved. My smallest boards for oil paint start at about 6 × 9 inches (15 × 23 cm). But I only use these tiny ones quite rarely and a range from about 9 × 12 inches up to about 18 inches square will probably cover most of my needs. If I go bigger than this working on the spot in a situation that only gives me one chance, the larger size can give me too much to do in the limited time. I've always been comfortable to have a mix of things on the go at once and will happily alternate between studio days, when perhaps it's raining too hard to work on location, and sessions when I work outside directly from my subject throughout the day. This often means that there are perhaps five or six bigger paintings coming along in the studio together with lots of studies and smaller things that have been done on location. Other painters may find that they prefer to finish one thing at a time before moving on to something else.

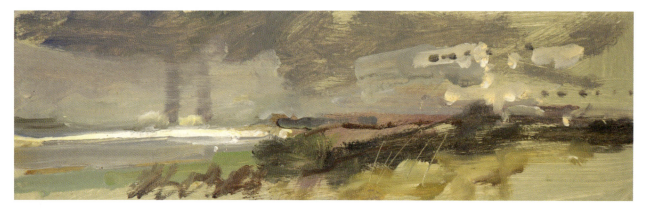

■ *Passing Showers, Long View to Golden Cap*. Oil on board, 4 × 13 in (10 × 33 cm), Richard Pikesley.

A BIG PAINTING IN OILS

I often work around 'families' of paintings, where I'll visit a particular location repeatedly over a number of days. Out of the variety of work I'll do on the spot, there will usually be something which will prompt me to want to work a bit bigger, and this usually means building a painting in the studio from notes and studies recorded on location. When we worked *en plein air* with oils, the fact that the painting was made in one session, or one 'wet', meant that there were few technical issues to worry about. When all the paint is wet at the same time and allowed to dry in its own time, a little solvent such as turpentine will be enough to loosen the colour and let it flow. Above a certain size, it's likely that you'll need several sessions to complete your painting. I sometimes work on a bigger painting for a couple of days. If the first day is spent making an underpainting this will generally be done with colour used very thinly diluted with a little solvent and will dry overnight, allowing you to work again the following day, but by the end of the second day things will be getting a bit sticky and it becomes quite difficult to keep things fresh once that tactile sense disappears. At this point the painting is set aside to dry before I can take it further and I'll turn my attention to other work for a few days. Colours vary considerably in how long they take to dry but you'll probably find that patches of colour including a lot of Titanium White are particularly slow. After a week or two, I should have a nice stable surface with no areas feeling at all sticky and I can carry on. My first session will have been done with just a little turpentine to dilute the colour. It's really important that I don't repeat that now as the new layer of paint, diluted with just turps, would form a weak layer, which over time will craze and even fall off the canvas!

So for this second wet, I add a bit of oil painting medium to the turps in the dipper. There are oils and resins in the medium which supplement the oil in the tube colour and allow the layers to stick to each other and to the canvas beneath without cracking later on. A third wet, if necessary, would be made with more medium and less turpentine in the mix and so on with any subsequent layer. Just like painting a door, you work 'fat over lean'.

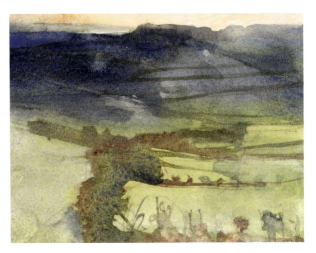

Small studies that I can read in one eyeful are a great way to find subjects for big paintings. This little watercolour study balances just a few elements within a small space and opened the door for a number of bigger paintings around the same location.

There are many recipes for oil painting medium, and I make my own to give just the working qualities I want. Linseed oil alone will do the job, though may yellow a bit over time. However, the major manufacturers of oil paints produce their own media and these are very good.

When wet, and initially as it dries, oil paint will keep its sheen; however, patches may appear to 'sink' as the painting dries and it may be useful to apply a thin layer of retouching varnish if this does happen once the paint is touch-dry. A matt surface, especially if rather patchy, may stop you seeing the darks in the painting at their full value.

I am lucky enough now to have a studio space which is quite big, and whilst I have often managed to paint in smaller rooms there is much about my current space that helps the flow of work. If I'm having a spell when I'm working outside on smaller oils painted on little boards, I can be bringing back six or eight wet paintings at the end of a productive day. Whilst these won't all be any good as finished pictures they all have a value in terms of being a record of where I've been and of the visual ideas that I have encountered. Oil paint takes a few days to dry and I like to be able to see all my recent work. Simple wooden battens screwed to the wall allow me to store lots of wet

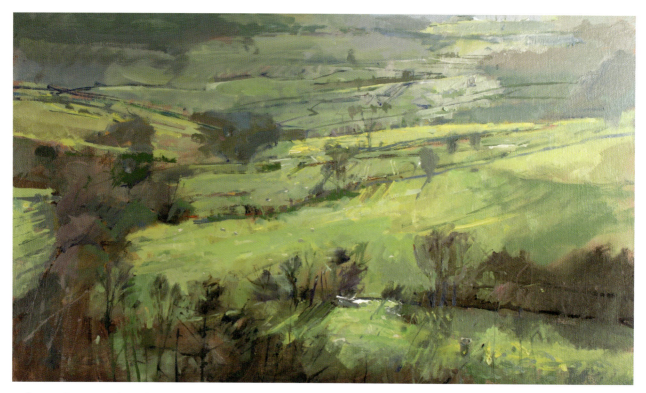

■ *Summer Green, Eggardon*. Oil on board, 18 × 30 in (46 × 76 cm).

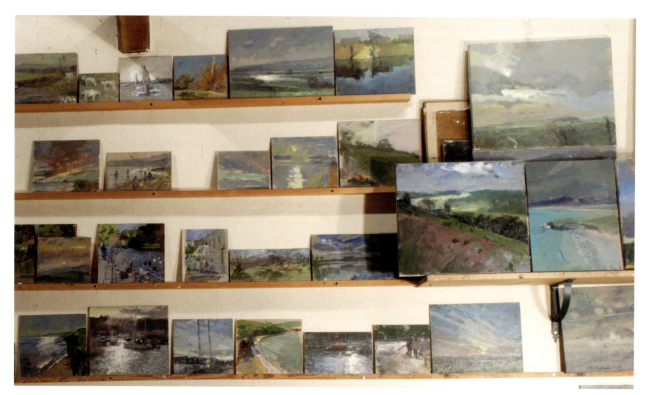

■ Little boards and larger canvases drying in my studio. Keeping lots of work visible in the studio helps me to keep track of what I'm doing.

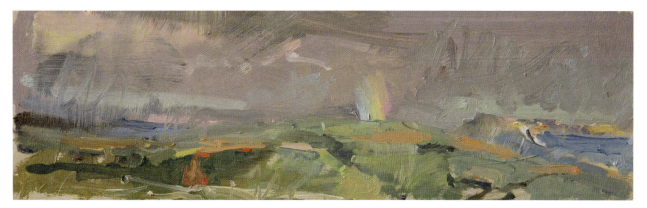

■ *Rainbow, Portland*. Oil on board, 4 × 13 in (10 × 33 cm), Richard Pikesley. I just happened to be painting this view when just for a few minutes this rainbow appeared.

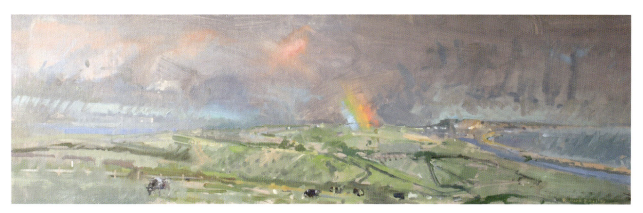

■ *Above Abbotsbury, Rainbow, Chesil and Cows*. Oil on canvas, 12 × 40 in (30 × 103 cm), Richard Pikesley.

and drying paintings and more importantly, be able to see them. Bigger canvases sit on shelves high up on the wall with the wet ones and those drying between wets at the front of each stack.

Often, on a bigger painting, my main concern will be around keeping a sense of wholeness during the period when I am building section by section. The first few minutes of blocking in the canvas with big brushes from just a few puddles of colour will give me a strong sense of what I'm trying to achieve, but at this stage the image will be underdeveloped throughout and will need several day-long sessions with one or two weeks of drying time in between each painting day. It's likely that throughout this process my attention will focus on resolving issues around different aspects or sections of a big painting. Throughout this period it can be all too easy to lose sight of the sense of wholeness that I felt at the outset and for the painting to become rather fragmented. A return to

bigger brushes and seeing the whole painting in the final 'wet' will help to pull the image together, but I feel I have to take risks at this stage and be prepared to lose some hard-won, but perhaps unnecessary, detail to regain the sense of unity. If I've done everything right, after weeks of work I feel I'm back where I started and can read the image as a coherent whole. The difference between how it looks now and how it was after twenty minutes is in the build up of paint and complexity within the image. The very rapid, on-the-spot, visual flash images made at the very start of the idea are absolutely vital, and I keep these in my sight line throughout this lengthy process.

Larger oil paintings have their own rhythm quite unlike *alla prima* studies on a small scale. A day or so of work will bring you to the point where oil paint becomes sticky and unreceptive and work has to be halted for a week or two while the painting dries. In order to use my time productively, and because there are always more

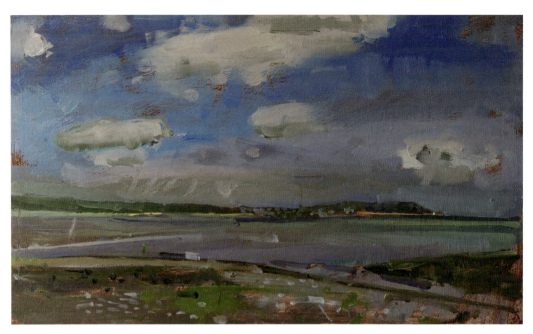

■ *Towards Carantec.* Oil on board, 7 × 12 in (18 × 30 cm), Richard Pikesley. Painted on the spot as the light varied with passing cloud cover.

ideas than time, I often find that a number of paintings are under way in the studio, so there's always something I can pick up and work on. On fine days, or if I'm getting a little crazy from too many studio days, I'll work outside on location, inevitably bringing back even more material for the next round of larger paintings. An empty diary and an eye on the weather forecast helps me to plan a day or two ahead.

Returning to a painting that's had its first studio session and then been left for a couple of weeks, the surface will be dry and receptive. Building the next layer will feel rather different from the first, as one is initially working over a sort of frozen image rather than mobile wet paint. Don't be too earnest about covering earlier layers completely. One of the delights of oil paint for the viewer lies in the way that touches and brushmarks from several sessions fuse into one visual experience even though the history of the way the painting has been built up can be clearly read. Closed up, sealed surfaces will never have this delicious ambiguity. A fine painter once said to me that she liked the surface of a painting to be a bit like a pack of cards that's been scattered across a carpet. In places the cards will overlap and be piled several layers thick whilst elsewhere there are glimpses

of the carpet showing through the gaps. Substitute layers of paint for the cards and the prepared canvas for the carpet and you'll see what I mean.

Whilst the initial touches of this second wet can feel a little stilted, as one continues to work the paint will begin to link up and touches that would have been difficult to make over wet paint are now much easier. This is a good time to assess whether there are errors in drawing which need to be corrected. It's easy to forget that it's only paint, and very easy to make even quite radical changes. Edges gradually emerge as touches of colour are added or wiped away and the painting jiggles and jostles its way towards completion.

It's worth pausing here to think a bit further about the differences between working out of doors in one session and a more considered build-up in the studio. On the positive side, when working outside directly from a chosen subject the artist will have all the information needed in view, together with a sense of place that one only gets from really being there. Some of the challenges will come from weather and other distractions. Another major consideration is having to make an instant judgement about how the subject will sit within the rectangle of the canvas that you have with you, and which may be

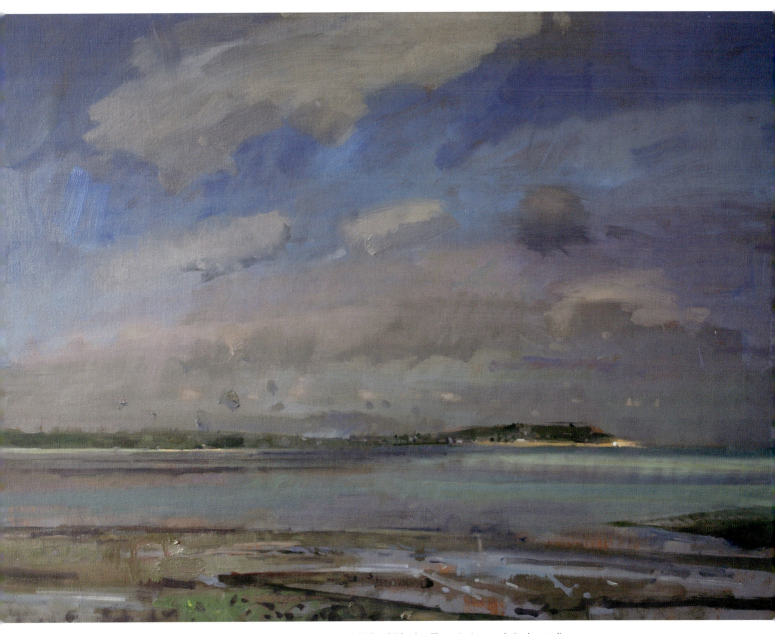

■ *Baie de Morlaix, Summer*. Oil on canvas, 30 × 40 in (76 × 103 cm), Richard Pikesley. The painting made in the studio stretches the height above the low horizon and further emphasizes the brightness of the strip of sand at the end of the promontory.

the wrong shape, and that without some preliminary drawing much time may be spent restating what has already been done as drawing errors become apparent. For myself, up to a certain scale, the sheer excitement of working on site, even if it might be a bit of a battle, usually wins and I try to get the best of both worlds by diving straight in to painting, but then returning later if necessary to make a more considered drawing and any other studies I may need.

■ *Last Light, Eggardon Hillfort*. Watercolour, 4 × 4.5 in (10 × 11 cm), Richard Pikesley.

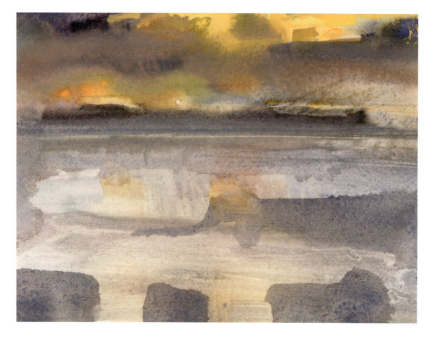

■ *Nightfall, Hebrides*. Watercolour, 5 × 6.5 in (12 × 16 cm), Richard Pikesley.

BIG SUBJECT, SMALL PAINTING

The process of working sight size was discussed earlier in this book but there are many occasions when I find that I have a big, wide-angle subject to fit onto a small panel or sheet of paper. At these times I always measure. It can be quite difficult to compress a big view onto a small painting but by measuring at least the main spatial divisions I can then push on quickly, with confidence that it will fit and everything is in proportion. There's something magical about tiny paintings of vast spaces, letting you through the frame to inhabit a bigger world. I always think of Turner in these situations and how he could make a scrap of watercolour paper into a near infinite space.

THE CORNER-OF-THE-EYE FLASH

Occasionally a small drawing will produce a design that I know will work on a bigger scale. The strongest designs often crop up in the most unlikely places, and I've learned to trust that corner-of-the-eye flash of recognition that means that something has moved or excited me. The drawing for my painting *Cattle by the Axe* was made sitting on my little folding stool in the middle of the river. The cows had been around all day while I was occupied with another painting, but paddling across the stream I noticed the black cow standing on the little river beach and stopped to make a drawing. The subject quickly became a matter of proportion; how much of the pale bubbly water was I going to include filling up the foreground? Adding a little watercolour, drawing quickly settled the cattle and the proportions I wanted and a watercolour study of the river followed. The painting was made in the studio over a period of several weeks, but without many changes from the initial note.

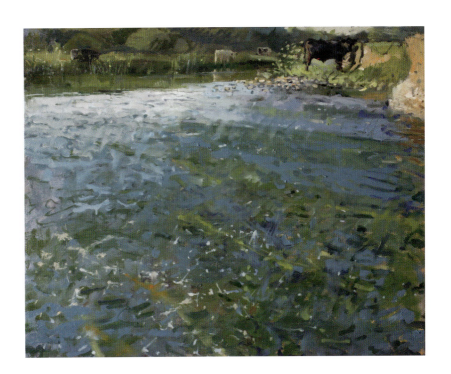

■ *Cattle by the Axe*. Oil on canvas, 24 × 30 in (61 × 76 cm), Richard Pikesley. It would have been very difficult to set up an easel to paint in the middle of the river, so working from drawings and colour notes made on the spot was the only option.

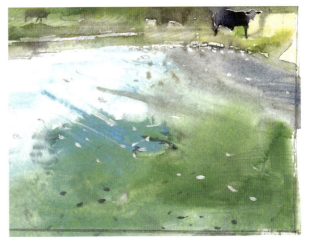

■ Sketchbook study for *Cattle by the Axe*. One of many made from my perch in the middle of the river.

A BIG PAINTING *EN PLEIN AIR*

I've already said that while nearly all of my smaller paintings are completed in front of the subject, usually in a single session, there are ways of working on larger paintings on the spot. Starting a big picture on location will only get me so far if I plunge straight in with lots of paint and colour straight away. If instead I start with drawing and establish how the subject will sit on the canvas and all the basic structures I can spend a whole day laying the groundwork. I'll draw straight onto the canvas with a brush and oil colour, but will treat the process just like drawing with a pencil or pen on a sheet of paper and will measure and make use of a plumbline and viewfinder to make sure I get everything as I want it. Once this layer has dried, which it should do in two or three days, I can return to the location for a second day's work, this time being more specific about time of day and the direction and quality of light. My drawing is all in place and now, painting with a loaded palette, I can

really 'go for it' and will perhaps have a two-hour window before the light has changed too much. A bit of planning ahead is a real help and an earlier day on location will enable me to have made lots of drawings and studies as the light changed, to establish the basic composition and the linear and tonal bones of the design before I commit to a big canvas. Once you get the painting home take the opportunity for a really good look at what you've done and don't at this stage rule out the possibility of making changes of design or composition before you make another visit to your location once everything has dried and you're ready for another painting session. Sometimes too, I will start and finish a big painting on the spot, but also utilize drawings and other studies to work from in the studio in between. The final session on location can be particularly useful at pulling a painting back together that may have started to get a bit fragmented.

My painting from Ham Hill was made on my third

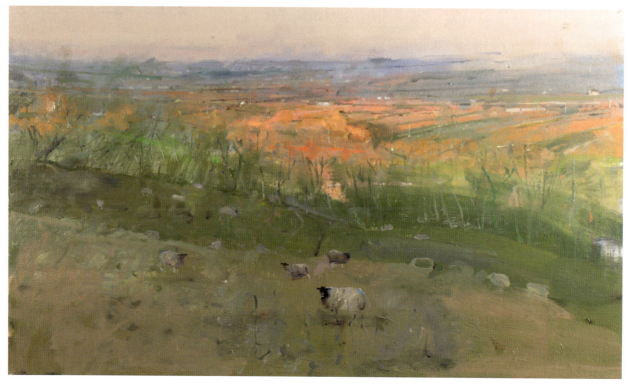

■ *Spring Evening, Ham Hill*. Oil on canvas, 18 × 30 in (46 × 76 cm), Richard Pikesley.

visit to this location over a period of a week or so. I had noticed that just around dusk the foreground below the hill would fall into shadow and I had painted a smaller scale study as a sort of rehearsal for something bigger. Arriving at the location two hours early, I already knew the time when the light was likely to be where I wanted it and spent the first couple of hours setting out the composition with drawing marks made with the brush alongside a thin underpainting. As dusk approached I could begin to block in colour and the pace accelerated until I was adding the final touches as it became too

dark to see what I was doing. At that point, my habit of always laying the palette out in the same way was very welcome, as it allowed me to work instinctively through the failing light.

Driving back across the flat land of the Levels from painting at another location I spotted a subject in a distant church tower breaking the horizon beneath a threatening sky. This one didn't need any preparatory drawing – fortunately I had a spare canvas of the right size and proportion and painted from the roadside in a couple of hours.

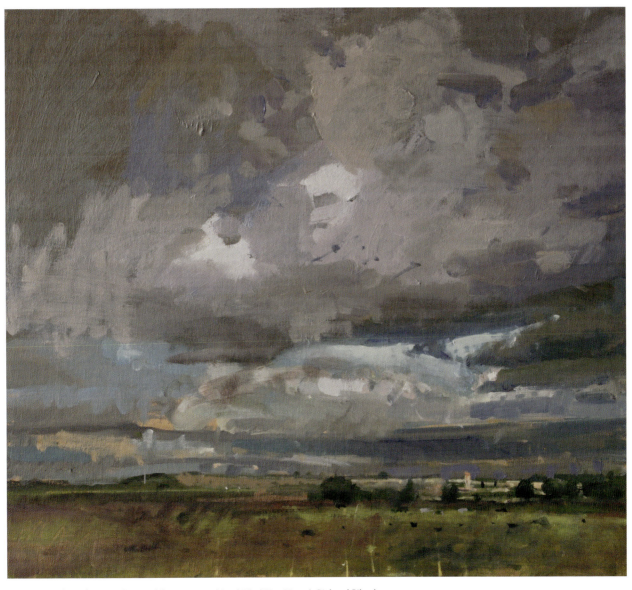

■ *Levels and Big Sky, Long Sutton*. Oil on canvas, 18 × 20 in (46 × 51 cm), Richard Pikesley.

WATERCOLOUR AND SCALE

Watercolour is a supremely flexible medium. Less constricted by the careful layering process required by oil paint it can happily be used in a great variety of different ways. Worked small as a sketchbook medium, washes can be applied at full strength, worked wet in wet and adjusted with further layers as the painting dries. Its range can be increased with other additions such as gouache and pencil or pen line. Big paintings in watercolour may be made in a completely spontaneous 'all in one' sort of way or may be built up in planned layers. Back in Chapter 2 we looked at a method for building a tonal drawing using multiple layers of a single coloured wash to produce a monochromatic drawing with a big range from light to dark. A development of this technique is to lay washes of different colours over each other, allowing each wash time to dry, utilizing the transparency of watercolour to let the lower colours shine through subsequent washes. An initial wash made with Raw Sienna might be overlaid with Cerulean Blue creating a variety of greens. Using varying strengths of wash within each layer will quickly lead to considerable variety of colour as each further wash is applied. It's a bit of a balancing act trying to predict how each layer will affect what lies beneath but once again, using familiar pigments and paper will all help the process to be just a little more predictable. A big advantage of working this way is that while the initial pale wash will give you a hint of how the image will develop, the technique allows the image to progress before you commit to very strong tones and colours. If things get a little too dark and further adjustments are needed, the image may be lightened with a sponge full of water or even run under a tap. Once dry you can continue to build once more. Although this method darkens the image with each successive layer, don't be afraid to mix a little white with colour to create a semi-transparent veil which may be used to lighten

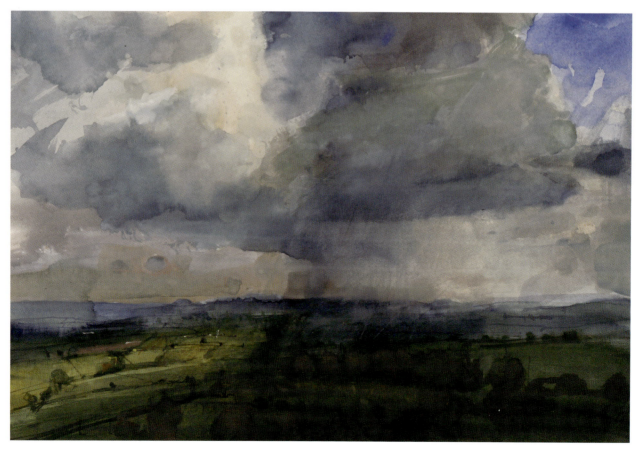

■ *Rain Passing, Pilsdon Pen*. Watercolour, 15 × 21 in (38 × 53 cm), Richard Pikesley.

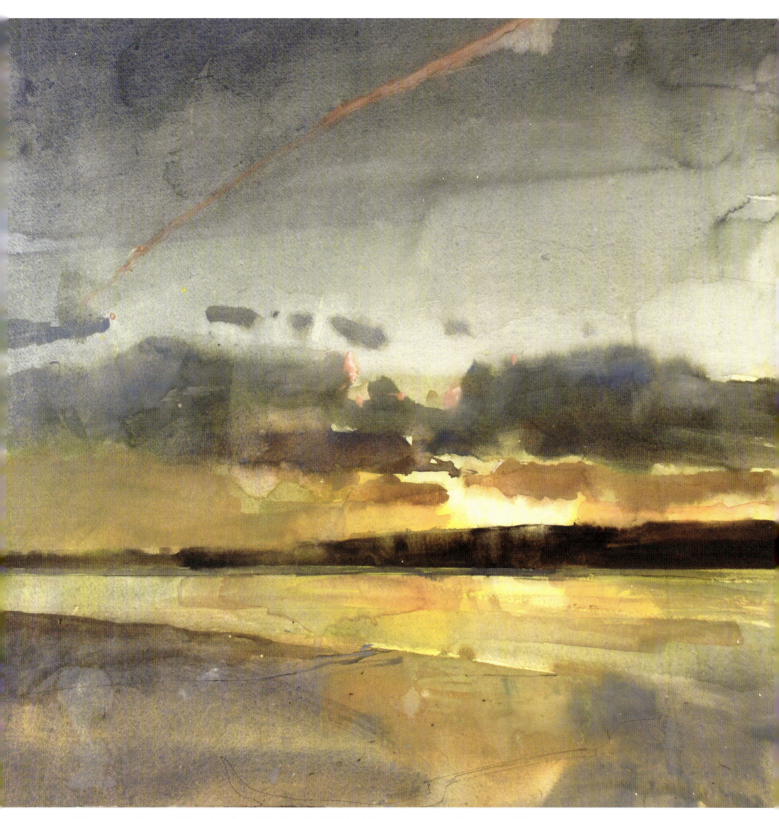

■ *Axe, Summer Evening*. Watercolour, 20 × 22 in (51 × 56 cm), Richard Pikesley. I started with a few pencil lines and some pale washes to feel my way, then strengthened with darker washes applied quickly with big brushes once the paper was sufficiently dry.

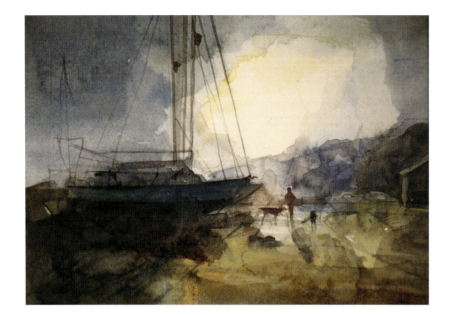

■ *Boat Road, Winter, Lyme Regis*.
Watercolour, 4.5 × 6 in (11 × 15 cm),
Richard Pikesley.

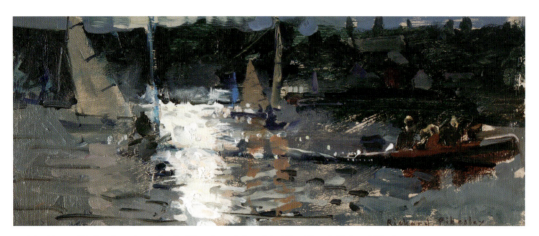

■ *Dinghies and Safety Boat, Lyme Regis*. Oil on board, 5 × 12 in (13 × 30 cm), Richard Pikesley.

an area if necessary. If a more linear approach is needed at any point, a dip pen loaded with watercolour from a brush will produce a wonderfully flexible line without the rather overpowering quality that Indian ink might have, producing a line which integrates well with the coloured washes. Remember too that although watercolour paper is most commonly available in cut sheets up to about A1 size, it may also be bought in a large roll, allowing very big paintings to be made.

This chapter closes with three images, painted around the same location, but at different times of year and for different reasons. A little watercolour records a winter view with the hulls of sailing boats lined up safely ashore.

Their static bulk and the walking figures and dogs were the starting point for this germ of an idea. The small oil is all about the fizz and sparkle of the harbour in high summer, with dinghies coming in after an evening sail. This is an example of something that seems right on its natural small scale. I was at full stretch painting this and feel it has an energy and immediacy that I wouldn't be able to replicate on a bigger version. The final image is a large studio painting, made from many notes and drawings. I felt the subject had a stillness and a strong, grid-like geometry which enabled the design to work on a larger scale, its size also helping with a feeling of depth and space.

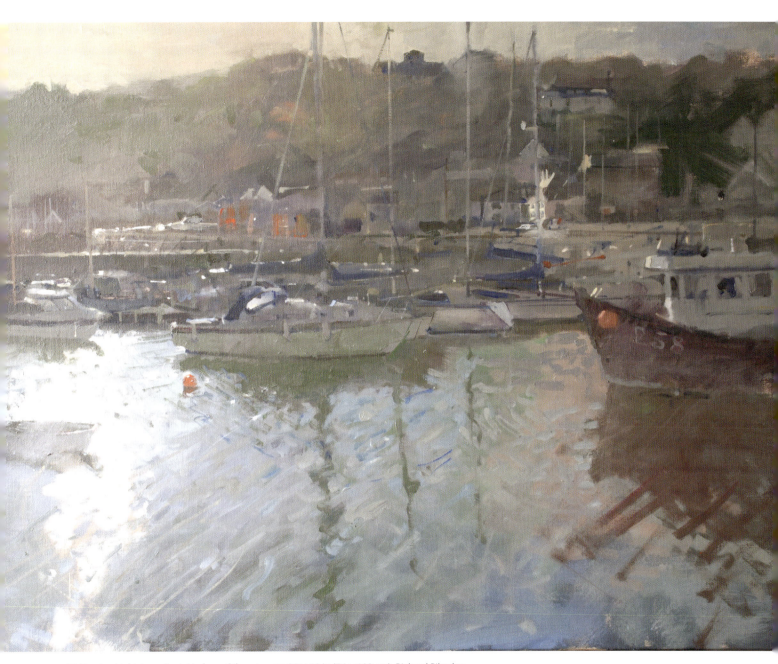

■ *Evening Light, Lyme Regis Harbour*. Oil on canvas, 30 × 40 in (76 × 103 cm), Richard Pikesley.

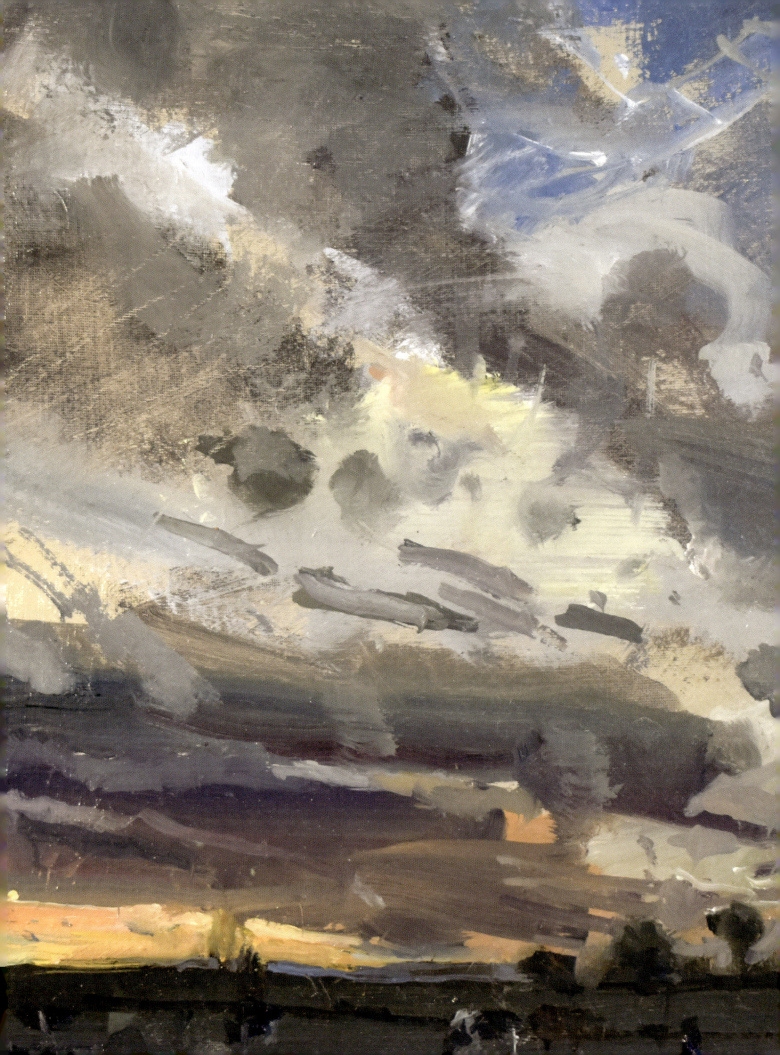

Order from Chaos – Finding a Viewpoint

'm back out on location to begin this chapter and I've deliberately chosen somewhere I've never painted before. I've got a variety of drawing and painting materials with me and today is going to be about exploring a number of approaches to selecting a viewpoint. One of the biggest challenges faced by the landscape painter is one of selection when confronted by such riches. A bit like the kid in the sweet shop, it's so tempting to just want everything, but selection is the key. Where I choose to stand and how I'm going to frame the subject are all endlessly variable and it can be fascinating to see how by moving my viewpoint even just a little, the arrangement of shapes and the story the painting tells can be completely different. I want to really see what a new location has to offer and so this will be a long day as the

changing light will be one of the biggest factors in helping me decide what I want to do here. As it's somewhere I've never painted, I'll also need time to make it feel it's mine in a way that won't happen if I only stay for an hour.

This isn't a day for carrying too much kit. I want to be fairly mobile so have only brought my little half-box French easel and a bag containing a few boards of various formats, a roll of paper towel, a small bottle of turps, a little sketchbook, some watercolours and my viewfinders. My pockets carry various pencils and pens, putty rubber, pencil sharpener, etc.

Once again, my intention today isn't to make a painting so much as to gather the subject in and start a conversation with a particular place that has the potential to draw me back over the years to come.

Evening Sky (and Cows), Somerset Levels. Oil on canvas (detail), Richard Pikesley.

FIRST VISIT

The first location I've chosen for this chapter is the landscape of the Somerset Levels, more particularly an area of this marshy wild place that I want to return to through the coming winter when much of it may lie beneath floodwater. It's a place of big skies, water and willow trees. The flat landscape of the Levels is ringed with hills and most of my previous visits have seen me painting from a high viewpoint looking down on the flat land criss-crossed with rivers and drainage ditches. I've come here because this place is elemental – just sky, flat land and water – and today I want to get down onto the low ground and explore the visual possibilities of this unique landscape. Today is very much about exploration: I'm not focusing on finished paintings so much as understanding what's here and making plans for future visits.

I've driven to a place where a river passes under the road and there are big sluices here to handle the winter rain. Parking off the road, my first priority is to walk the area with a sketchbook, making thumbnail notes of any view that I think might work as a painting. As ever, I'm looking for an intuitive sense of recognition, though at this stage I have no preconception about what I might find; I'm simply trying to be receptive to the possibilities

of the place. Walking half a mile back along the road I'm looking for water that I'd registered as a flash of reflection as I drove past earlier. The flat land is drained by ditches that form a rectangular grid that stretches for many miles and it was one of these rhynes that I'd seen. Not much room to spread out my kit here as I'm right on the busy road's edge, but I put down my bag and begin to make simple drawings in my notebook using a soft Conté pencil. I'm looking into the sun here and there's a massive, strongly structured sky, brilliantly reflected in the great gash of the drainage ditch. Drawing quickly, my first little composition is made from a point off to the left of the ditch which runs away at a diagonal. I notice that although it is a breezy day, the water in the rhyne is quite still, running as it does a little below the level of the fields so out of the wind. The sky's moving quite fast and I squeeze out some Payne's Grey watercolour and white gouache ready for the next drawing. I find I can make changes quicker this way and avoid the smeariness of using an eraser. The water surface mirrors the sky above perfectly and I make another drawing focusing on this observation.

SMALL MOVES MAKE A BIG DIFFERENCE

Moving just a few feet to my right, I position myself right over the bridge where the ditch passes under the road. I'm in the middle of its little span and the straight lines of the ditch converge symmetrically towards the horizon like a perspective diagram. There's more of the water visible now and I can clearly see the reflections of the cloud masses above. This has something of the uncompromising quality that I think I'm looking for but as I make the drawing I feel dissatisfied with its symmetry and find it strangely difficult to relate the foreground to the sky. Now finding a viewpoint slightly to the left of the previous drawing I get a sudden jolt of recognition that this is the view I've been looking for. The left-hand edge of the ditch has become a vertical and provides the main

■ A quickly made drawing begins to explore possible viewpoints.

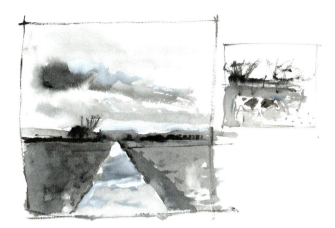

■ Placing myself above the centre of the ditch gives a very symmetrical design.

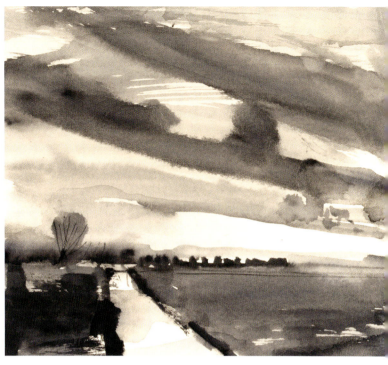

■ Moving just a couple of feet to my left, the left-hand edge of the straight ditch has become a vertical line and strengthens the design.

compositional division in the foreground of my little drawing. The dark rectangle formed to the left of this line immediately relates to the paler mass of the sky above. I think I'm getting close. In a final small adjustment I try sitting down and find that the lower viewpoint widens out the water and changes the angle of its right-hand bank. A conversation with a local farmer later in the day reminded me what an unforgiving place this can be, as he tells me that three of his cows had been swept away in last winter's floods and were never seen again. The composition I've settled on seems to have some of this rather brutal character and seems to be appropriate. I've learnt to be open to the emotional charge that a place may have; it's not all about a solely visual response.

STARTING TO PAINT

Moving away from the water and the road I'm becoming even more aware of the strength of the wind-blown shapes of the clouds above me. The flat land here emphasizes the sky and I want to make a painting that celebrates this. I've already noticed that the clouds are organized into a broken pattern that fans out in perspective and gives me strong diagonal lines as a foil against the flat horizon. As I turn all the way round to see where it's best, the view into the sun away to the south seems to have most to offer. Colour in the sky and the dark land is more muted, almost monochromatic in this view, but the sculpted feel of the cloud masses is at its strongest. To give a sense of scale,

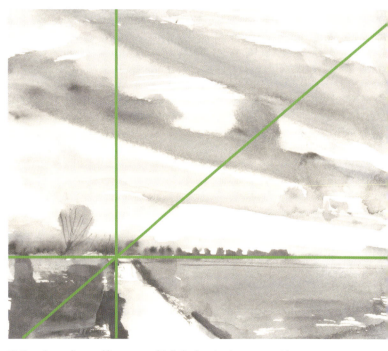

■ Drawing a diagonal line across this little drawing intersects with the corner of the rectangle formed by the edge of the ditch and the horizon, and reveals the design's simple geometry. I only spotted this afterwards, but your eye likes simplicity and will tend to find these spatial divisions quite intuitively.

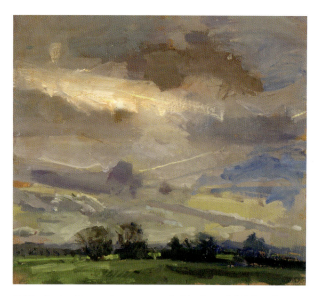

■ The flat landscape gives a sense of a big sky and dividing the subject with a low horizon seems an appropriate choice.

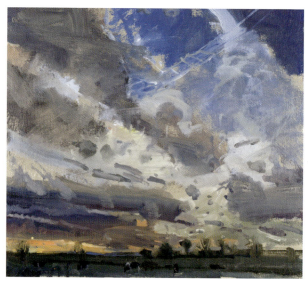

■ *Evening Sky (and Cows), Somerset Levels*. Oil on board, 14 × 16 in (36 × 41 cm), Richard Pikesley.

a line of trees in the middle distance breaks up the more distant horizon. This has the makings of a big painting so I need to get as much information as I can if I'm going to be able to re-capture this in the studio later. I paint a little oil study with low horizon and dominated by the sky, but feel a wider angle of view might give me more of a sense of the wildness of this place.

Setting up the French easel, I select the biggest board I've brought with me and start to block in the big tonal masses with a large brush and colour made a bit more mobile with a little turpentine. I'm painting on a board that has a muslin surface and an imprimatura coat to lower its tone. I know the sky's going to change very fast and I want it as it is right now so a simple band of dark across the foot of the painting will stand in for the land while I focus on recording the sky. Making an effort to widen and relax my gaze, it becomes easier to notice the subtle changes in colour across the sky and there's a sort of yellowish glow low down near to the horizon. As I look and start to block in the pattern of the clouds, a vapour trail from a jet starts to open and spread, giving another diagonal linear accent, but this time in the other direction than that of the cloud masses.

With the sky blocked in I can now start to refine individual cloud shapes. Where I sense I'm getting too fussy or losing the broad masses I switch back to my big brushes and simplify once more. In the far distance beyond the trees I can see hills, very close in tone to the sky, and I make a careful note of the tones across this important boundary. I notice again that if I 'telephoto' my eye into the far distance I miss-read the tonal step as being much too big. With a relaxed, 'wide-angle' eye I once again take in the entire view and the troublesome tonal step falls into place. Now it's time to place the trees and their small scale on this still modest sized board begins to give a sense of a vast sky above.

SO MANY SUBJECTS

I've been working on this for well over an hour and know that if I continue much longer the sun will have moved too far and I'll miss the backlit character that attracted me in the first place. I stop painting and spend fifteen minutes making a careful line drawing of the 'land' part of the subject paying particular attention to the irregular rhythm of the placement of the line of trees. My thoughts are turning to what I might do next and I've already spotted a group of tall trees, top heavy with great balls of mistletoe. I think I might come back for that later; for now I'll get everything back to the car and have a good look at a view I noticed as I parked earlier.

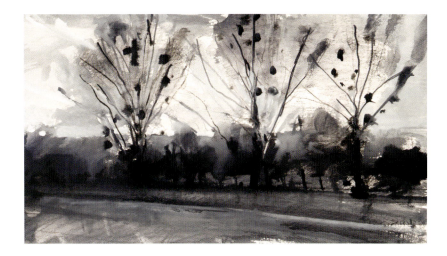

■ A quick note of the pattern of three trees against the sky. The balls of mistletoe in their branches give them a top-heavy quality, which caught my eye.

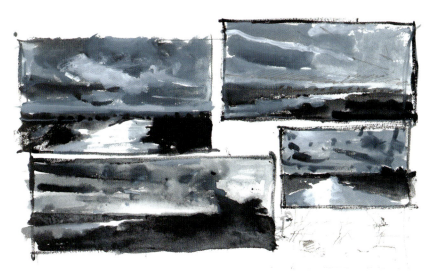

■ About half an hour was spent making these sketchbook drawings from several viewpoints, exploring various ways of framing the subject. Payne's Grey watercolour and a bit of white gouache makes a very flexible tonal medium and quickly lets me see a number of possible variations.

I'd left the Land Rover in a lay-by close to the sluices and the curving track of the river was making a bright accent where it curved below the sun in the far distance. Once again it's time to make some quick drawings to help me decide on a vantage point and the best way to frame the subject. This time I'll use simple washes of watercolour and white gouache to make my drawings in one of my little watercolour books. The hard, hot pressed paper will allow me to add some pen lines if I need them for more definition. With these quick drawings on a single page I select the third version which gives me a composition that's about two thirds sky and with the accent of the brightest part of the river about one third of the way along the horizon. This division into thirds with the accent placed on one of the 'eyes' is a well tried compositional device, although I haven't used this consciously this time. Over my shoulder I notice

the black and white cows in the field behind me. The potential subjects are stacking up and as a first visit to a location to consider future painting, this place is looking really good.

The main drama of the subject is in the feeling of looking into the distant sky just above the horizon, emphasized by the roof of clouds above my head. Just at the moment, the brightest point on the river is just where I want it, but this will change as the sun's position appears to move further to the right, so I'd better get on with it!

It's getting towards the end of the day and there's a subject I'd spotted earlier that I want to return to now that the failing light has simplified the subject into simple, heroic shapes. Three trees with great balls of mistletoe in their upper branches reach up into the sky. I love the elemental quality of this place and I want to make a very simple painting of this subject which will express it in the

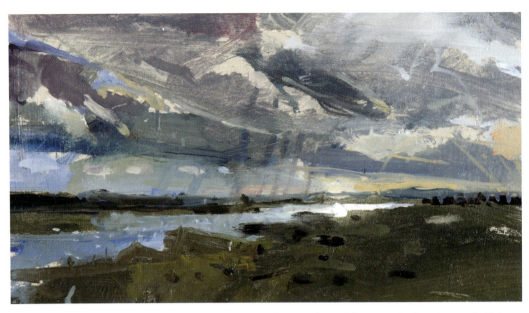

■ The curve of the river as it runs through the fields catches the vertical axis of the sun and reflects it strongly. Sitting on one of the 'eyes' of the composition, this bright point becomes the dominant focus in this little study.

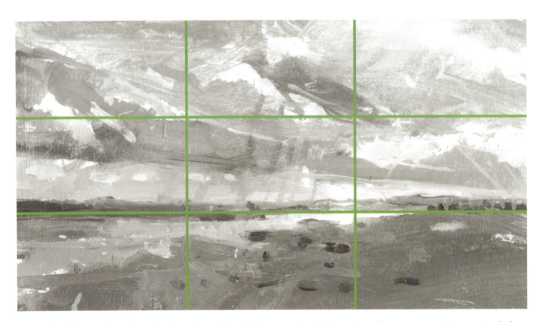

■ Dividing the view into three, horizontally and vertically, creates 'eyes' where these lines cross, creating a natural place for the eye to settle.

most powerful way. Not much time left so I just make a quick page of studies, thinking only about the placement of the component parts of the subject. Three trees, sky, horizon, field. I decide that I'll keep things simple and place the trees more or less symmetrically with quite a lot of sky showing above them. The foreground field is becoming quite dark and, as often happens, once the light goes a lot of the distracting detail pretty much

disappears. I get about twenty minutes to make a little oil study before it's too dark for me to see what I'm doing.

Next morning I spread everything out on the studio table. On reflection it had been a fairly typical day on location and as usual I'd come home with a mix of paintings and studies. The main outcome is that I'd found somewhere I want to keep returning to, and having a mixture of drawings and sketches along with one or two

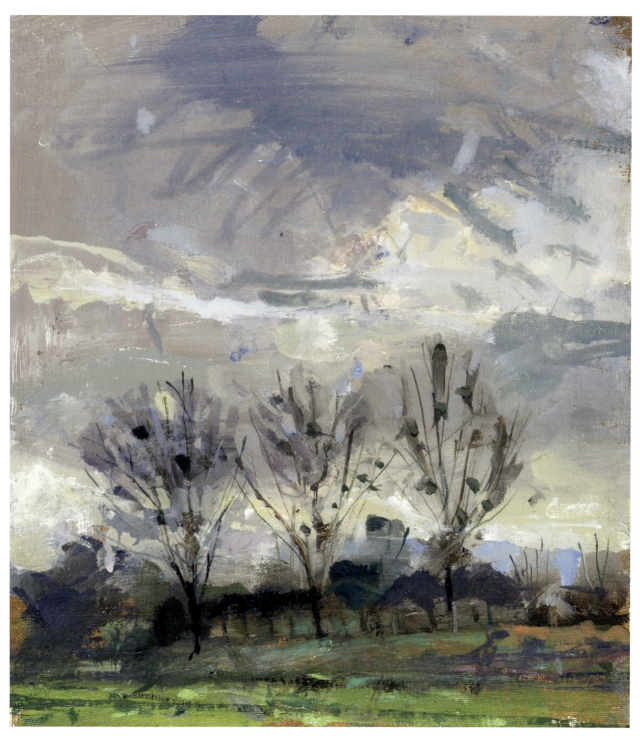

■ *Three Trees, Somerset Levels*. Oil on board, 10 × 8 in (25 × 20 cm), Richard Pikesley.

more finished paintings and a head full of ideas, is a good demonstration of the way that painting is most often for me about the continuing process, where there are always further possibilities opening up from each day's work. I'll be back on the Levels a number of times through the winter ahead, and each time I will look again at subjects and viewpoints discovered on previous trips. Over time the work produced gradually develops some of the motifs discovered on my first visit, and just as some of these early ideas are brought to some sort of conclusion, so other possibilities open up.

SELECTING A VIEWPOINT

■ *Ash Tree, Spring Sun*. Oil on canvas, 16 × 12 in (41 × 30 cm), Richard Pikesley.

So let's now look in a bit more detail at how quite small changes of viewpoint might radically effect the painting I'm about to make.

HOW CLOSE?

It's always tempting to paint the grand view. Whilst this sometimes works, more often than not the result is rather disappointing. Big views often start in the middle distance and stretch to the horizon, and additionally have a wide angle of view to try to get it all in. It's easy to get side-tracked into recording a lot of detail at the expense of having a strong compositional framework. Paintings done in this way often have the feeling of a room in which all the furniture has been pushed back against the walls,

and have a sort of vacant look. To make such a subject work, start with something that gives you a strong, simple set of shapes. Getting in close, at least to one element in the subject, can often result in a stronger design and a less detached feel to the painting, physical closeness adding an extra emotional charge.

HOW HIGH?

Painting on the Somerset Levels was a good example of having a fairly low viewpoint. Standing or sitting in such a flat landscape there's a strong sense of foreshortening through the land element of the view, with a lot of over-lapping of hedgerows and the background hills. There's a strong emphasis on the horizontal and in perspective terms the eye level is set very low. Generally such compositions have great calmness and stability. The painting of a Spanish landscape, viewed from the hill town of Ronda, is quite the opposite. There's little overlapping in the lines of hedgerows and trees and there are hardly any horizontal lines. In this composition a high horizon squeezes the sky down to a narrow slice right at the top edge. The composition becomes a sort of jigsaw of irregular shapes as I look down on the landscape in the valley below. On another occasion painting around the Somerset Levels, a rainy day found me on a hillside looking down on the flat and flooded landscape below. The regular criss-cross of the drainage ditches now adds a bright, grid-like pattern to the subject and becomes quite different to the earlier examples of a closely related subject.

HOW WIDE? WHAT FORMAT?

Once I've chosen my viewpoint in terms of where I'm standing or sitting, there are still other decisions to make. How much to fit into the painting is probably the most pressing, as it will determine scale and set the viewer's relationship with the landscape image. We've already seen how a painting may be made sight size and if this

Below Ronda, Andalucia. Oil on canvas,
18 × 16 in (46 × 41 cm), Richard Pikesley.

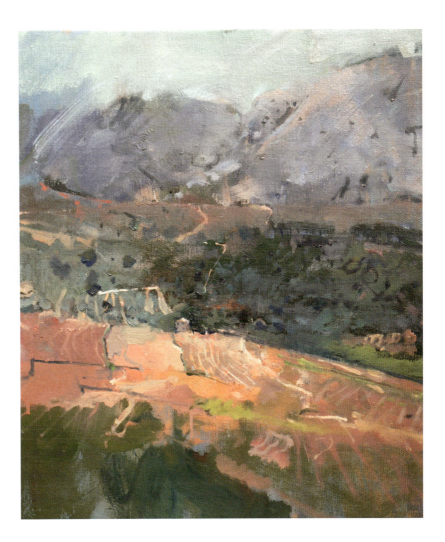

Rain, Somerset Levels. Watercolour
10 × 14 in (25 × 36 cm), Richard Pikesley.

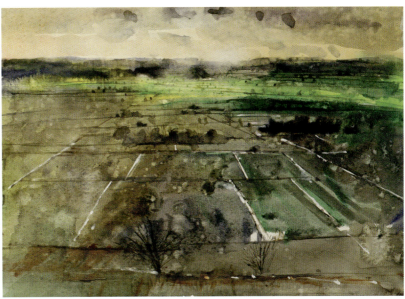

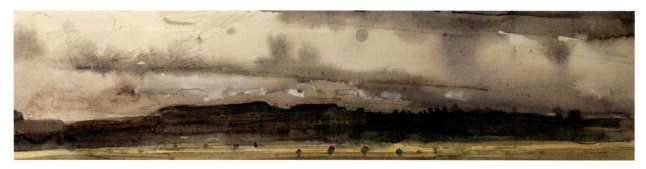

■ *Levels and Hills*. Watercolour 2.5 × 10 in (6 × 25 cm), Richard Pikesley.

is done there will be an exact amount that can be fitted into your canvas or paper. By working a little smaller than sight size a wider angle of view will fit more in and though the scale is smaller the sense of space can be greater. There's something strangely compelling about the illusion of a vast space when it's delivered by a very small painting or drawing. I always find that when widening my view I have to measure particularly carefully to get the first drawing marks down and set the scale. Going the other way, narrowing the angle of view puts you into telephoto mode, painting slightly above sight size and with less fitting in.

Think also about the shape of the painting. By carrying a few boards in a variety of formats I have some choice on the spot and if the fit's not perfect I can cut a board to adjust later if necessary. On paper there are no such constraints and it's easier to let the painting spread across the sheet and then make choices about cropping and framing later. There's more about this in Chapter 12. Some proportions seem to be quite difficult to work on. I generally avoid perfect squares (though near-square shapes seem particularly good), and I always find 2 × 3 tricky; maybe that ratio is just too predictable and stable. Tied up with this choice is another about where the main focus of the painting lies, and whether it's sensible to include other elements which seem to pull your eye away. Having too many parts of the painting equally dominant can weaken the effect and look indecisive. Be particularly careful with strong points set at either edge of a painting as this can result in a sort of 'ping-pong' effect as the viewer's eye hops from one side to the other with nowhere to settle. Take care too with very symmetrical

compositions or situations where the horizon cuts the rectangle of the picture plane in half. However, all of these apparent rules are there to be broken and how lines sit within a diagram of your painting only tells part of the story. A central horizon could be made to work brilliantly by also considering the contribution made by the big tonal masses of the composition, which may be far from symmetrical.

On a day in late spring I've come to another location, but this time one that I know quite well. A small settlement on the northern edge of Dartmoor sits above a deep moorland valley cut by a tumbling stream. The elements of sky, land and water are here in abundance just as they were on the Somerset Levels but it couldn't be more different. Heading first down the twisting footpath into the valley I pause to look at a group of trees. They are twisted and small like Japanese bonsai growing in this harsh environment but their contortions and fight with the weather has produced wonderful shapes. Branches dividing close to the ground produce strong diagonals and my eye is caught by the relationship of the whirling branches with their cast shadows. Stopping to make a sheet of drawings I spend my first working hour getting enough down on paper to entice me back here on another day. Hemmed in by the trees and with a shallow space this is a landscape that contrasts sharply with the wide, flat Levels with their grid of vertical trees and wide horizons. The emphasis here is on strong sinuous movement and it's there to draw everywhere I look. The challenge is in how to take this visually rather overwhelming and congested location with its shallow space and make paintings from it.

■ The stunted little trees made fantastic shapes.

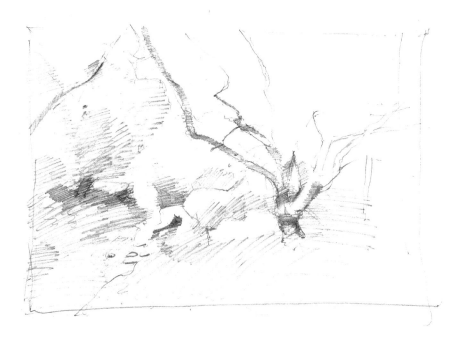

■ I explored a number of different viewpoints in these notes which are a good reminder to come back and spend more time here.

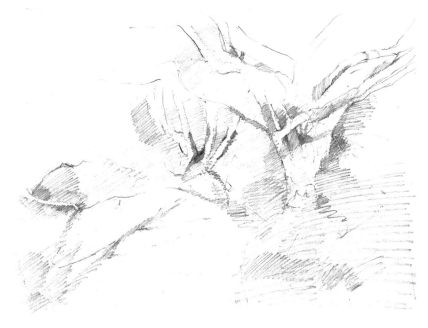

Well, I don't know until I start and the act of drawing begins to untangle my visual imagination if not the trees and their branches. I follow my instincts here and move just a little between each drawing. It's the sort of place where apparently insignificant changes of viewpoint make big changes to what I'm seeing. When I was painting on the Levels, I had that visual flash of seeing a potential subject all of a piece and knowing straightaway how I would compose my paintings, but here I'm not at all sure. The place has a spine-tingling energy but this could easily be a case of not being able to see the wood for the trees! If I were to start painting here straight away I think the result could be a bit of a muddle. There are simply too many elements. The very fact that drawing is partial and incomplete forces me to select and, of course, to sit still and really look. This selective quality of a drawing means that by the end of an hour I have a couple of sheets of information along with a clear idea of what's important here, and if I come back tomorrow I can tackle a painting, or maybe several.

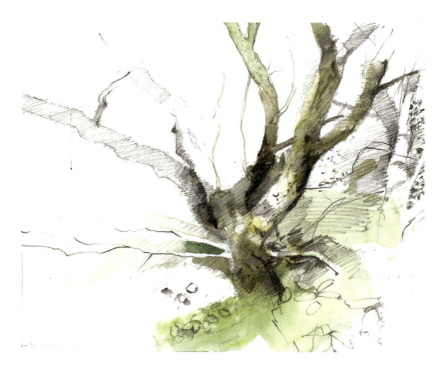

Simple washes of watercolour take this study just a little further.

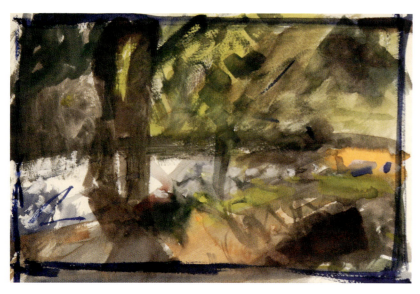

■ Tree trunks and their shadows give strong darks cutting across the brilliance of light reflected from the little river.

Moving on just a few steps, I cross a little footbridge over the stream. At first sight what I'm seeing is more of the same, this time with the new element of light on water. Landscape painting for me is fed by all the senses and here the noise of the little river forcing its way through the boulders of the stream bed makes the experience of being here even more immersive. There's just a little more open space here as the wood gives way to open moor and the stream valley makes a divide between the banks of trees. I also have a bit more clarity about

what I want to do, as I've drawn here before. The trees grow right from the water's edge so every view across the river is punctuated by their dark masses.

I'm going to start in my watercolour book here and also begin mapping out a slightly bigger composition on the easel. The little book not only gives me something to do while washes are drying on the bigger piece, it lets me rehearse aspects of the larger composition and try things out. The view I've chosen here gives me a broken view of the tumbling water whose surface ranges from the

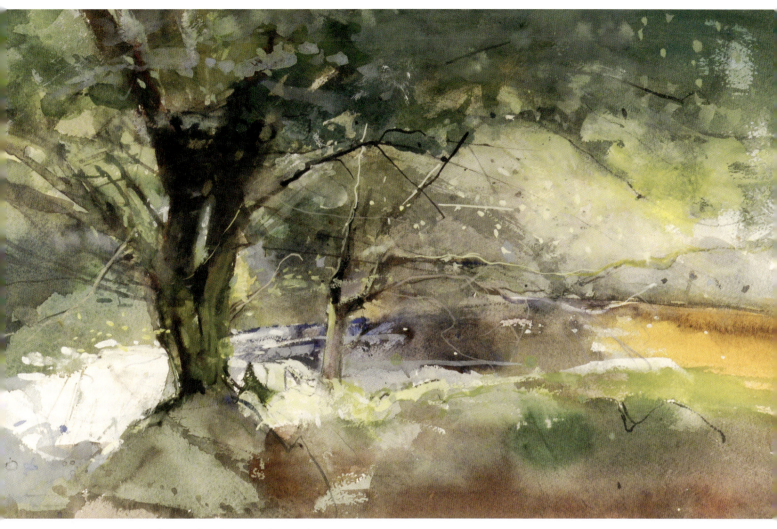

■ A more considered watercolour drawing at the same location.

brilliance of reflected sunlight on the left-hand edge to a transparent tea colour where it comes out of some cast shadows further to my right. I've got to gauge the tones so that I can describe the strength of the glare whilst not losing everything into the deepest shadow. Watercolour, for all its delicacy, can work well in this situation and I want to use the reflective quality of the paper itself to maximum advantage. It is quite a complicated subject, however, so if I have to use a bit of opaque gouache later to get the lights back, I won't mind too much. My first stage is a few measured marks in pencil on the bigger sheet, to start to map things out a little before I pick up a brush.

Later in the afternoon I explore further and just a few yards from where I've been working the river emerges from the trees to broaden and become quieter. As I start to work here, two dogs come out of the woods to splash through the shallow stream and I make a rapid note in my little book. I also note how this little ford looks from a number of different viewpoints, each only a foot or so from the other. My first little drawing strikes me as a bit bland and open and needing a bit of imbalance to bring it to life. After trying out a few possibilities I hit on a viewpoint a little to the left, which pulls in some foreground boulders and a bit of shadow to break up the big foreground. I think I'll get another hour or so until the shadow fills in completely so there's time for another watercolour.

Building a watercolour in layers

Step 1. Looking for the simplicity of big interlocking shapes, I put down the first washes. I'm drawing in my head to know where to leave white paper but could have used some pencil marks as a guide.

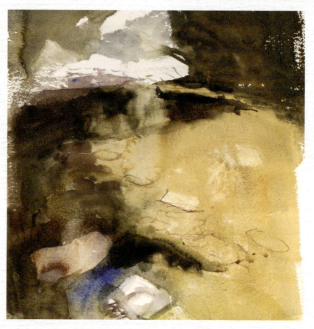

Step 2. In the sunshine it takes little time for the paper to dry and I continue with the next transparent layer.

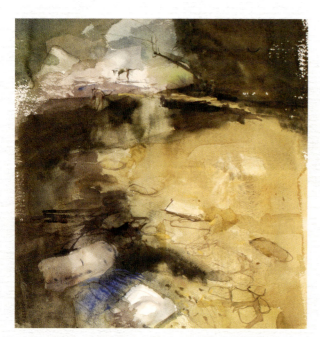

Step 3. As I work on, two dogs appear on the far side of the stream and splash around for long enough for me to make a note of them.

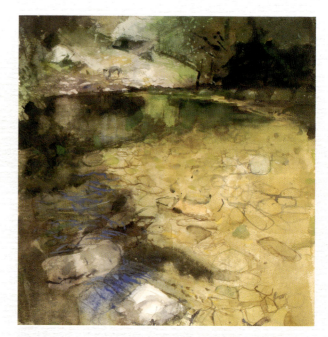

Step 4. Paying more attention now to the trees and their reflections across the stream, I continue to build in these areas.

■ *Red Hat and Royal Palms, Maharashtra.* Watercolour, 14 × 21 in (36 × 53 cm), Richard Pikesley. Very much a grid, the regular spacing of the palm trees are crossed by garden paths. The red hat of the gardener was irresistible.

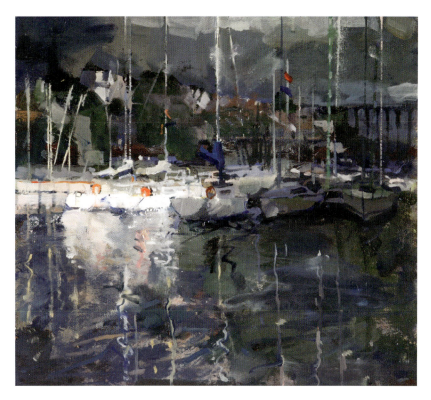

■ *Morlaix, Light Comes and Goes.* Oil on board, 12 × 13 in (30 × 33 cm), Richard Pikesley. Reflections carry the vertical accents of the masts down into the water.

Looking back over these two locations, I've accumulated a lot of material as well as the knowledge that these are two very special places that will nurture me for a long time to come. When I'm putting together paintings for an exhibition I usually find that a handful of special places are all I need and the feeling of having a particular and personal response. The growing connection that comes from returning to somewhere I think I know and yet encountering surprises, is a sort of rocket fuel. Choosing a subject to paint isn't entirely a visual process and whether your landscape theme is the top of the Himalayas or the bottom of your garden doesn't matter much, as long as there's something about the place that gets your visual and imaginative juices flowing.

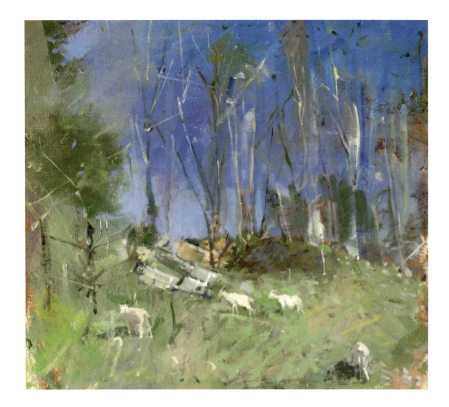

White Goats, Mendip Hills. Oil on board, 12 × 13 in (30 × 33 cm), Richard Pikesley. I spent a day following these white goats up and down these crags. The low angle sets the pale tree trunks against quite a strong blue sky.

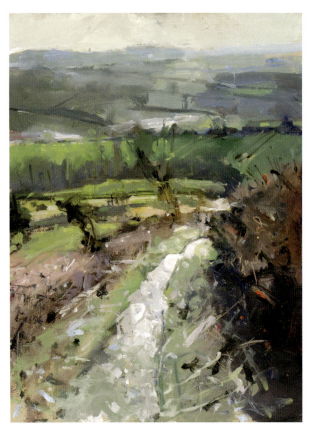

The 'tunnel' of the path, hedge and surrounding perspective moves your eye quickly back to the middle distance.

Looking down from a high cliff top as I make this drawing, I love the sense of being encircled by the landscape below.

GRIDS, TUNNELS AND HOOKS

Of course, there are countless different views and compositions out there, and every one will be different. But looking through paintings in my studio I recognize that there are design features that unite whole groups of paintings. These often have their origin in where I choose as a viewpoint.

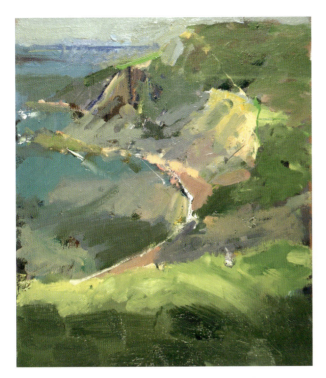

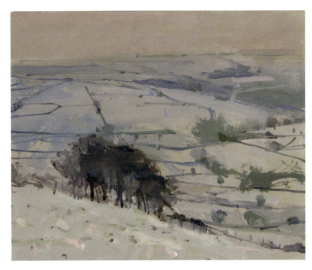

Snow sometimes changes everything, and the dark smudge of the hanger of trees set against the web of hedges made a subject I might have missed in other conditions.

Chapman's Pool. Oil on board, 12 × 10 in (30 × 25 cm), Richard Pikesley.

Grids, emphasizing the vertical and horizontal division of the painting, are an often-used starting point and with good reason. Trees in a landscape or buildings in more urban settings give us lots of vertical lines and the horizon is a very compelling horizontal. Paintings built in this way often emphasize the picture surface.

I use the word 'tunnel' as shorthand to describe those situations where perspective creates a sense of a strong movement away from the viewer. Horizontal and vertical lines play a less prominent part and there's probably a strong sense of knocking a hole back into the pictorial space. Painting by the coast as I do, my third category of 'hook' is most familiar to me in landscapes that curve round to a coastal promontory, but they also pop up in other situations where there's a feeling of the landscape wrapping itself around the viewer.

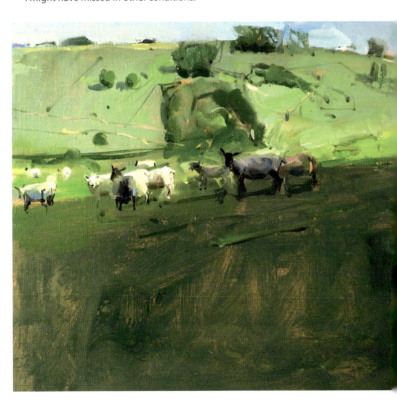

Ewes and Lambs, Shadow Edge. Oil on board, 12 × 13 in (30 × 35 cm), Richard Pikesley.

WEATHER AND LIGHT

Choice of a viewpoint and how you might frame a subject are intimately tied up with other factors. A subject that might seem quite commonplace in flat light can be brought to life by cast shadows, which give a sense of geometry and structure. The reflections of a wet day or the transformative effect of a fall of snow will reveal exciting subjects to paint which might otherwise have gone unnoticed.

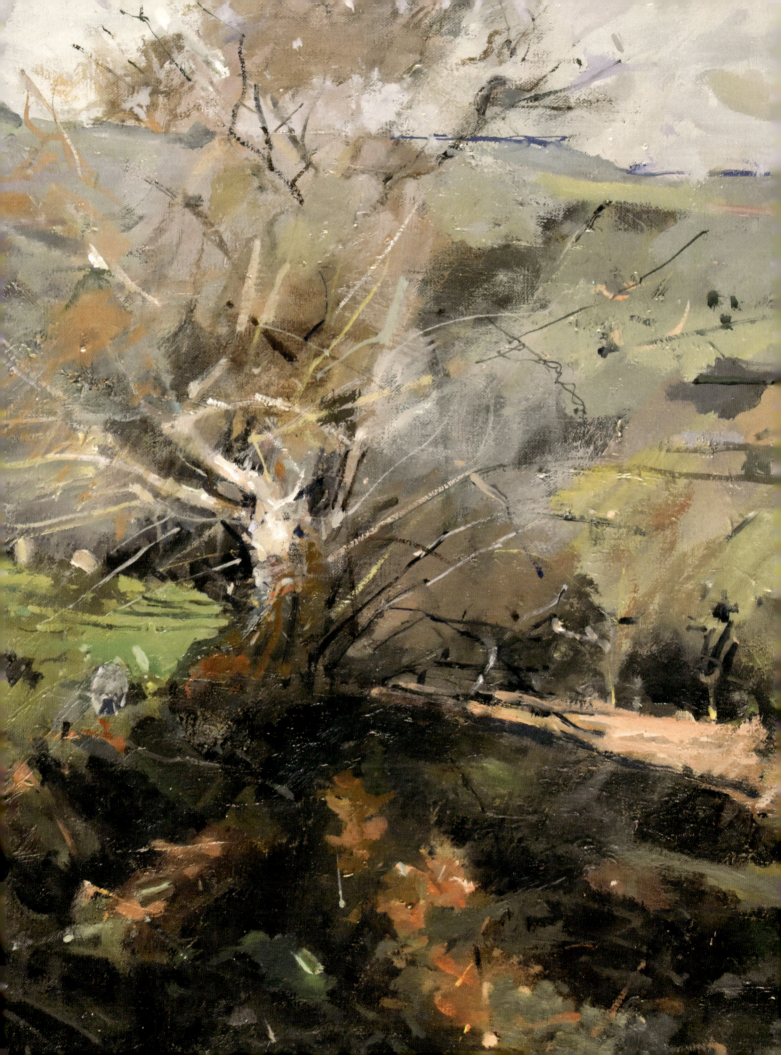

Studies and Process

A lthough much of my work is done on the spot, there are times when I choose to work in the studio from studies made on the spot. There are times when the weather turns against me or I don't have sufficient time to complete something on location. As we've discussed before, bigger paintings are more likely to be painted in the studio as their demands on time and the amount of kit needed make it unlikely to be made entirely in front of the subject. I don't, by any means, expect that every piece of work I start will end up framed and in an exhibition. Far from it: the daily work is partly like a musician playing scales, but more importantly for me it's a way of thinking visually, getting an immediate reaction to something seen down on paper or canvas, without too much thought about where a little seed of an idea might take me. Talk to ten artists and you'll find ten different ways of working. For some, studies are a rehearsal for the main event, while for others, they're valued as a way of storing visual memories until they can be brought together in the studio.

So these drawings and colour notes may be made for a host of different reasons; sometimes the need is for a well worked-out piece of drawing or compositional study. At other times, however, it's that first flash I want to get down, that first glimmer in the corner of my eye when I know I've seen something good. It may only be six lines drawn hastily on the back of an envelope, but can be the key to unlock how the subject will be revealed.

◾ *Dorset Landscape, Early Spring*. Oil on canvas (detail), Richard Pikesley.

GETTING ENOUGH INFORMATION

I find that simply trying to square up a little painting to enlarge into a bigger one doesn't really work for me. I've talked in Chapter 9 about the differences between a small and a large painting being not solely a matter of size. If I know I want to make a large painting in the studio, I'll generally collect information to make that process more straightforward. I will, of course, focus my attention around the aspect of the subject that excites me, so quickly made tonal or colour studies will be particularly valuable as I try to understand the light at a particular moment. But by slowing down a bit, there's a lot I can do over a longer time span. A line drawing might take me a whole day, but I can take my time, knowing that the edges and structure I'm recording aren't dependent on a momentary light effect. Spending a longer time at a place may reveal other ways of interpreting the subject as its appearance alters through the day. I tend to go for heart first, then head. The value of a small oil painted fast in rapidly changing light is that it has the immediacy and brevity of an emotional response with all its signs of struggle. In a situation where I need to record extra information to enable me to paint in the studio, I'll often take a whole day to visit a location again to make a more thoughtful drawing, concentrating on aspects of the subject which aren't solely due to fleeting effects of light.

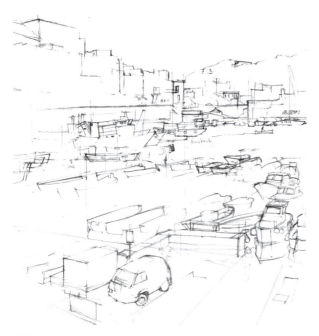

■ Carefully made drawings of complex subjects are a good starting point for work in the studio.

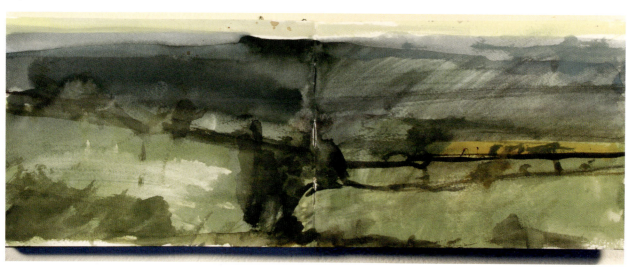

■ Sketchbook drawings and colour notes, however slight, are great memory joggers and often grab the essence of a first encounter with a subject.

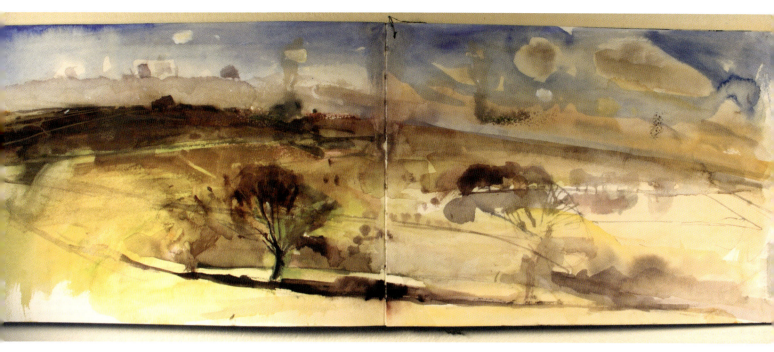

■ The hard paper allows me to draw and add colour.

SKETCHBOOKS

I don't really like the word 'sketchbook' as it implies that there's something trivial about this aspect of painting. However, whatever the word, I use these all the time and if my studio was on fire they would be the thing I'd choose to save from the flames. I've used lots of different types and sizes over the years though I've now settled on hardback books of good cartridge paper for drawing and watercolour books made up with hot pressed paper. These are very versatile; I can draw or use watercolour or gouache and they're robust enough not to fall apart in my painting bag. The work done in these little books serves many purposes: a quick note of something to help fix it in my memory, a reminder to come here again or a piece of drawing to establish how the perspective works. There are as many reasons as drawings, but for me it's what I do and who I am – particularly on days when the rest of life gets in the way it becomes a continuing thread and a visual diary. The books are part of the process of making paintings, but they're also a way of keeping my eye in tune and provide me later with a rich source of

reminders of particular places and days. In many ways, these little books are the most private part of picture making. When I'm done I can close the book and no-one else has to see it, so I'm free to experiment and play. Some of my favourite pages in my own books would mean very little to anyone else; the important thing is how they work on my visual memory.

During a day's painting, where I'm working in either oil paint or watercolour on an easel, I'll nearly always have my sketchbooks and appropriate media within easy grabbing range. A momentary incident, or an idea for a future encounter need to be noted fast before I forget, and it's good to give your eye a rest from the main event now and again so that it's seen afresh when work is restarted.

Books for drawing in must be made of decent paper and with a robust spine and covers. Much as I like the idea of spiral bound books which will lie flat when previous pages are folded back, they can tend to self-destruct, with the metal spiral binding coming away from the perforations at the spine.

A PLACE TO WORK

STUDIO SPACE

As noted in an earlier chapter, I'm very lucky to have a big space to work in. More room brings lots of advantages: it's easier to arrange storage for materials and kit and I can step right back from a painting in progress to see how it's going. There have been times in my painting life when I've had to use a much smaller space or set up in the kitchen only to have to put everything away at the end of a session. The disadvantage for me of having a lot of room is that it can get very untidy before I have to straighten things out, and then I lose a day's painting. So what follows is a description of something ideal, but for most of us, we just make compromises. Ideally, it's good to have a room where work in progress may be left until you're ready to continue. Stepping through the door into your studio it's easier to mentally prepare for the day ahead, rather than having to work out of boxes.

STUDIO FURNITURE

A good studio easel which will hold your painting securely and which can be adjusted to give a comfortable

Two easels set up side by side allow supporting material to be seen close to the painting in progress. My palette is clamped onto the front of the easel, exactly where I want it.

working height is a great help. Mine is a huge Victorian model with plenty of adjustment to wind it up and down and to tilt the uprights forward or backward a little if necessary. Its size does mean that a high ceiling is essential. I've mounted mine on lockable castors so that it can be rolled out of the way when not in use. The castors have a lever that locks the two front wheels so that the easel is rock steady when in use. Good easels have an adjustment that allows you to vary how close to vertical the canvas is held. Sometimes reflected light from the surface of the painting can be a nuisance and raking the painting slightly forward at the top can help, but remember to have it well clamped. A second easel on which to support any working drawings or studies as close to your eye line as possible is also very handy. It's good practice to have your palette very close to the painting, so it is worth giving some thought to how it will be supported. A big kidney-shaped palette may be held in your non-painting hand but this limits your movement and can be a strain if you paint all day. My solution is to clamp my large rectangular palette onto the easel. It's held firmly and close to the painting to reduce the distance my gaze has to move between palette and painting.

Remember you need space to get back from your easel, as sometimes it can be hard to read a whole painting when you're very close and working. Clear space behind you will encourage you to step back regularly to look from a little further away. An alternative to an easel if space is tight is to work on the wall, and it is quite easy to arrange a shelf at a comfortable working height with some means of locking the top of the painting.

HAVING PAINTINGS VISIBLE

I've built racks around the studio, where finished and framed work can be stacked safely, ideally stood upright and alternating face and back, to reduce the risk of the fittings on the back of one frame damaging the one it's leaning against. They can be stored in bubble wrap or padded envelopes for extra protection. As I tend to have a

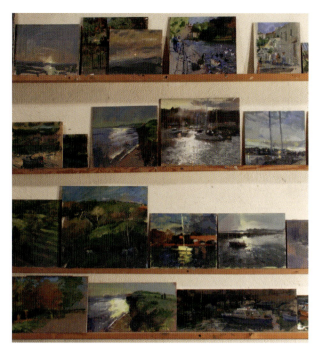

Battens on the wall turn the studio into one big sketchbook. Paintings are there to dry and more importantly to keep them in view.

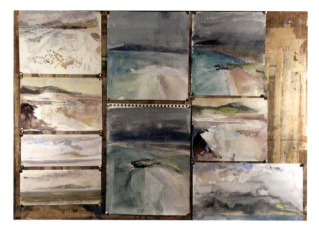

Watercolours from a painting trip pinned to a drawing board, where I can see them.

Thumbnails of paintings as I assemble work for an exhibition. It's very useful to be able to see a whole show on a couple of A4 sheets, even if the paintings aren't yet finished.

number of paintings in progress at the same time, shelves to place wet paintings on and have them visible are a great asset. In my studio these are high up; below these I have screwed narrow wooden battens on which I can sit all the little panels to dry. Another advantage of this set-up is that when I am working towards an exhibition, all the current 'candidate' works are visible.

Returning from a painting trip I'll have a batch of work ranging from very slight notes to finished paintings. Amongst all of this there will be things I want to use as material for studio paintings, so I'll keep these together in batches with any sketchbooks used, and find a way of displaying them if I can. The watercolours made on a trip to the Hebrides are pinned to a big drawing board and one or two have the potential to be developed into larger paintings. It's almost inevitable that if you work in oil paint you are likely to have a few paintings in progress at any one time. Different pigments and painting media dry at different rates but with my materials I find that I may get a day, or possibly two to work on a painting in its first 'wet', before it becomes sticky and unresponsive. Allowing the paint surface to dry thoroughly before I

can work on it for another day may need an interval of a couple of weeks. My solution to this is to have a number of paintings under way at any one time, and this means being organized. It's very frustrating to have time to paint but not to have a canvas or board of the right size or proportions, so time has to be set aside for preparing boards and canvases so that I always have something to pick up and work on.

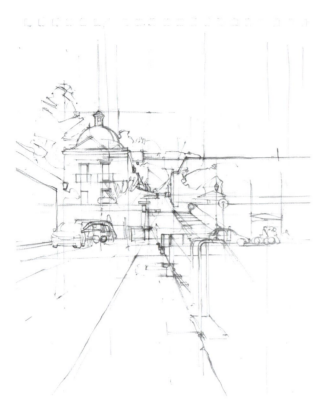

The drawing of the Isola di Ponza subject as it was made in my sketchbook.

I've found another way of keeping track of what I'm doing is by photographing paintings either in their finished state or at each stage of a more complex studio painting. These photographs can then be printed as little thumbnails, and often I'll start to make decisions about grouping paintings within an exhibition by printing their images on A4 sheets.

NORTH LIGHT

Buildings constructed specifically as artists' studios were usually designed to be lit from windows on the north side of the room. This allowed the steadiest possible, shadowless daylight throughout the day. For those lucky enough to have such a space its benefits are much appreciated, as good consistent daylight is a huge asset. The building I use wasn't built as a studio and is lit by big windows at its western end. Throughout the summer the sunlight streams in and at times can make work inside difficult. In spite of this, I've learnt to love this quirk, and many of my interior and still life paintings celebrate the splashy intensity of direct sunlight. It could be controlled a little with gauze curtains, but I've never got around to installing them. Pretty much any space can be made to work with a little ingenuity.

USING SOURCE MATERIAL IN THE STUDIO

Unless you confine yourself to only working on the spot, an important part of your working practice will focus on how you use material recorded on location once back in the studio. You may, for example, have a small drawing which needs to be re-stated on a bigger scale. Once the composition is settled it can then form the basis of the painting. Remember that it's important that the little study and the enlarged painting should be in the same proportion, and that canvas stretchers increase in 2-inch steps. This may mean that these constraints may have to be considered when settling the dimensions of the little study (though when enlarging onto board or paper which can be cut, this won't be an issue). The quickest way of reliably making an enlargement is by squaring up. There are a number of ways of doing this but I'll show you my favourite which involves very little measuring.

Enlarging a drawing

■ Ideally, you want your drawing on a separate sheet, so if it's been drawn in a sketchbook, make a photocopy and mark an accurate rectangle exactly on the edges of the composition. Trim the photocopied drawing to this line.

■ With a ruler and a sharp pencil or fine pen, draw two diagonals to find the centre.

■ Now draw a horizontal and vertical line creating a sort of Union Jack arrangement. As you do this you'll need to measure to make sure these two lines are exactly horizontal and vertical. From this point on there's no more measuring.

■ Draw the second diagonal into each of the four rectangles.

■ Lay a ruler across the new centres and draw horizontal and vertical lines.

■ Repeat these two stages until you have eight rectangles across and eight down, sixty four in all. If one area is particularly intricate you can divide it further if you wish, but most of the time sixty-four rectangles will be plenty.

If you're working on a sheet of paper or board, lay the squared-up photocopy exactly on one corner. Using a long straight edge laid exactly on the long diagonal on the photocopy, extend this line across your big sheet until it cuts the edge of the paper. Using this point where the long diagonal cuts the edge to mark the limit of the composition, draw a line across the big sheet or trim to size. If you're working on a canvas you'll have already chosen a canvas whose proportion is the same as your drawing, so you can miss this step. Writing this out, it seems quite a lengthy process, but with practice, it's very quick, and certainly a lot quicker than guessing and getting it wrong a few times!

The point of squaring up is to preserve the accuracy and compositional values of a small study and repeat it on any scale you choose. The most usual way I'll use this technique is to enlarge a small study to paint bigger in oil. Investing this effort in getting it right gets me off to a flying start and means I can work surprisingly freely as I start to transcribe the image in paint. It's important not to feel inhibited by having to stay within the lines of the squared up drawing but to use the paint generously; on occasions marks in paint will spill across the drawn lines and as the new painting develops these lines will be obscured. However, I still have my squared up drawing and it's a simple matter to draw again in the same way as before, over the top of the paint if I'm in any doubt.

The drawing I have chosen to demonstrate the squaring-up process is of the quayside in a Mediterranean sea port. Before the drawing I'd made a little painting on the spot, excited by the pattern of light and dark offered by this view for just a brief time in the morning. The subject was backlit and two interlocking rectangles of brilliant reflected light from the quayside and the sloping road beyond caught my attention. It was only about half an hour before the sun's axis had changed too much to continue on the painting. The drawing followed after the excitement of the little painted study, as I returned to the same viewpoint several times over the coming days and added a few more lines each time. Further painted studies of backlit figures in a sketchbook were also made. With the gridded up drawing repeated onto my canvas and all the other source material assembled where it can be easily seen, I'm ready to start painting.

BUILDING IN LAYERS

As I progress from session to session with drying days in between I remember to paint 'fat over lean', adding a little more oil-rich medium to the turpentine in my dipper with each wet. It is important that the paint isn't built up too much in the first layer if you know it's going to take a number of sessions. By about the third session I'll be using just my medium to loosen the colour a little, adding no extra turpentine or solvent. At this stage the paint can be applied quite freely, confident that the underpainting layers have been carefully managed. As I continue to work I can experiment with adding figures, happy that these can easily be scraped out and moved as the design settles down. The painting I've chosen to feature in this demonstration was well prepared with drawings and *plein air* oil studies so was largely a process of enlargement and adding some of the incidental groupings of figures and other traffic that I'd noted down on site.

I've often heard the advice not to overwork the painting, but I disagree, as long as I can regain the quality I want at the end. However, it's not at all uncommon for a painting to have a sort of mid-life crisis and I've learned to expect that at some point during the process I'll be dissatisfied with how things are progressing. I think this can be understood as a sort of change of focus. At the start, I have the whole thing in my head in a very complete image. The first day's work will be a process of blocking in and the painting will quickly gain a sense of wholeness that may slip a little as I work through subsequent 'wets'. Inevitably, I have to concentrate my attention on all the component parts and it's easy to lose sight of the whole thing. It's worth being brave and not too precious about things and I'll often wipe or scrape big areas out and restate more simply. This is always much more straightforward than I expect it to be. It's only paint and I can put back what I've lost quite easily.

It's not always clear how many sessions I'll need or even if I'm getting close to finishing. The difference between things seeming hopeless and being just right can be surprisingly slim, so if you sense you are getting close remember to put your brushes down regularly and step back for a good look.

Step-by-Step
Onto the canvas

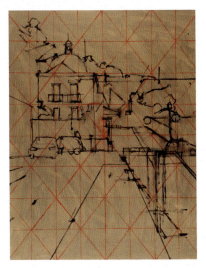

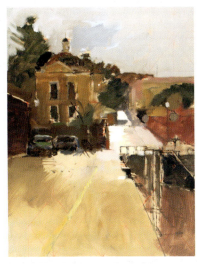

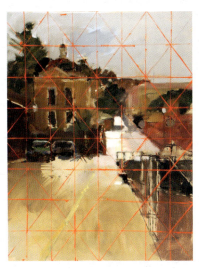

■ Once the drawing has been carefully gridded up into sixty-four rectangles I'm ready to repeat the image onto the canvas. The canvas chosen is in the same proportion as the drawing and has been prepared with the usual imprimatura wash of a neutral colour and left to dry. Exactly the same process is used to draw the grid onto the canvas, except this time I use a fine rigger brush and red oil paint.

■ With the grid complete, I can work from square to square, copying my drawing until the whole design is established. Now the canvas is set aside for a day or two to dry.

■ As the image starts to take shape I find I am losing some key bits of drawing and my grid. If this is a problem I can simply draw the grid again and reinstate any key bits of drawing that are getting lost. Once again, the painting is set aside to become touch dry before the next session.

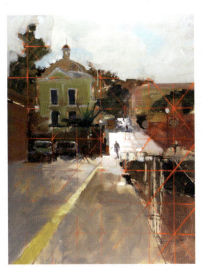

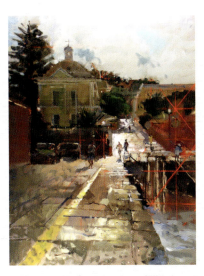

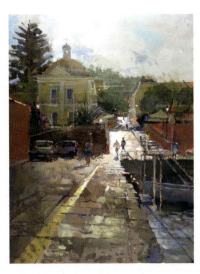

■ It's time to assemble all my source material and with a loaded palette I can get to work. I try not to be too constrained by my drawn lines and let the paint spill across them in places. At this stage the paint is thinned a little with turpentine plus a little medium.

■ Now working from all my assembled source material I can push on quite quickly having built a solid foundation. If I lose my way I have enough material to quickly re-state an earlier stage.

■ *On the Waterfront, Isola di Ponza*. Oil on canvas, 24 × 30 in (61 × 76 cm), Richard Pikesley.

■ Oil colour at the end of a day's work, tidied onto a spare palette and saved under clingfilm.

At the end of each day, or more frequently if necessary, I'll clean my palette. Usually, if this happens during a day's work it will be prompted by things getting just a little too crowded. I'm careful to reserve any puddles of pre-mixed colour as it saves me a lot of time and keeps the continuity of colour from one session to the next, and oil paint is too expensive to keep throwing it away! To preserve the colour from one day to the next, I gather it up onto a spare palette and cover it with clingfilm.

USING GLAZES

Before Impressionism it was normal practice for oil paintings to be built up a bit like watercolours using layers of transparent colour to modify the underpainting below. In watercolour these would be called 'washes' but in oils the term 'glaze' is used, reflecting the glass-like brilliance of effects that could be achieved. These can be used in a number of different ways and my own use is confined to occasions when I want to darken or change the colour of a fairly large area of an ongoing studio painting. The most transparent tube colours should be used to create glazes which darken or adjust the layer below. The usual 'fat over lean' procedure must be followed, so glazes tend to be used later on in a painting's development. My own glaze medium is a mix of oils and varnish, but the oil painting medium produced by the major paint manufacturers works perfectly well. The reason the Impressionists turned away from this procedure is that it can't be used very satisfactorily *en plein air*, as each layer has to be allowed time to dry fully before the next glaze can be applied. They also realized that applying layers of glaze tends to reduce the variety and richness of observed colour. Used sparingly, however, it still has its place and can be used to great effect to unify a painting that's become a bit fragmented.

AN ONGOING PROCESS

Not every start leads to a finished painting ready for inclusion in an exhibition. There's a great deal of other activity that is part of the process and it's typical for me that even when I am fully engaged with making a painting on location, my antennae are twitching as other possibilities occur. I have had the experience before now of turning to look behind me as I pack up at the end of the day to see something spectacular that I hadn't previously noticed. Now, rather than being too cross at a missed opportunity, it just goes on a mental list for a return visit. My studio can be a slightly bewildering place for a visitor. I use its walls as a sort of visual diary with many fragments and half-done paintings visible on battens and shelves. I will know which of these are ready to frame; there will be others, though, which are there to act as a prompt to go back and have another look somewhere. Much of what's on view may well be failures, things that I haven't been able to resolve, but most of these will have some little thing within them that pleases me. In the run up to an exhibition I do things a little differently and only those paintings that are likely to be included in the show will be kept visible. An exhibition will perhaps require about fifty paintings and once I've got fifty spread around the studio, if I then do another one which I think is a better fit in the group, I'll swap it for one that pleases me less. Eventually, the exhibition takes on its finished form and individual paintings relate to one another and find their place in a show which I hope has variety, but also the feeling that it's been made by the same pair of eyes.

Building with glazes

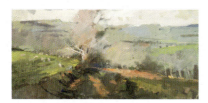

■ This big painting was started on location and given time to dry, and return visits to draw and make colour studies enabled it to be finished in the studio later.

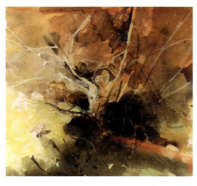

■ Colour study.

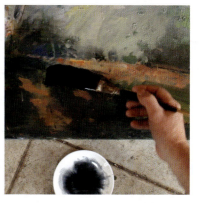

■ Tube oil colour thinned with glaze medium in a white saucer; applied with a soft brush, initially rather dark. The painting is laid flat on the floor or on a table to stop the paint from running.

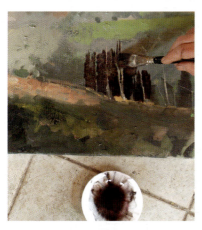

■ Manipulated with a brush, colour is placed to darken and tonally adjust the underlying paint layer.

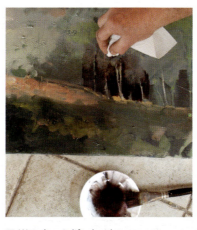

■ Wet glaze is lifted with a paper tissue to leave the amount of colour wanted.

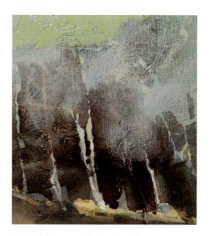

■ This close-up shows a small area following the addition of glaze.

■ *Dorset Landscape, Early Spring*. Oil on canvas, 18 × 40 in (45 × 103 cm), Richard Pikesley.

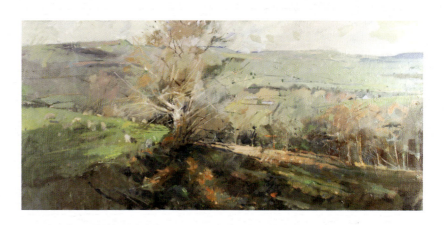

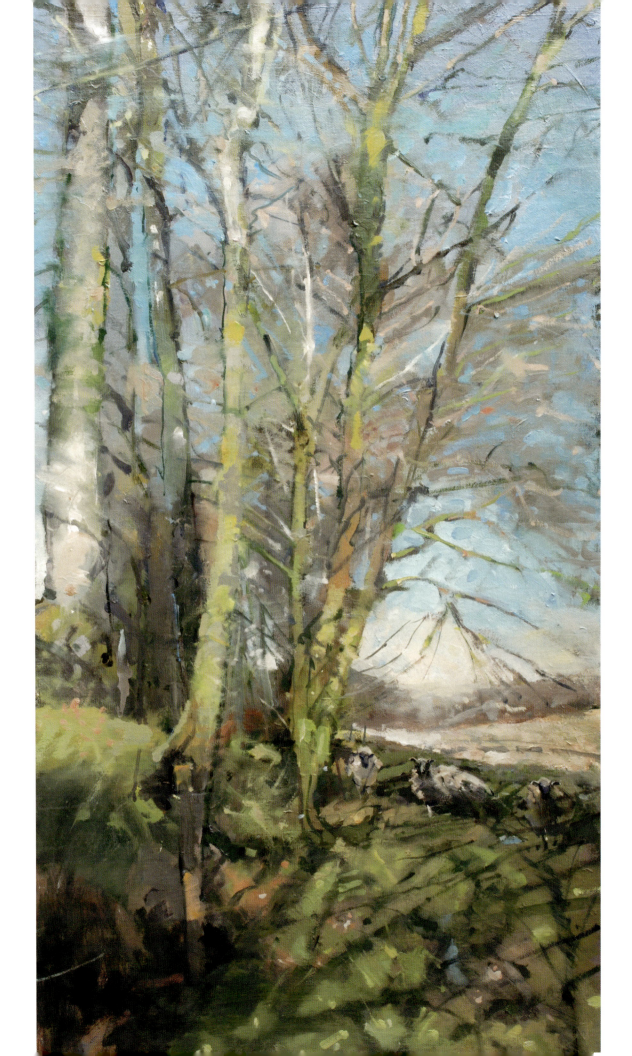

Finding a Language and Finishing a Painting

Walking around a mixed exhibition in which many artists' paintings are displayed can be a great education. As well as probably having quite clear reactions about which works you do or don't like, focus on how you can tell when you step from a group of one artist's works to that by another hand, and try to see just what it is that makes each painter's work unique.

There can be a lot of pressure to find your own style and for a young or novice painter this can be unsettling at a time when there seems to be so much to learn. My advice would be to ignore these voices and allow your paint handling, your choice of one subject over another, and your chosen medium and the tools for its use to slowly

weave a manner of working which is undoubtedly you. Just like handwriting or your signature your painting will express your personality in a way which is quite impossible to fake. Having received a good training at the start of my career I can still remember the advice of a valued mentor who said I should just paint as much as I could, but to do nothing bigger than 10 × 12 inches for a year, at the end of which I would have a few things to sell which wouldn't be too expensive to attract buyers but more importantly would hone my instincts and intuition and allow me to discover what sort of painter I was to become.

In no hurry to settle into a recognizable style you are free to experiment and play for as long as you like with no pressure. Sooner or later this issue will take care of itself as your work will become more distinct and very much your own. While there may be some conscious decisions along the way, for the most part your work will start to speak for itself.

■ *Dartmoor*. Oil on canvas, 36 × 20 in (91 × 51 cm), Richard Pikesley.

REFINING THE LANGUAGE

■ A close look at one of my oil paintings shows my 'handwriting'. Years of working moulds every artist, and everyone's characteristic way of handling paint becomes as unique as a thumbprint.

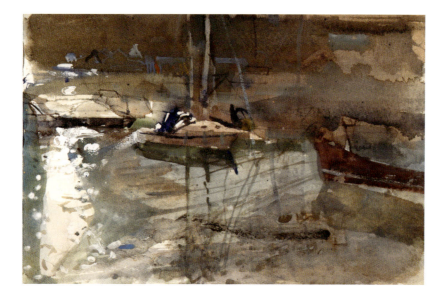

■ A page from a sketchbook where I'm working as fast as I can in rapidly changing light. Even though here I'm using a mix of pencil, pastel, watercolour and gouache, the handling is quite similar to the previous example.

Like handwriting, or our habits of speech, a lot about the way that we handle paint, making marks and building images, may seem to have a life of its own and be outside our control. The difference between a competent piece of representational painting and an exceptional one happens at the point where the acts of seeing and making collide. A sensitivity to the way that paint marks build a coherent world is a vital part of this, but it's not just about lovely paint. Part of the role of the medium is to be almost invisible, allowing us to see through the surface of the flat canvas to an imagined, three-dimensional world beyond. In apparent contradiction of this, I'd also recognize that this can happen just as convincingly with a broken and craggy surface as with a completely smooth one.

This aspect of painting is something that can't be forced; it emerges over time and is part of the fluency that comes with experience and is too personal to be taught in great detail. Looking at paintings and trying to figure out how they work can be a great help.

EDGES AND BOUNDARIES

It's all too easy to get stuck inside a drawn line. I've often seen painters making drawn marks first, even if quite

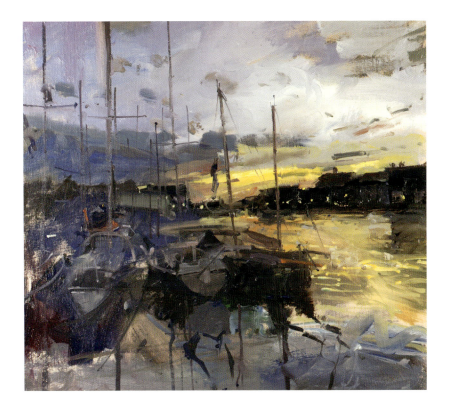

■ *Last Light, Summer Evening, Weymouth Harbour*. Oil on canvas, 16 × 18 in (41 × 46 cm), Richard Pikesley.

carelessly, and then just filling in the shapes with colour. The flow of space then comes to an abrupt stop at every boundary line and there's often a small gap around the line. Better to let each brushstroke just push across the edge into the patch of paint next door. Edges then have a sense of growing out of the paint rather than being forced. The way that the transition across an edge is handled can say a huge amount about whether it's describing an abrupt edge like the top of a fence or a soft ambiguous change of a hillside that just turns away from you a little. If you're used to figure drawing, this sort of sensitivity to edges becomes second nature and figure drawing is a surprisingly useful discipline for any landscape painter.

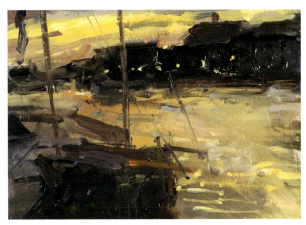

■ A small detail taken from the previous image showing little change in the paint handling as I move across boundaries from one area to another.

DIRECTION OF MARKS AND CHANGES OF GEAR

Brushstrokes which change direction at each contour can disrupt the sense of continuous space, and marks which run lengthways along a narrow shape will always look weak. Better to work across these narrow shapes when you can to keep things looking more robust. Beware too

of 'changing gear' as you cross a boundary or move from one section to another. An example would be across a horizon with side to side strokes below giving way to more blocky treatment of the sky. If the paint handling stays in one consistent manner across the surface of the painting irrespective of the object being depicted the feeling of space and depth will be more natural and convincing.

Now none of the above are hard and fast rules, but may be used as a starting point when considering paint handling. Best of all, experiment and see what works for you, alongside developing a rather forensic approach to looking at the work of other artists, both in museums and contemporary exhibitions.

HANDLING WATERCOLOUR

Watercolour can be manipulated in lots of different ways. It can be built up in overlaid washes, with each allowed to dry before the next is applied, or painted 'wet in wet', where strokes and washes of wet colour are allowed to touch and run. I don't mind too much if 'cabbages' appear in my washes but it's useful to know that these form when washes of colour are over-diluted with too much water, so if you find these disfiguring they can be avoided by thinning the colour just a little less. Pure watercolour, in which no white pigment is used, relies on reserving the white of the untouched paper by either using the faintest pencil line as a guide or by going straight in with the brush, relying on your ability to see the drawing in your head. I often start with pure washes to get things moving quickly, but I'm relaxed about introducing white or incorporating gouache in the mix. Best to experiment and find out what works for you.

■ *Man on a Beach*. Watercolour, 26 × 35 in (66 × 90 cm), David Firmstone.

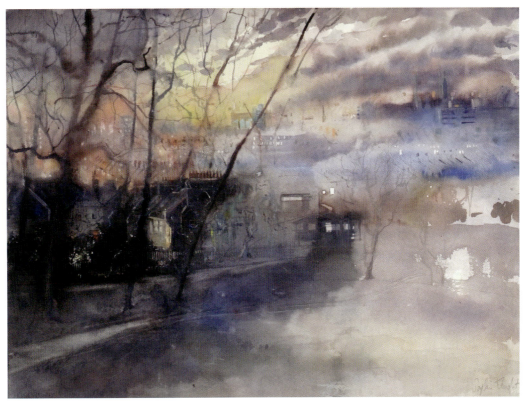

■ *Day Turned into Night, Little Lights Appeared in Distant Windows. Mounts Field Park, South London.* Mixed media on paper, 22 × 30 in (56 × 76 cm), Sophie Knight.

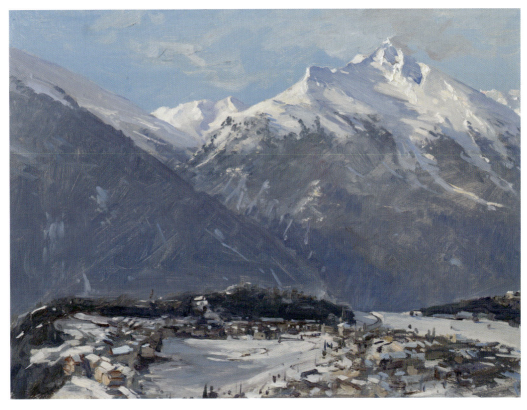

■ *Aussois, French Alps, March 2018.* Oil, 12 × 16 in (30 × 41 cm), Peter Brown.

Chapter 12: Finding a Language and Finishing a Painting 207

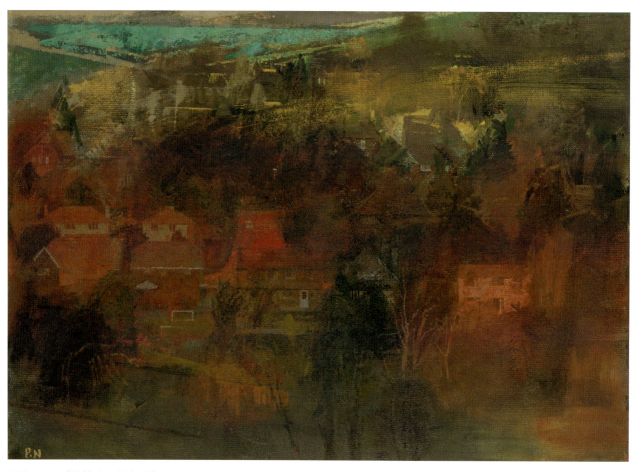

■ *Houses and Fields, Last Light*. Oil, 11 × 14 in (28 × 35 cm), Paul Newland.

KNOWING WHEN IT'S FINISHED

Working out of doors on smaller paintings, things naturally seem to come to some sort of conclusion when with changing light a piece of work is set aside and another begun. It may be that it will need a return trip, or a few touches from memory or sketches back at the studio, but it's one of the delights of working on the spot that the challenge of working in this way makes the painter edit and abbreviate and gives the little work a sense of wholeness and completion.

It's another story with paintings made in the studio, however, especially when working from multiple sources. You'll often hear the criticism that a piece is overworked, and I think this refers less to the amount of effort expended as to the fact that too much time has allowed the artist to go off at a bit of a tangent and miss the point of the original vision for the piece. It still surprises me that I can think I'm miles away from completing something and I make a very minor adjustment and all of a sudden I'm there and can put my brushes down. There are, however, occasions when I think I can improve something and it just becomes over-elaborate and needs knocking back again with big brushes before I can bring it to a close. There will be many moments when you're just not sure and that's the time to put the painting out of sight for a week or more before looking again. When you see it fresh after some time away, you'll know in an instant whether it's finished, and have a better idea of what it needs – if more work is needed. Seeing the work reversed in a mirror can also help, as can taking a photograph of the painting, especially if the image is cropped to the edge of the canvas to remove any distracting background. Temporary framing can help, too, and it's worth keeping any discarded frames in a few shapes and sizes for this purpose, to help you focus on the image.

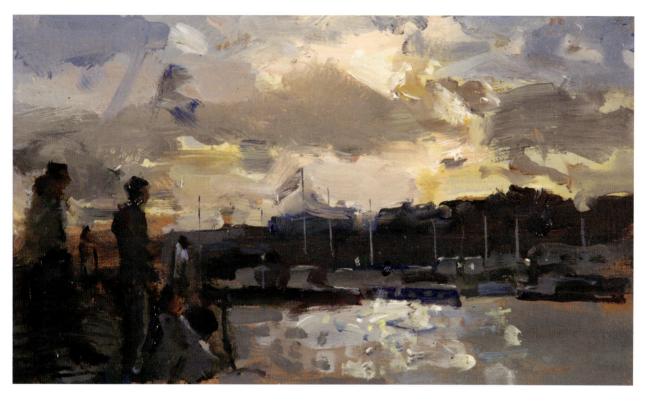

■ *Evening Harbour, Jurassic Coast*. Oil on board, 7 × 12 in (18 × 30 cm), Richard Pikesley.

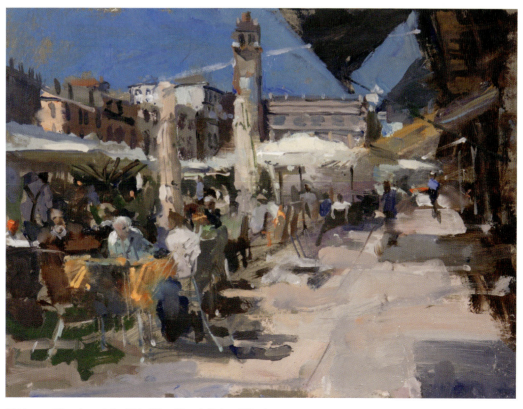

■ *Verona*. Oil on board, 9 × 12 in (23 × 30 cm), Richard Pikesley.

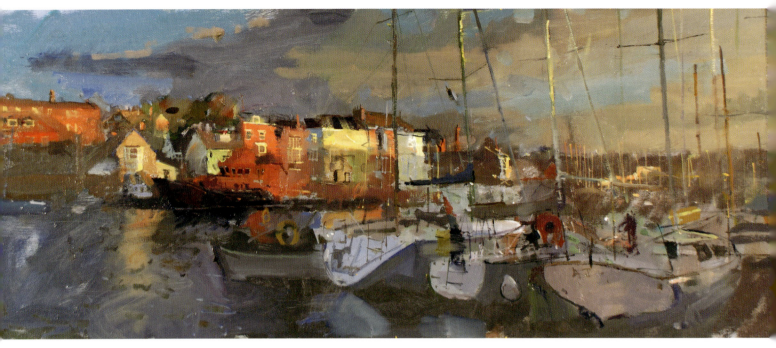

■ *Lifeboat and Visiting Yachts, Last Light, Weymouth Harbour.* Oil on canvas, 18 × 48 in (46 × 122 cm), Richard Pikesley.

EXHIBITING YOUR WORK

There are many exhibitions which accept work from an open submission and these are a good way of getting your paintings seen and hopefully making a few sales. But their biggest attraction is that as an exhibitor you are starting to be noticed, and private views at such exhibitions are a great way to meet other painters and gallery folk. If you do receive an approach from a commercial gallery, don't expect to be offered a solo exhibition straight away. A safer and less stressful route for both parties is for the gallery initially to include your work in its mixed exhibitions and as gallery stock before progressing to maybe a three-artist show. Very few galleries or dealers buy from the artist, so holding your work on a sale or return basis is the normal arrangement. After forty years of working with galleries I've made some very good friends and have only shown where I feel I have a rapport and complete mutual trust with the gallery proprietor. I don't begrudge one penny of their commission – usually 40 per cent or more – as they do all the work of contacting prospective buyers and carry all the risk of promoting the exhibition.

■ Exhibitions with selection from an open submission offer a good way to reach a wider audience. (Image courtesy of Mall Galleries/Federation of British Artists)

OPEN STUDIOS

Another option may be to open your studio to the public, and many towns and counties have open studio weeks which make this an attractive proposition. There's usually a guide published in which all the venues are listed, and these events can bring in buyers who welcome the opportunity to spend a week visiting creative artists and seeing them in their own workspace.

ART SOCIETIES AND PAINTING GROUPS

There are art societies in most towns and many more informal groups of friends who paint and perhaps exhibit together. Having other painters to talk to can be a massive help and discussing what you are doing is a great way to crystallize your own ideas as well as listening to an alternative view. Painting is necessarily a pretty solitary business for most of the time, so this sort of contact and conversation can be very positive when the opportunity arises.

PRESENTING YOUR WORK

Even when you've finished a painting that you want to exhibit there are still many choices to be made that will determine how your work is seen. Inappropriate frames, an overly flamboyant signature, poorly executed varnish, and many other pitfalls can quickly undo all the earlier hard work.

Keeping your presentation simple is a good start. Frames should be well made but unobtrusive. Watercolours should be presented with simple window mounts under glass with unfussy frames. If frames are coloured and gilded they must provide a platform for the painting rather than competing with it. Using acid-free boards for mounts and backing will further protect your work on paper.

CROPPING WORK ON PAPER

It's unusual for me to mount and frame a work on paper without first considering how it might be cropped. Quite often, a big watercolour that hasn't quite worked, perhaps because it's become too complicated, will contain within it a much better painting. There's a temptation when working on paper to just keep going until you hit the edge of the paper and unless there's been a lot of thought beforehand this can lead to a rather arbitrary composition. In my studio I have a mount cutter and always keep lots of mounts, either too grubby to use or mis-cut; these can be very handy to try out different crops to a painting before it goes under the knife. It may be that having started a painting with a single clear idea where it

might go, I've got side-tracked into having an extra focus which is fighting the main story. My initial reaction is that I want to keep everything, but ten minutes playing with some spare mounts might tell a different story. Once you start to do this you will quickly realize that there may be several ways of cropping an image, each of which is an improvement on the full sheet – but you'll have to decide which one to go for!

You may wish to offer watercolours and other works on paper for sale unframed. Some galleries will offer this to their exhibitors and have browsers to accommodate mounted but unframed works, and it's also a good way of offering work for sale from your studio. The paintings and their mounts should be protected using acetate film, neatly secured at the back of the mount to make a sealed envelope that allows the work to be clearly seen but offers some protection. Include a backing board behind the mount to protect the back of the mount and the painting. Adhesive labels can be used to display the details of the work and maybe a short biography of the artist. Such works will cost you less to present well and may be sold for a little less, a good thing when you're trying to attract buyers. Cutting window mounts isn't a particularly difficult skill. I now have a mount cutter but for many years managed with nothing more than a craft knife and a nice heavy metal straight edge. Mountboards are available from art shops and heavier grades from specialist suppliers. Avoid darker or brighter colours; a pale off-white board does a superb job of focusing attention on the painting and gives it a sort of weightlessness.

A mixed media watercolour drawing in which I've worked to the edge of the sheet without much thought about composition.

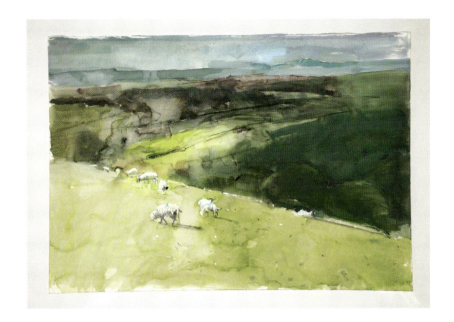

Two 'L' shaped pieces of mountboard allow me to consider my options for cropping the image.

A squarer crop shows an alternative solution.

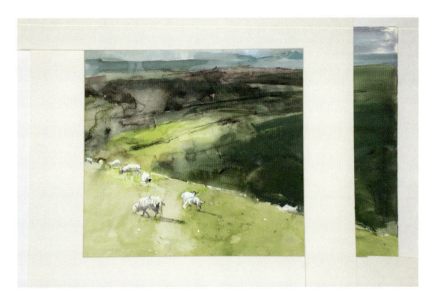

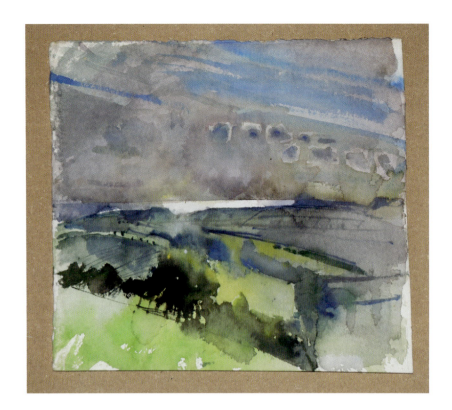

■ A small watercolour landscape.

■ A selection of various shapes and sizes of mounts helps me make a decision about how I should crop the image.

Oil paintings too might be improved by cropping. More difficult, though not impossible with stretched canvas, oil paintings on board are easier to cut down in the same way as watercolours. Playing with window mounts or laying sheets of white paper around the painting will soon tell you if you should leave things alone or make a cut. Edges of paintings are particularly important visually and it can be tempting to want to contain your subject with no vital component of the design being cut by the frame. Another lesson from the Impressionists, learnt by them from the twin strands of the newly emerging street photography and woodblock prints from Japan, was that their compositions gained another layer of vitality and reality by allowing the frame to cut through a figure or a sailing boat, resisting the urge to get it all in. Sometimes you might want to go the other way and it's not unusual to find paintings which have grown onto a second panel or sheet of paper. These can either be glued and assembled to make the joins disappear or framed as a polyptych with two or more panels framed separately but in a single outer frame.

Oil paintings on canvas can sag on their stretchers and it's important to put this right before they are framed. Canvas, even when it's been stretched drum-tight can go a bit baggy if the air around it dries. There are a couple of things you can do to rectify this, though bear in mind that when your painting leaves your studio it will still be subject to these changes. A bit like the old-fashioned guy ropes on a tent, canvas tightens as it absorbs atmospheric moisture and a roll of canvas stored in a damp room may need drying before you attach it to a set of stretchers. When the canvas dries further under studio or gallery lights it can sag. The easiest ways to deal with this are to add moisture to the back of the canvas; a damp sponge wiped across the back of the painting as it is laid face down can do the trick. You can also gently tap in all the stretcher wedges to tighten the canvas a little. Your framer will then leave a small gap in the rebate so that the stretchers can be tightened further if necessary.

Varnishing is necessary with oil paint to provide protection to the paint and also to unify its surface. I have a dislike of overly glossy varnishes but some degree of

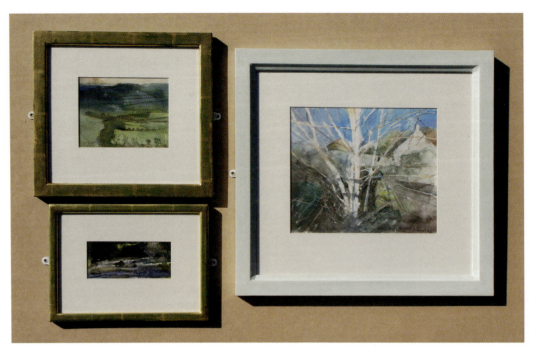

■ Three watercolours ready for exhibition. One has a simple painted frame whilst the other two are gilded. Mounts are made from a pale coloured mountboard.

sheen can be useful in giving the painting an even surface and helping the sense of the viewer looking into the space and depth within the picture. By giving the whole surface the same refractive index, a good varnish will immediately give the painting a sense of the space behind the frame, your pictorial space, being all of a piece. Finished picture varnishes should only be applied once oil paint has had six months to dry, so for most working artists is unlikely to be used before a painting goes off to an exhibition. Instead I use retouching varnish which can be applied as soon as the surface of oil paint is touch dry and can be diluted with a little white spirit to ensure that the thinnest layer is applied. It does an amazing job of giving a uniform surface to a painting which may have 'sunk' in patches as it's dried unevenly. Keep a good varnish brush which is used for nothing else and apply in broad sweeps, covering the paint with a thin layer, allowing it to dry

completely with the painting lying flat on a table. If you do have time to apply a finished varnish to your painting before it leaves your studio there are again a number of options. The most usual varnish is clear and glossy, and although it must still be applied as thinly as possible it does the vital job of unifying the refractive qualities of the paint surface extremely well. Another choice is a matt varnish, which can look very handsome but tends to emphasize the surface of the painting rather than creating an illusionary window for the viewer to look through. Varnishes from an individual manufacturer can be mixed to create intermediate degrees of sheen, but check with the maker's recommendations first. Varnishes may be available in a bottle for brush application or as an aerosol, which when used with care can produce a fine and even layer.

FINDING THE RIGHT FRAME

Once thought has been given to cropping, and oil paintings have been protected with a thin layer of retouching varnish, it's time to visit the framer. There's such a bewildering variety of framing styles to choose from that it may pay to spend time visiting exhibitions and getting an idea of how other painters do things. Most high-street framers will stock a large number of mouldings; many of these will be too assertive, heavily textured or just plain garish! Look instead for simpler timber sections, either stained or painted, which won't fight with your paintings. Big paintings can be framed with comparatively narrow mouldings but your smaller pictures may need something proportionally wider. There's a current fashion for sending unframed work to exhibitions and while this can work well for the right picture, a frame will do the job of separating the painting visually from the wall on which it's displayed as well as supporting the illusion of depth and space. As your work progresses I would strongly advise you to seek out the work of an individual craftsman with experience of making frames for artists, rather than a high-street framer whose work is mostly making one-off frames for consumers. A good framer with a sensitive eye can be such an asset and, along with the galleries where you show your work, is an essential part of the team.

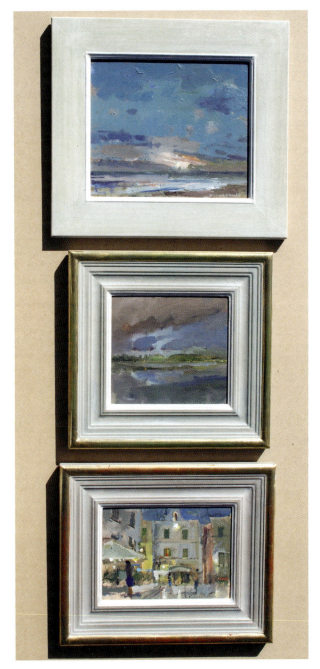

■ Three oil paintings in their frames. Small paintings like these sometimes benefit from proportionally wider frames than large canvases, which may work well with something rather thinner.

CONTRIBUTORS

Louise Balaam NEAC, RWA is a painter of expressive, gestural landscapes, who writes that she 'loves the way paint is simultaneously itself, essentially coloured mud, while also evoking the space and light of the landscape.' Working in the studio from drawings made in the landscape as starting points, for her the light is a crucial aspect of the emotional aspect of the painting. www.louisebalaam.co.uk

Peter Brown PNEAC, RP, ROI, PS Hon. RBA (affectionately known as 'Pete the Street') paints a great deal across the UK – its cities, landscapes and coastline and in particular London. He rarely paints from reference in the studio, preferring to work directly from the subject on site in sometimes the foulest of weathers, doing what he calls 'see and put'. www.peterbrownneac.com

Patrick Cullen NEAC is a painter in oils, pastels and watercolours, known for his scenes of Tuscany, Andalucia and Southern France, in all seasons and 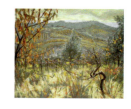 weathers. Over the past fifteen years he has also made a number of trips to India, painting and sketching in the streets and markets of Rajasthan and Gujarat. www.patrickcullen.co.uk

David Firmstone RWS MBE writes: 'All my work is concerned with landscape and seascape. I am fascinated by marks: the painters and those that humans make when they work the land. The spirits of artists and land workers past and present shape my view. I work on a large and small scale in oils, tempera and watercolour. I use tradition as my touchstone and modernism as my flight.' www.davidfirmstone.com

Sophie Knight RA(dip) RWS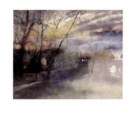
lives in London, but much
of her work is done outside
working directly from the
landscape or cityscape. Her
watercolours are worked in
an energetic and vigorous manner; squeezing paint
straight onto the paper, scratching in marks and
drawing directly with a brush, she aims to retain the
freshness and vitality of her visual excitement and
record the physical experience of working within the
landscape. www.sophieknight.co.uk

Paul Newland RWS NEAC
MA writes: 'I hope the work
speaks for itself. I sometimes
paint directly from things but
mostly, perhaps, I work from
drawings and studies. Often I am trying to combine
recollection and imagination with observation, in a
single picture. I am fascinated by the way we see, for
instance, a place – the ways in which our perceptions
are overlaid or conditioned by memory, imagination,
history and emotion.' www.paul-newland.co.uk

Melissa Scott Miller RP
NEAC RBA paints mainly
urban landscapes, specializing
in London where she was born
and still lives. Fascinated by
detail and effects of nature
on the man-made environment, her paintings have
a strong emotional charge. She works outside or
from high windows, often using tiny brushes as if
embroidering. www.newenglishartclub.co.uk

Toby Ward NEAC – unlike
many artists, Toby's working
life is propelled by commissions
and immersive projects which
give him a particularly strong
bond with each location where he draws and paints.
The panoramic drawing illustrated in this book
was made as part of a commission for The Lincoln
Historic Trust. www.tobyward.net

USEFUL CONTACTS

Bankside Gallery
www.banksidegallery.com
The home of the Royal Watercolour Society and
the Royal Society of Painter Printmakers and hosts
a number of exhibitions through the year which are
open to submission by non-members.

Daler-Rowney
www.daler-rowney.com
Makers of high quality artists' materials
and equipment.

Jackson's
www.jacksonsart.com
Suppliers of a wide range of materials and equipment
for the artist from many different brands, both online
and through their shops.

LION Picture Framing Supplies Ltd
www.lionpic.co.uk
Trade suppliers of everything necessary to create
and hang picture frames, including a wide range of
mouldings and mountboards.

Mall Galleries
www.mallgalleries.org
Mall Galleries hosts a diverse programme of
exhibitions and events, and is home to the Federation
of British Artists. A good starting point to look for
opportunities to exhibit and to learn.

New English Art Club
www.newenglishartclub.co.uk
An elected society of contemporary painters, including
many contributors to this book, whose ethos resides
in art informed by the visual world and personal
interpretation. Its annual exhibition invites submission
from non-members and it also runs a vibrant
education programme including two scholarships,
which are awarded annually.

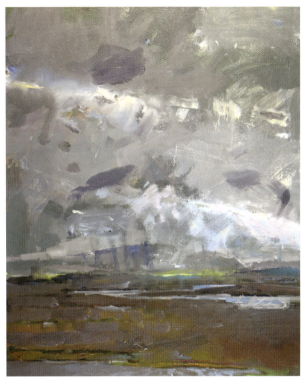

■ *Trails of Light*, Hebrides 24 × 20 in (61 × 51 cm) oil on canvas. Richard Pikesley.

Winsor & Newton

www.winsornewton.com
Manufacturers of materials and equipment for the artist.

Michael Harding

www.michaelharding.co.uk
Maker of fine quality artists' oil colours and materials.

Rosemary brushes

www.rosemaryandco.com
Makers of high-quality brushes for watercolour, acrylics and oil paint.

Stuart R Stevenson

www.stuartstevenson.co.uk
Suppliers of gold leaf and gilding materials and tools as well as a huge range of materials for the artist.

INDEX